slight warping &
stains on back pages

Officially Noted
By AH Date 1/17/17

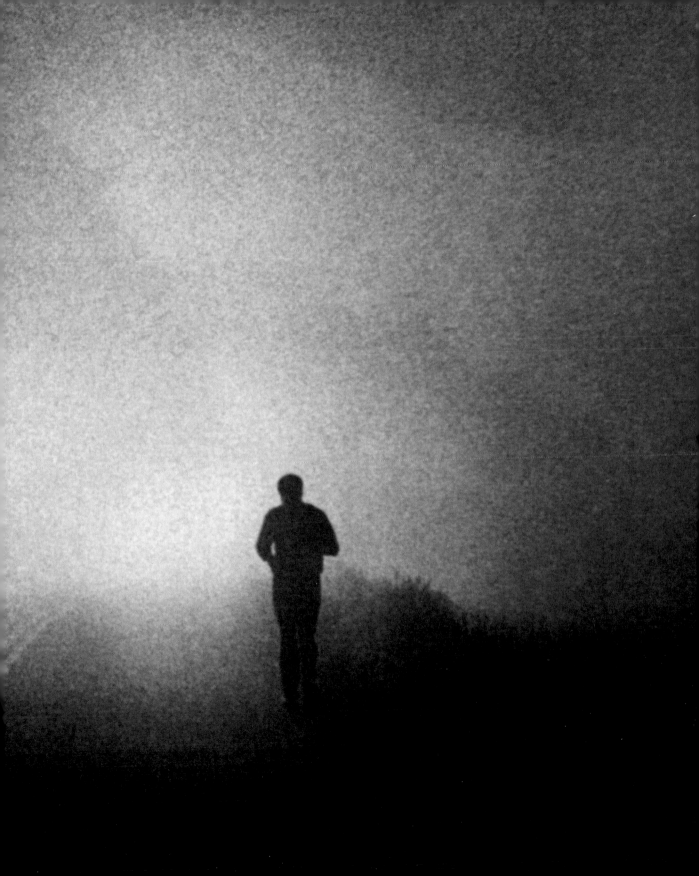

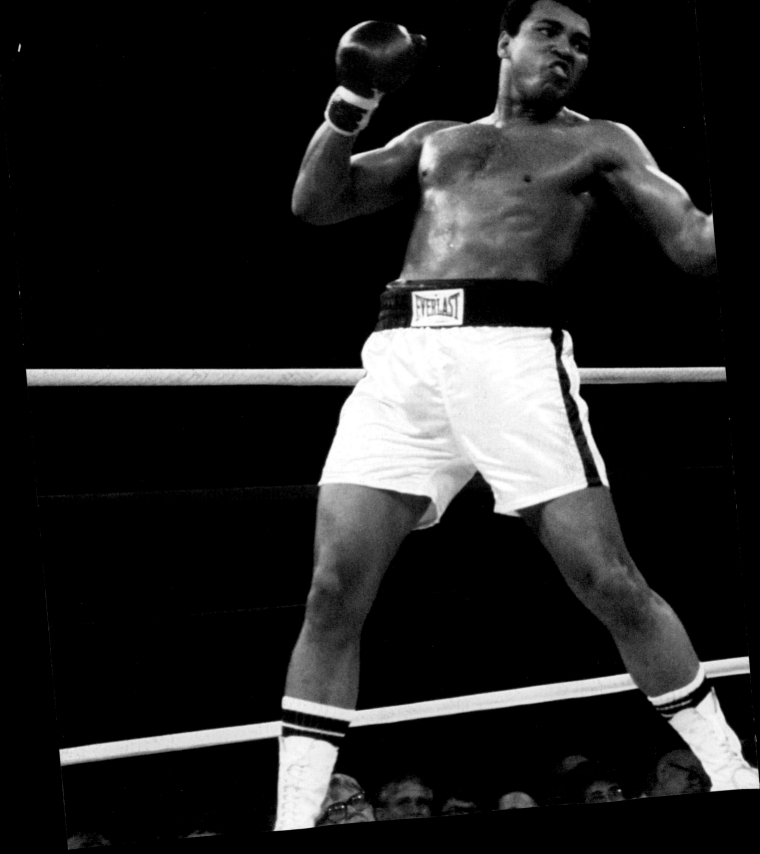

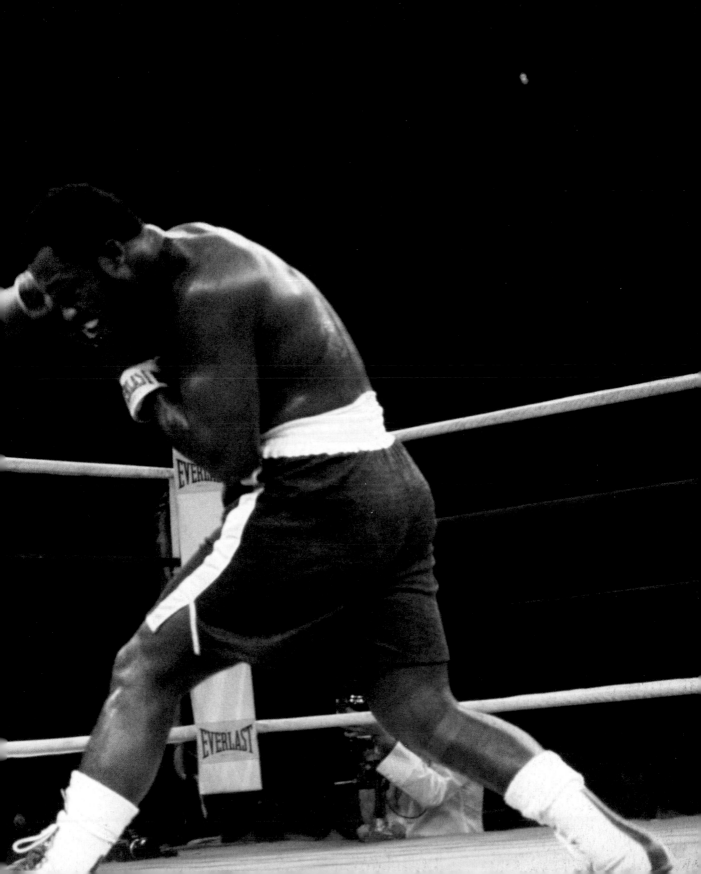

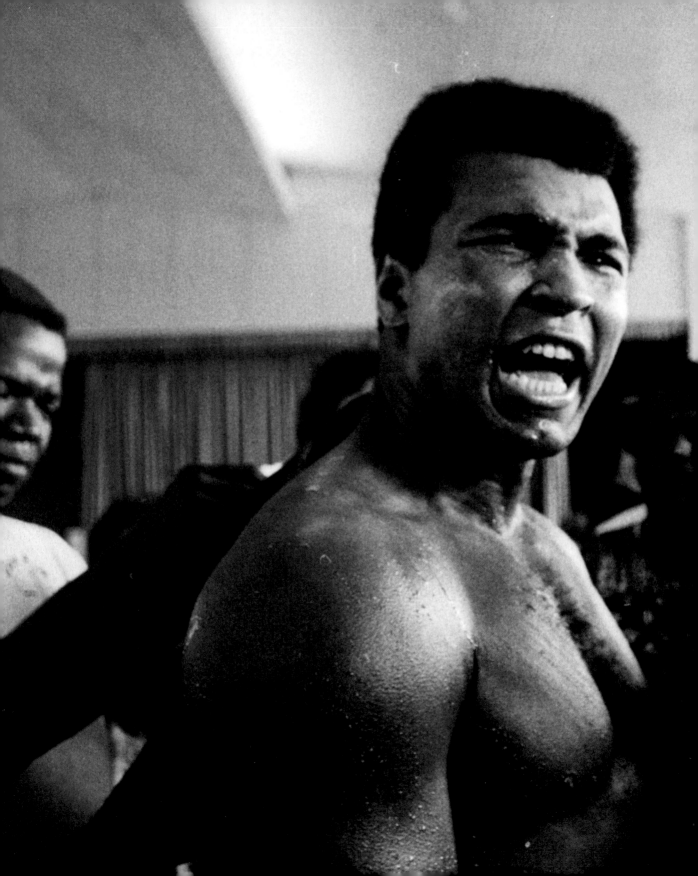

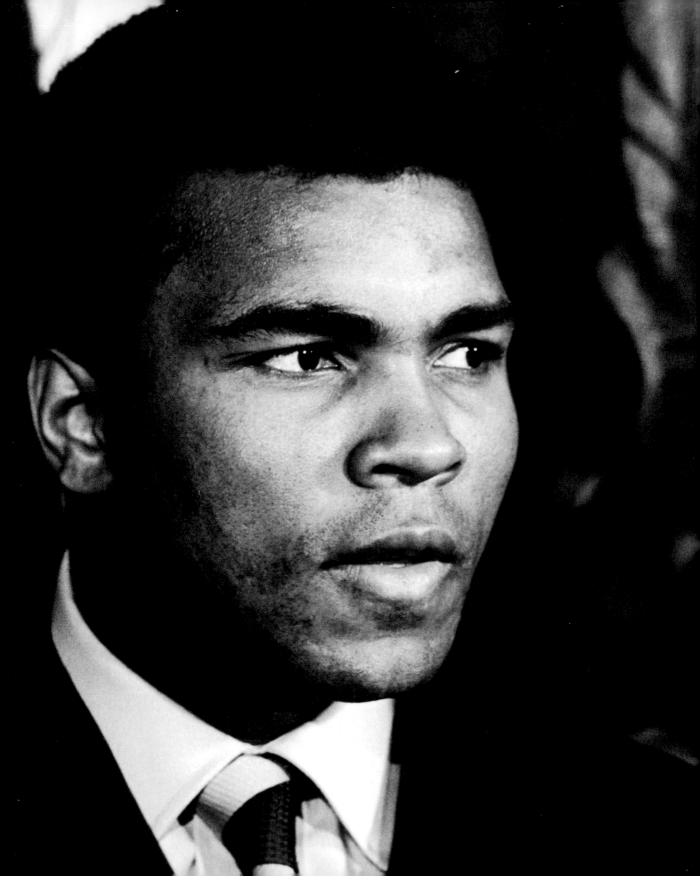

MUHAMMAD ALI
UNFILTERED

JETER PUBLISHING

NEW YORK LONDON TORONTO SYDNEY NEW DELHI

JETER PUBLISHING

Gallery Books
An Imprint of Simon & Schuster, Inc.
1230 Avenue of the Americas
New York, NY 10020

First Gallery Books hardcover edition October 2016

For information about special discounts for bulk purchases, please contact Simon & Schuster
Special Sales at 1-866-506-1949 or business@simonandschuster.com.

The Simon & Schuster Speakers Bureau can bring authors to your live event.
For more information or to book an event contact the Simon & Schuster Speakers Bureau
at 1-866-248-3049 or visit our website at www.simonspeakers.com.

Interior design by Nate Beale/SeeSullivan
Photo editor: Maureen Cavanagh
Photo researcher: George Washington

Manufactured in the United States of America

10 9 8 7 6 5 4 3 2 1

Library of Congress Cataloging-in-Publication Data is available.

ISBN 978-1-5011-6194-0
ISBN 978-1-5011-6199-5 (ebook)

FOREWORD
BY LONNIE ALI

While Muhammad walked among us, he gave the world the best of himself—
gifts if you will—the kind he always said were the best. The kind you can't hold
in your hand but can hold in your heart. Inspiration, hope, and a love of all
people, in all cultures, across the globe. And because he gave so freely, without
condition, these gifts carry on. His goodness still carries on.

Muhammad embodied many different things to many different people through-
out his life. He was committed to a path of personal growth, peace, compassion,
wisdom, and heightened spiritual awakening. And although Muhammad was
a great many things, if we invoked a litany of descriptors to somehow try and
communicate all that he was, the one thing that would always hold true would
be that he was a man of principal and conviction. We counted on him for that
constancy. We counted on him to always be authentically Muhammad Ali.

This photographic collection consists of some rarely seen images of Muhammad.
As you look at these images, I hope you get a sense of the multi-faceted man
I knew. Muhammad will forever be a legend—a man we can all recognize at a
glance and yet whose many sides we still can't quite capture. There will always
be something new to discover about him. Words will never be able to fully define
him because he was always so much more. However, being able to experience him
through the rich visual tones of photography is a special kind of thrill, one that I
hope you too can feel, as clearly as the ringing of the fight bell.

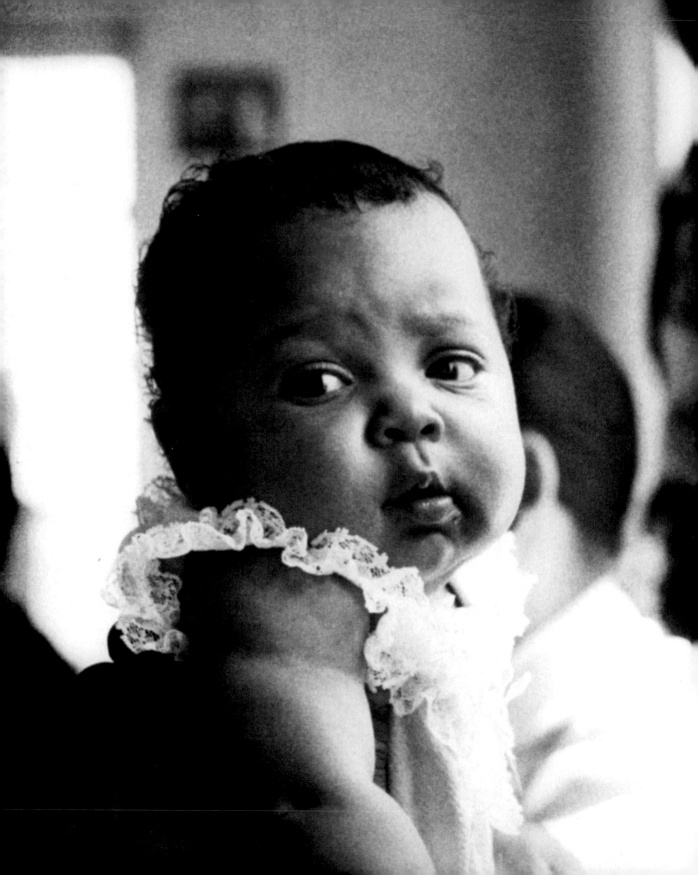

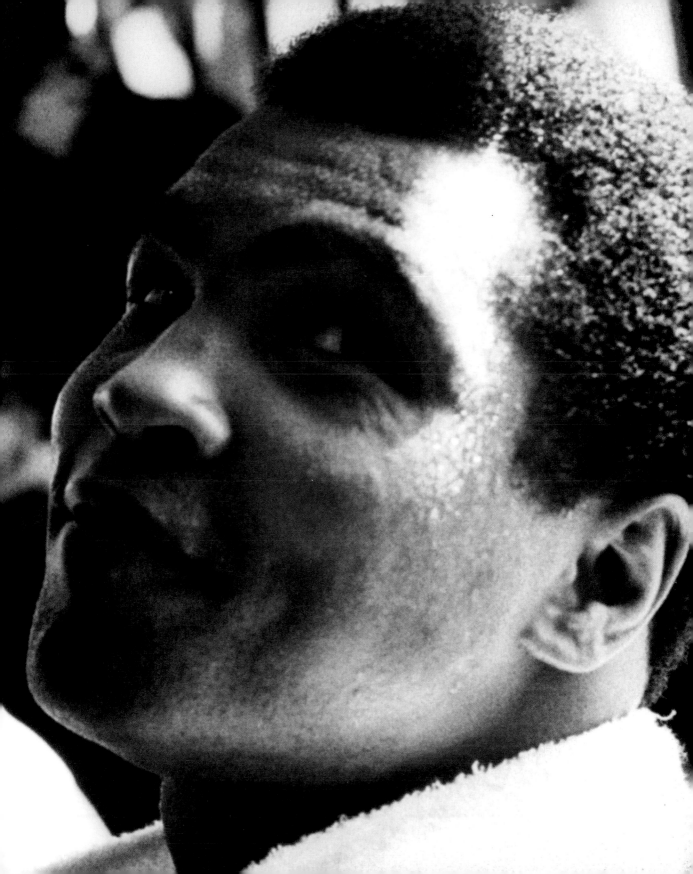

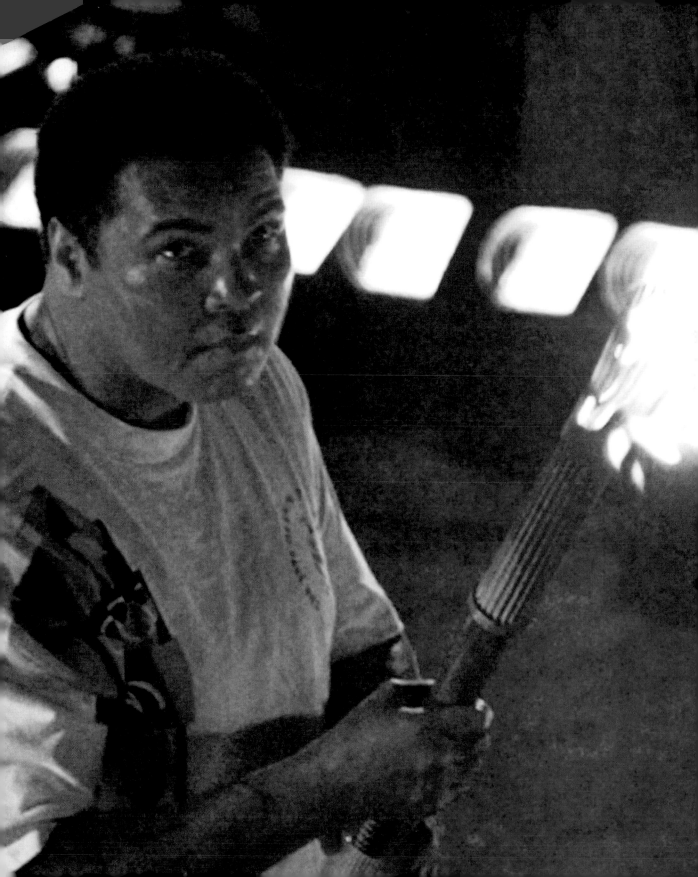

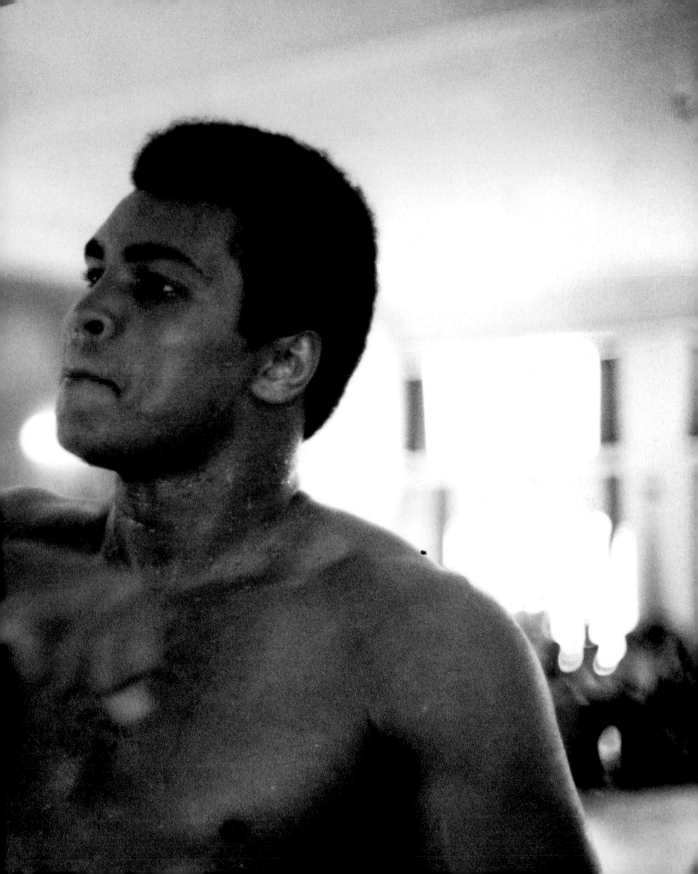

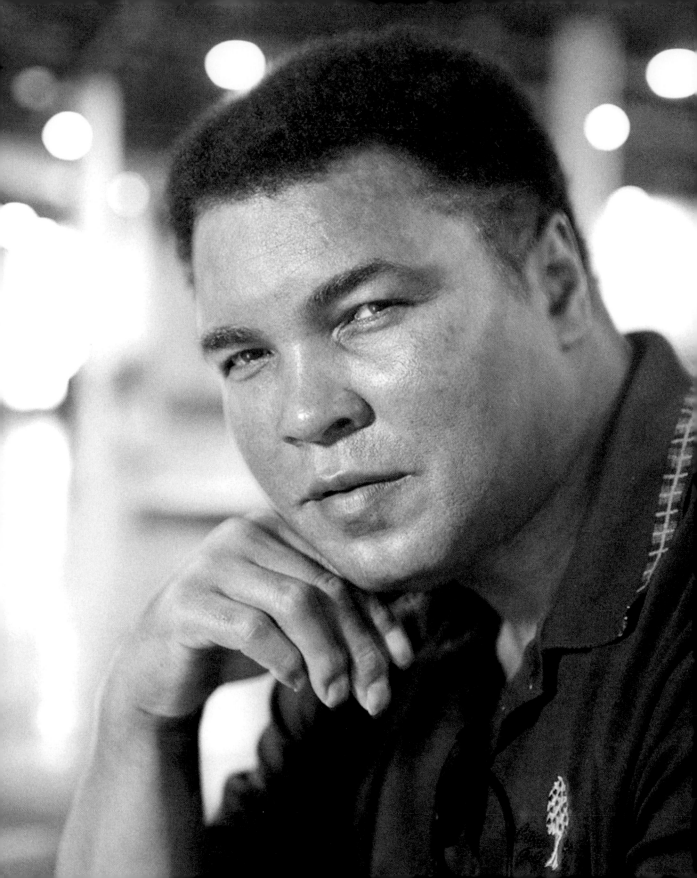

EULOGY
BY LONNIE ALI

On Friday, June 10, 2016, Lonnie Ali paid tribute to her late husband before 15,000 mourners at a public memorial service in an arena in Louisville, Kentucky, their hometown.

As-Salaam-Alaikum. Peace be upon you.

Thank you all for being here to share in this final farewell to Muhammad.

On behalf of the Ali family, let me first recognize our principal celebrant, Imam Zaid Shakir, and also Dr. Timothy Gianotti. We thank you for your dedication to fulfilling Muhammad's desire that the ceremonies of this past week reflect the traditions of his Islamic faith, and as a family, we thank the millions of people who, through the miracle of social media, inspired by their love of Muhammad, have reached out to us with their prayers. The messages have come in every language, from every corner of the globe. From wherever you are watching, know that we have been humbled by your heartfelt expressions of love.

It is only fitting that we gather in a city to which Muhammad always returned after his great triumphs, a city that has grown as Muhammad has grown. Muhammad never stopped loving Louisville, and we know Louisville loves Muhammad.

We cannot forget a Louisville police officer, Joe Elsby Martin, who embraced a young 12-year-old boy in distress when his bicycle was stolen. Joe Martin handed young Cassius Clay the keys to a future in boxing he could scarcely have imagined. America must never forget that when a cop and an inner-city kid talk to each other, miracles can happen.

Some years ago during his long struggle with Parkinson's, in a meeting that included his closest advisers, Muhammad indicated that when the end came

for him, he wanted us to use his life and his death as a teaching moment for young people, for his country, and for the world. In effect, he wanted us to remind people who are suffering that he had seen the face of injustice, that he grew up in segregation, and that during his early life he was not free to be who he wanted to be. But he never became embittered enough to quit or to engage in violence.

It was a time when a young black boy his age could be hung from a tree: Emmett Till, in Money, Mississippi, in 1955, whose admitted killers went free. It was a time when Muhammad's friends, men that he admired, like Brother Malcolm and Dr. King, were gunned down, and Nelson Mandela imprisoned for what he believed in.

For his part, Muhammad faced federal prosecution. He was stripped of his title and his license to box. He was sentenced to prison.

But he would not be intimidated so as to abandon his principles or his values.

Muhammad wants young people of every background to see his life as proof that adversity can make you stronger. It cannot rob you of the power to dream—and to reach your dreams. This is why we built the Muhammad Ali Center, and that is the essence of the Ali Center message.

Muhammad wants us to see the face of his religion, al-Islam, true Islam, as the face of love. It was his religion that caused him to turn away from war and violence. For his religion, he was prepared to sacrifice all that he had, and all that he was, to protect his soul and follow the teachings of Prophet Muhammad, peace be upon him.

So even in death, Muhammad has something to say.

He is saying that his faith requires that he take the more difficult road. It is far more difficult to sacrifice one's self in the name of peace than to take up arms in the pursuit of violence.

All of his life Muhammad was fascinated by travel. He was childlike in his encounter of new surroundings and new people. He took his world championship fights to the ends of the earth, from the South Pacific to Europe to the Belgian Congo. And of course, with Muhammad, he believed it was his duty to let everyone see him in person, because after all, he was The Greatest of All Time.

The boy from Grand Avenue in Louisville, Kentucky, grew in wisdom from his journeys. He discovered something new: that the world really wasn't black and white at all. It was filled with many shades of rich colors, languages, and

religions. As he moved with ease around the world, the rich and powerful were drawn to him. But he was drawn to the poor and the forgotten.

Muhammad fell in love with the masses, and they fell in love with him. In the diversity of men and their faiths, Muhammad saw the presence of God.

He was captivated by the work of the Dalai Lama, by Mother Teresa, and church workers who gave their lives to protect the poor. When his mother died, he arranged for multiple faiths to be represented at her funeral, and he wanted the same for himself. We are especially grateful for the presence of the diverse faith leaders here today, and I would like to ask them to stand once more and be recognized.

As I reflect on the life of my husband, it's easy to see his most obvious talents. His majesty in the ring, as he danced under those lights, enshrined him as a champion for the ages. Less obvious was his extraordinary sense of timing. His knack for being in the right place at the right time seemed to be ordained by a higher power. Even though surrounded by Jim Crow, he was born into a family with two parents who nurtured and encouraged him. He was placed on the path to his dreams by a white cop. And he had teachers who understood his dreams and wanted him to succeed. The Olympic gold medal came, and the world started to take notice. A group of successful businessmen in Louisville, called the Louisville Sponsoring Group, saw his potential, and helped him build a runway to launch his career. His timing was impeccable as he burst onto the national stage, just as television was hungry for a star to change the face of sports.

If Muhammad didn't like the rules, he rewrote them. His religion, his name, his beliefs were his to fashion, no matter what the cost. The timing of his actions coincided with a broader shift in cultural attitudes across America, particularly on college campuses. When he challenged the U.S. government on the draft, his chance of success was slim to none. But the timing of his decision converged with a rising tide of discontent on the war. Public opinion shifted in his direction, followed by a unanimous Supreme Court ruling. In a stunning reversal of fortunes, he was free to return to the ring.

When he traveled to central Africa to reclaim his title from George Foreman, none of the sportswriters thought he could win. In fact, most of them feared for his life. But in what the Africans call "The Miracle at 4 A.M.," he became a champion once more.

As the years passed, although slowed by Parkinson's, Muhammad was

compelled by his faith to use his name and his notoriety to support the victims of poverty and strife. He served as a human messenger of peace and traveled to places like war-torn Afghanistan. He campaigned as an advocate for reducing the yoke of third-world debt. He stunned the world when he secured the release of fifteen hostages from Iraq.

As his voice grew softer, his message took on greater meaning. He came full circle with the people of his country when he lit a torch that seemed to create new light at the 1996 Olympics.

Muhammad always knew instinctively the road he needed to travel. His friends know what I mean when I say: He lived in the moment. He neither dwelled in the past, nor harbored anxiety about the future. Muhammad loved to laugh, and he loved to play practical jokes on just about everybody. He was surefooted in his self-awareness, secure in his faith, and he did not fear death.

Yet his timing is once again poignant. His passing and his meaning for our time should not be overlooked. As we face uncertainty and divisions at home as to who we are as a people, Muhammad's life provides useful guidance.

Muhammad was not one to give up on the power of understanding, the boundless possibilities of love, and the strength of our diversity. He counted among his friends people of all political persuasions, saw truth in all faiths, and the nobility of all races, as witnessed here today.

Muhammad may have challenged his government, but he never ran from it, or from America. He loved this country, and he understood the hard choices that are born of freedom. I think he saw a nation's soul measured by the soul of its people. For his part, he saw the good soul in everyone—and if you were one of the lucky ones to have met him, you know what I mean.

He awoke every morning thinking about his own salvation, and he would often say, "I just want to get to heaven. And I've got to do a lot of good deeds to get there."

I think Muhammad's hope is that his life provides some guidance on how we might achieve for all people what we aspire for ourselves and our families.

Thank you.

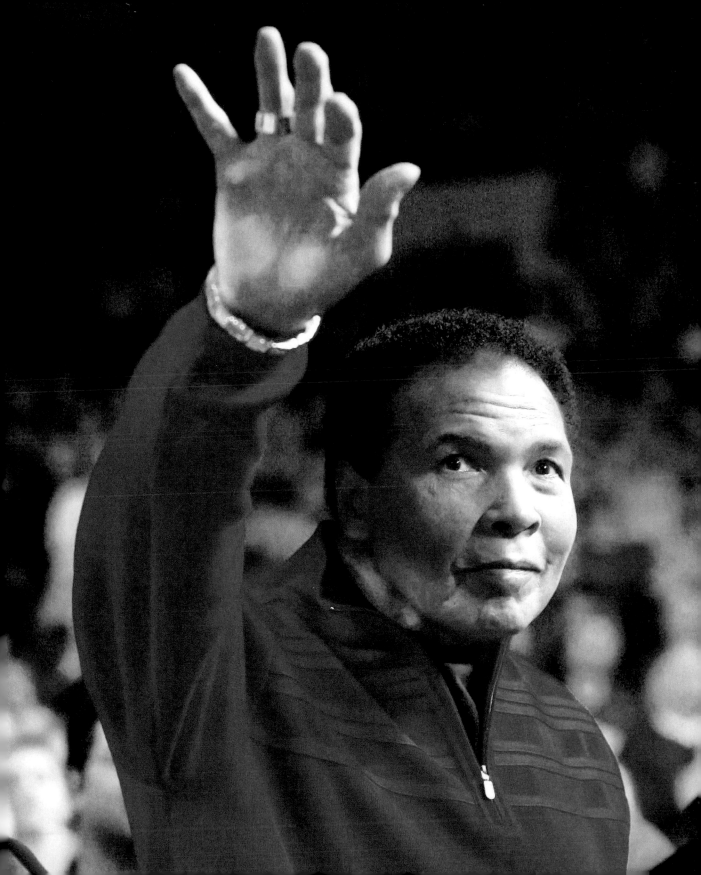

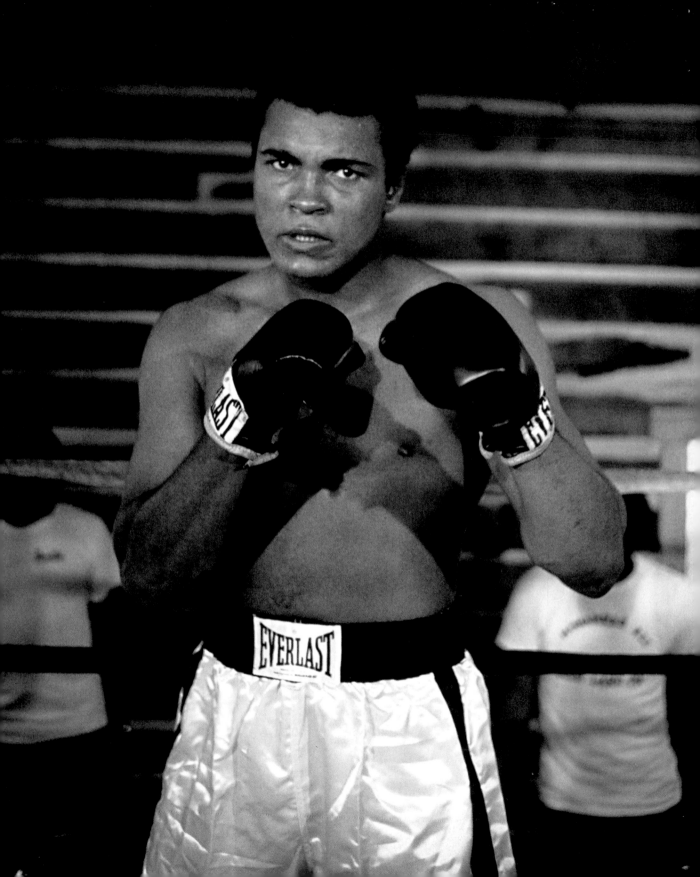

ALI
THE FIGHTER

"

**I am the greatest. I said this
even before I knew I was.**

"

"Imma show you how great I am."

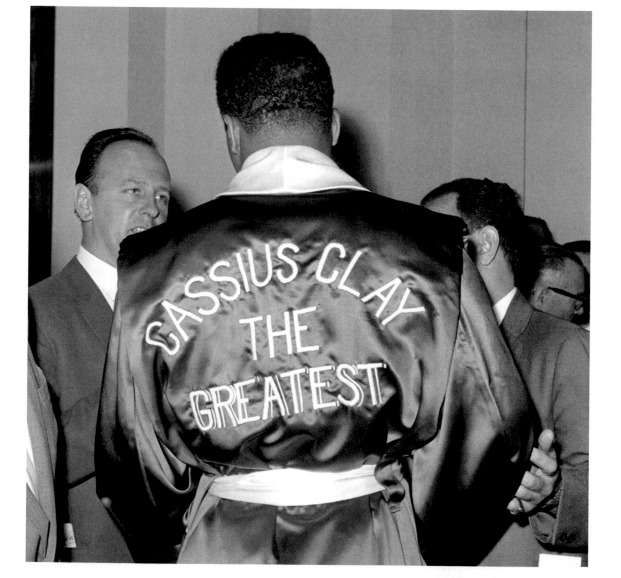

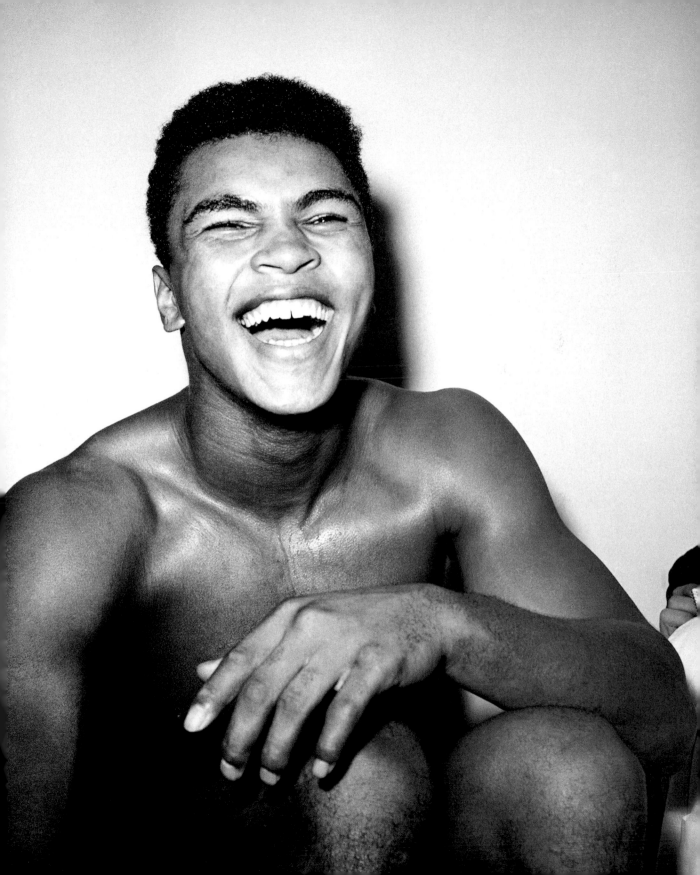

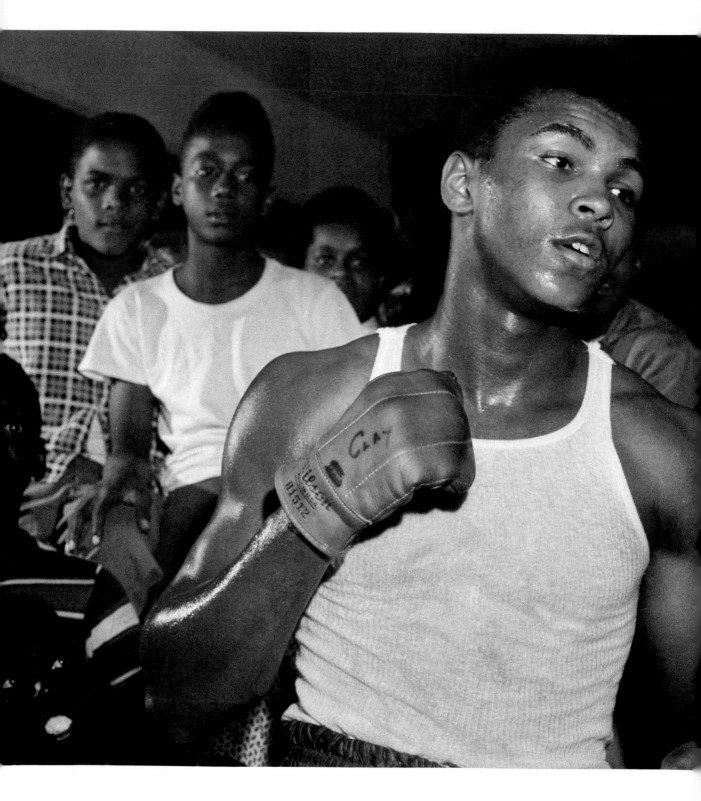

"

**IF YOU EVEN
DREAM OF
BEATING ME,
YOU'D BETTER
WAKE UP AND
APOLOGIZE.**

"

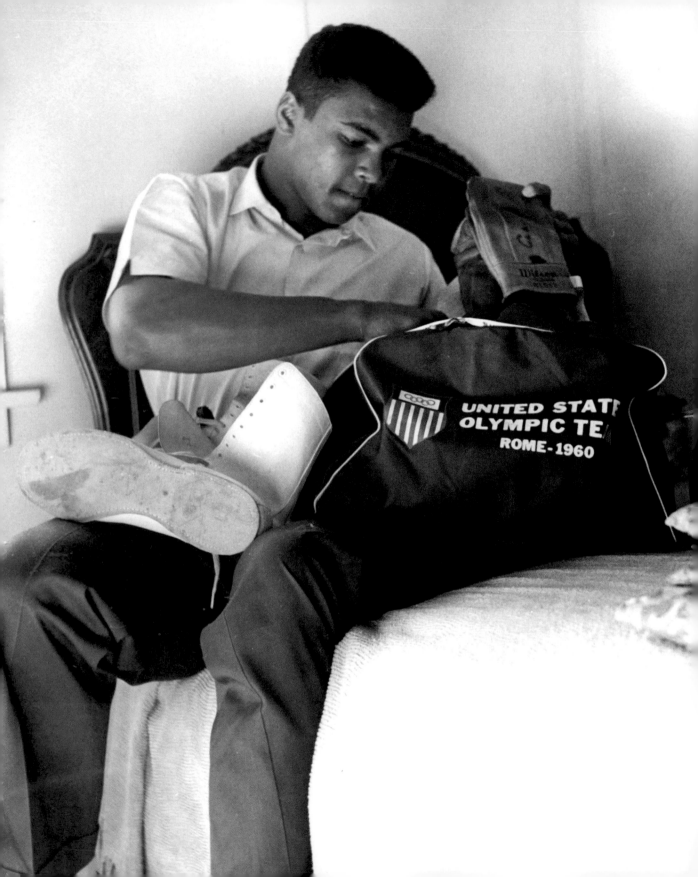

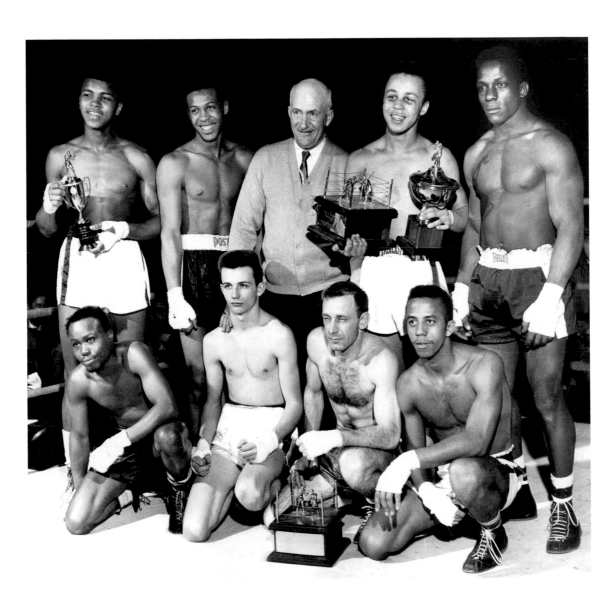

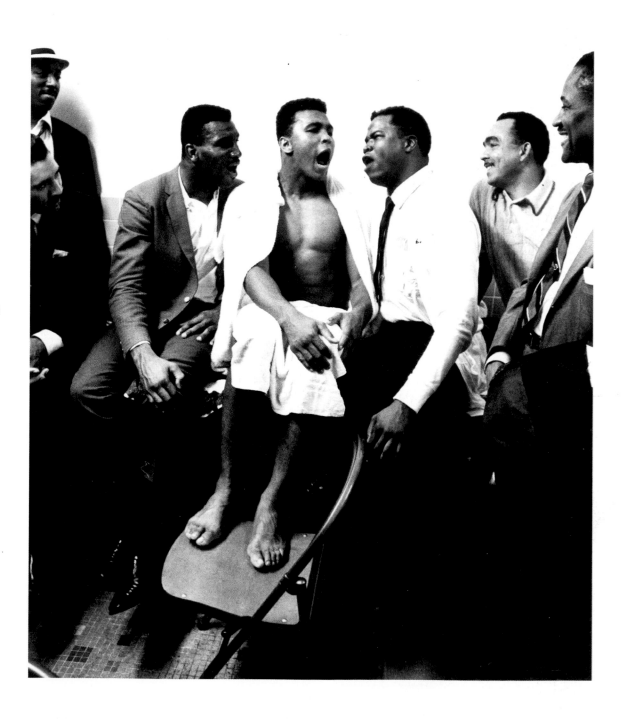

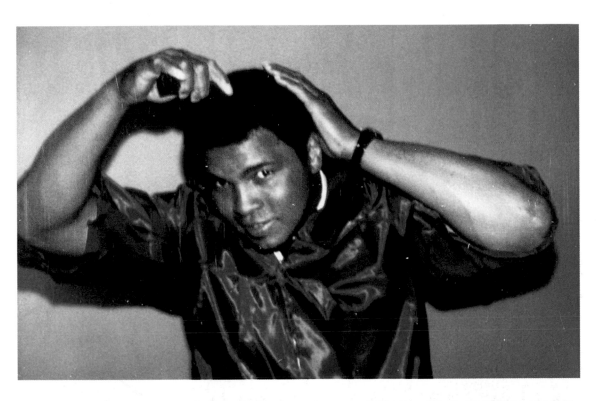

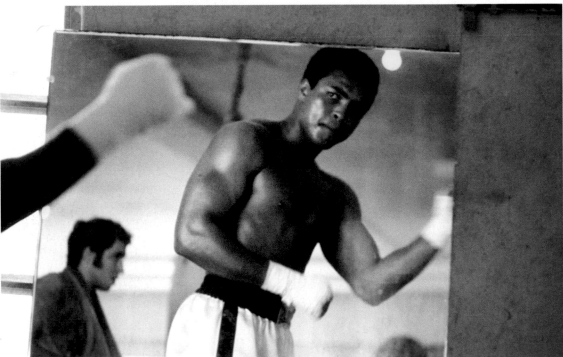

"

If your dreams don't scare you they aren't big enough.

"

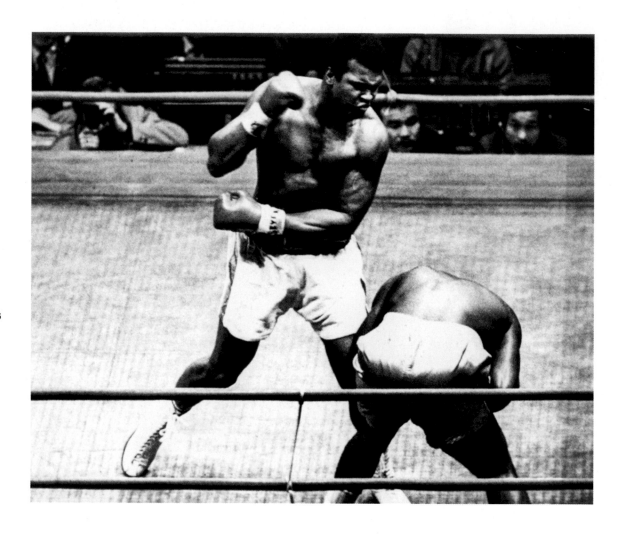

"Only a man who knows what it is like to be defeated can reach down
to the bottom of his soul and come up with the extra ounce of power
it takes to win when the match is even."

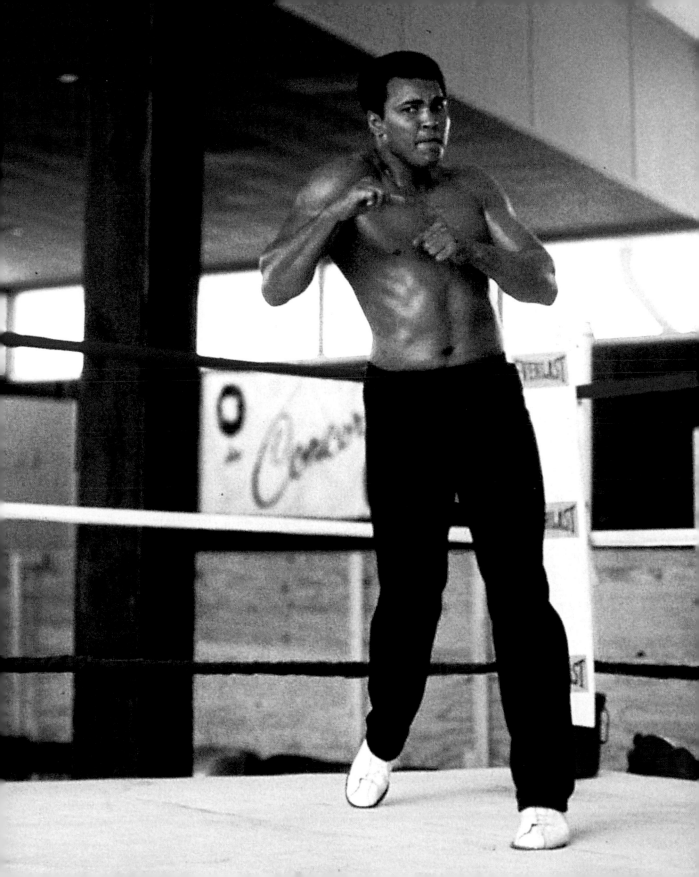

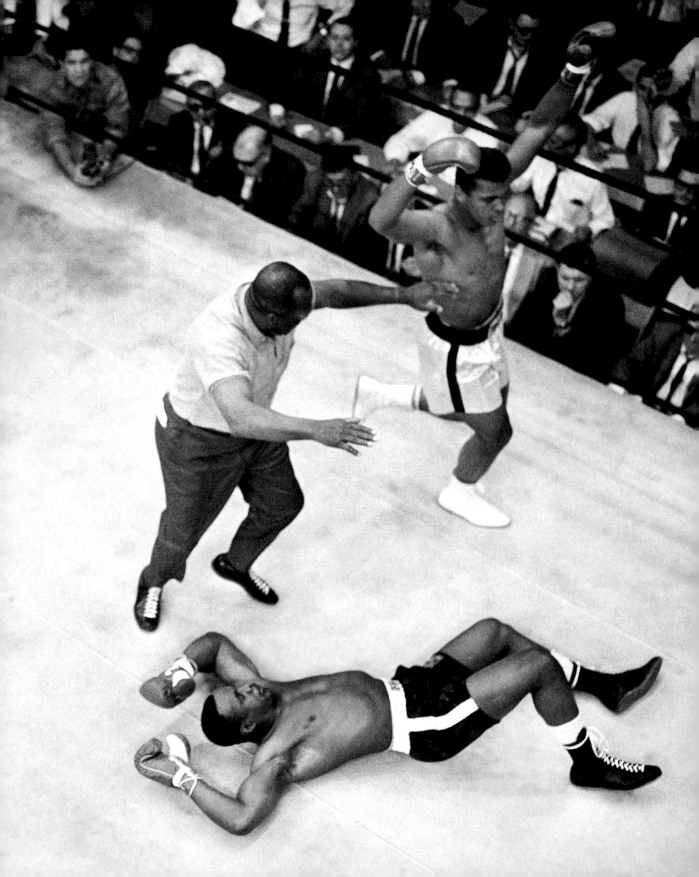

"I am the king of the world. I'm pretty.
I'm a baaaad man!"

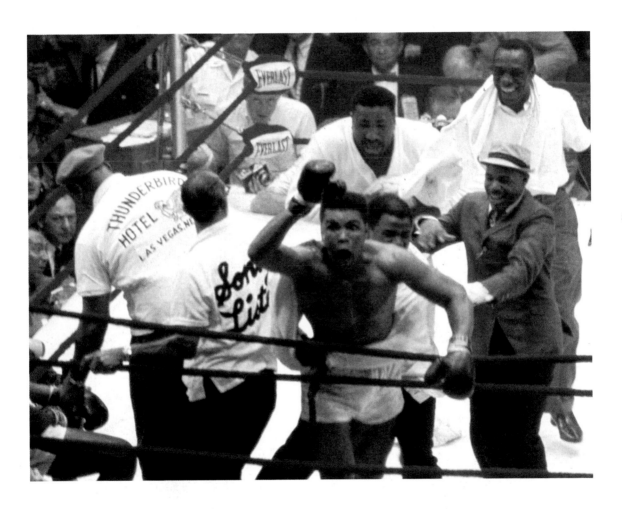

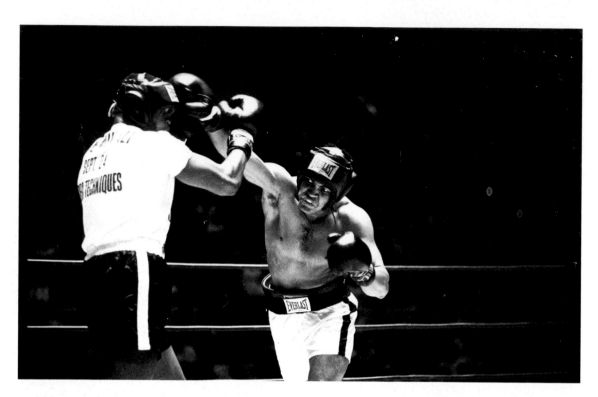

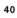

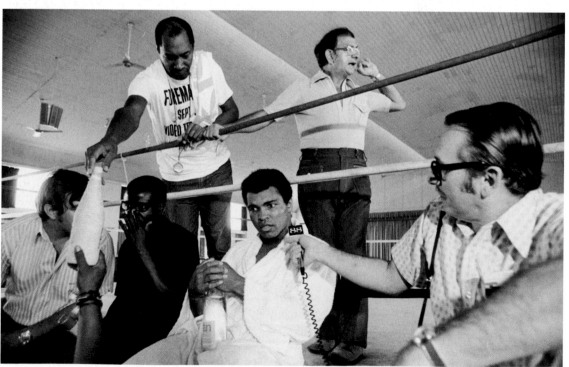

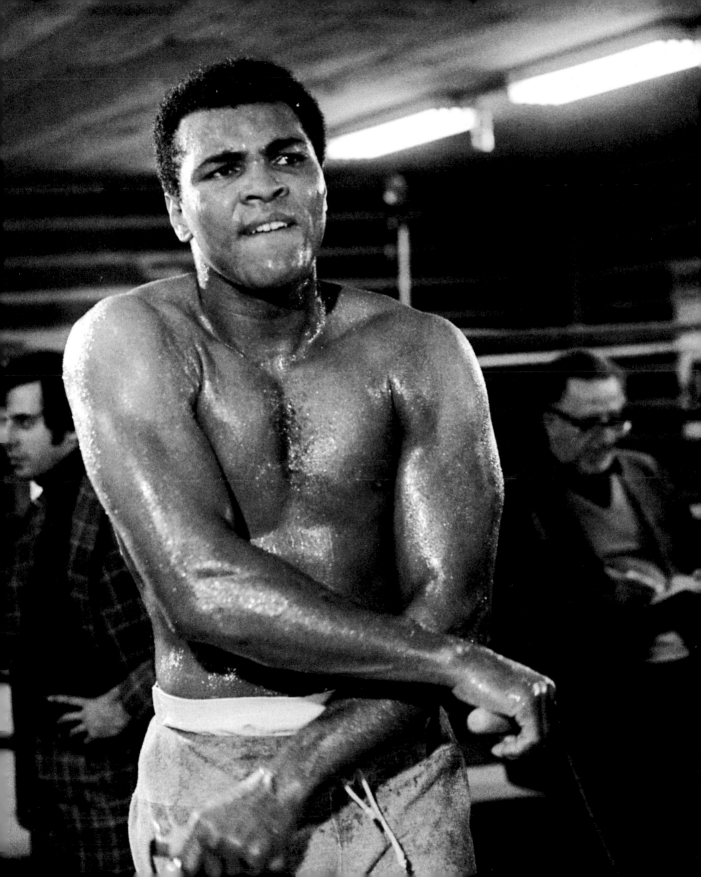

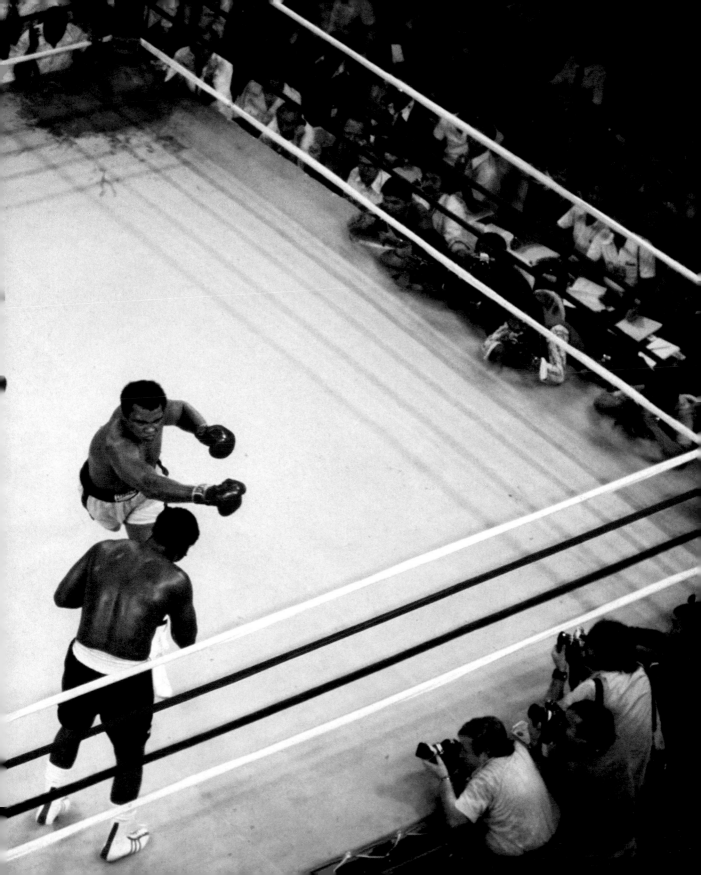

"Champions aren't made in the gyms. Champions are made from
something deep inside them—a desire, a dream, a vision.
They have to have the skill, and the will. But the will must
be stronger than the skill."

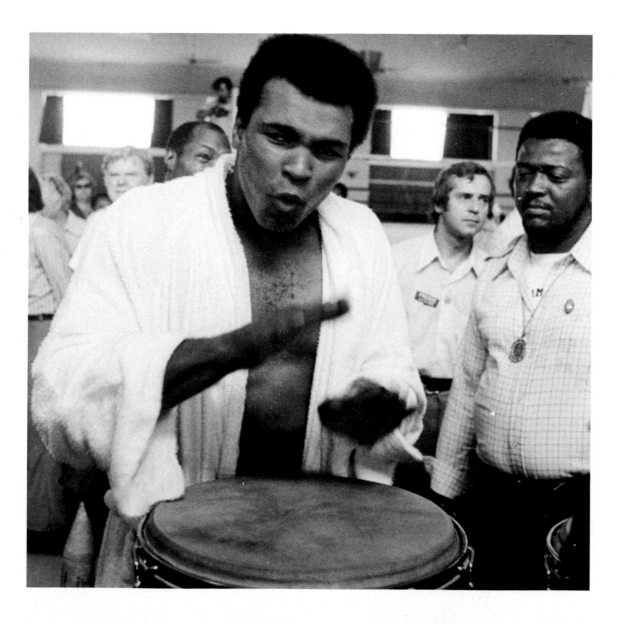

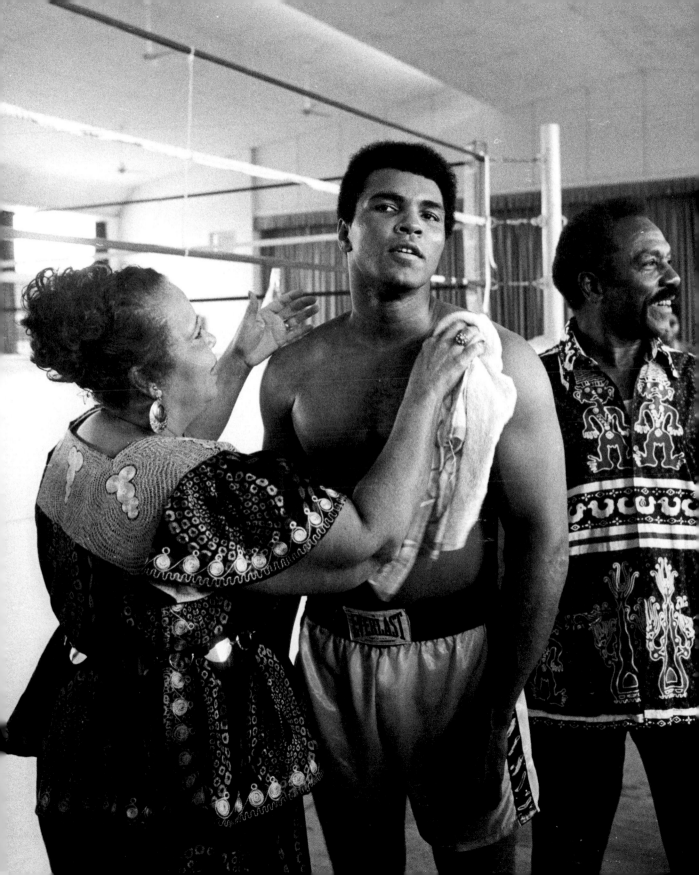

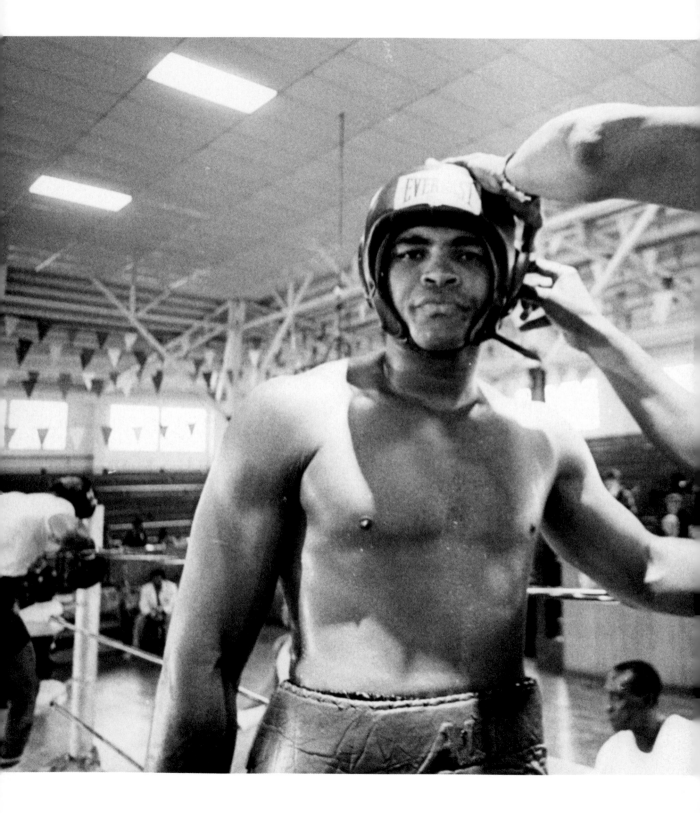

"

I HATED EVERY MINUTE OF TRAINING, BUT I SAID, 'DON'T QUIT. SUFFER NOW AND LIVE THE REST OF YOUR LIFE AS A CHAMPION.'

"

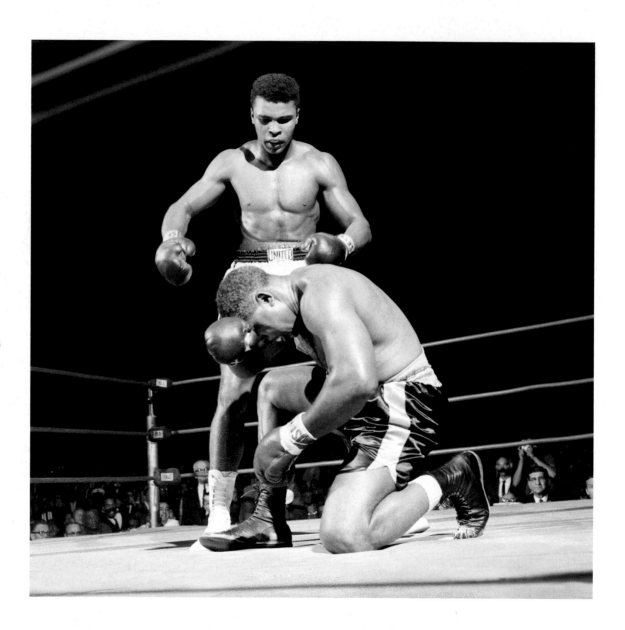

"Float like a butterfly, sting like a bee."

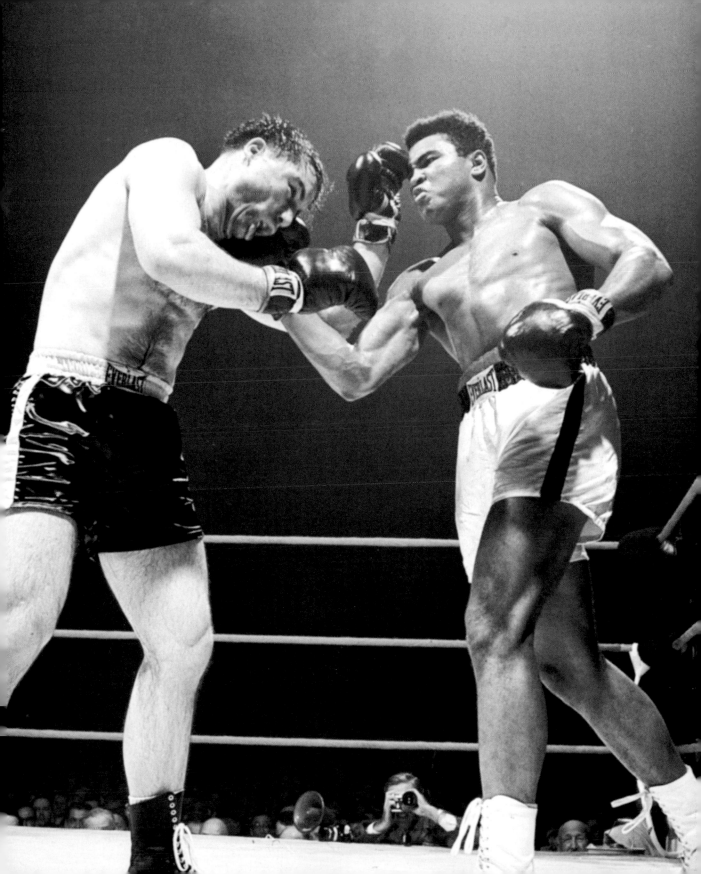

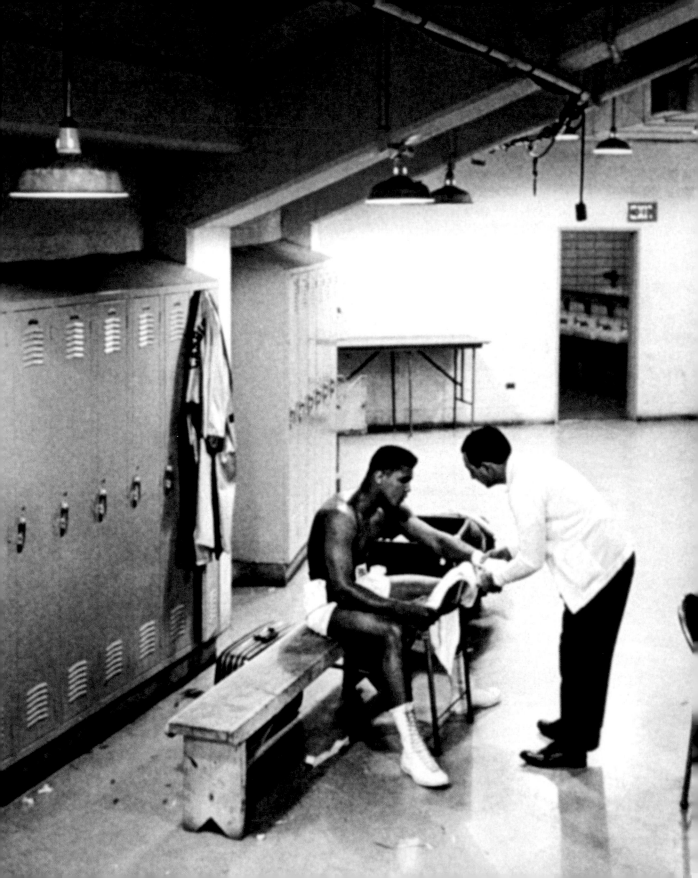

"I'm No. 1. After me, it don't matter."

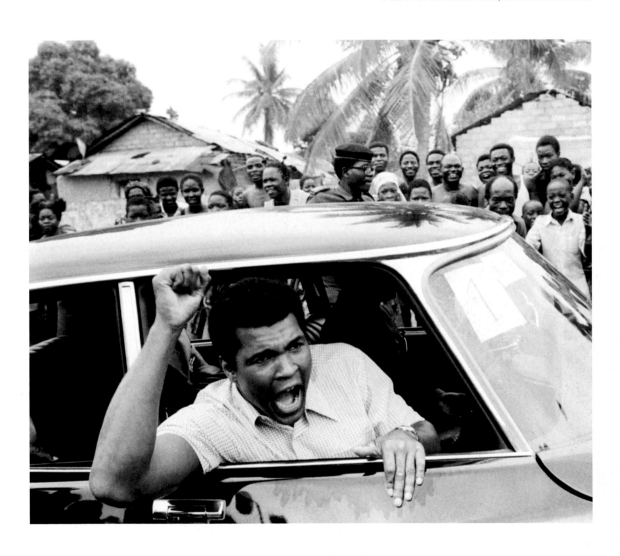

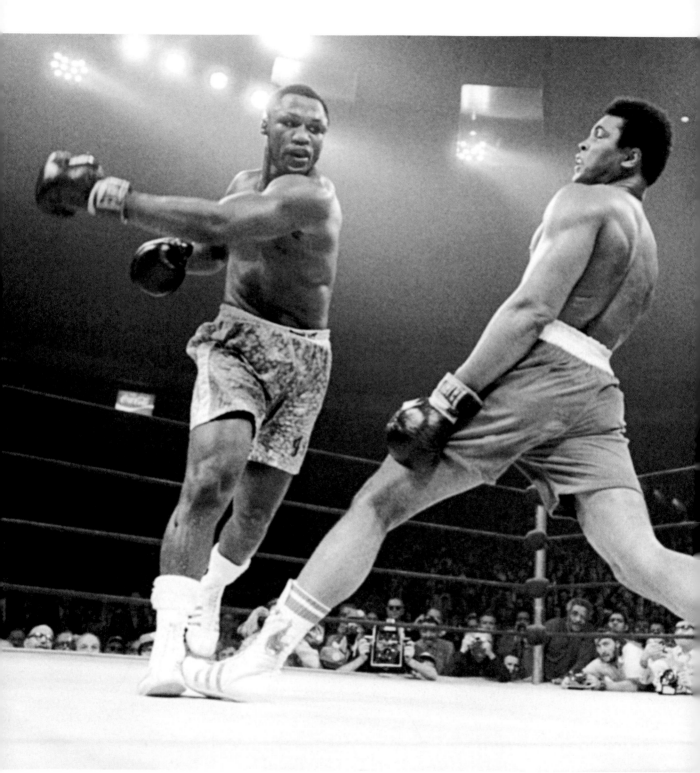

"

I'M SO MEAN,
I MAKE
MEDICINE SICK.

"

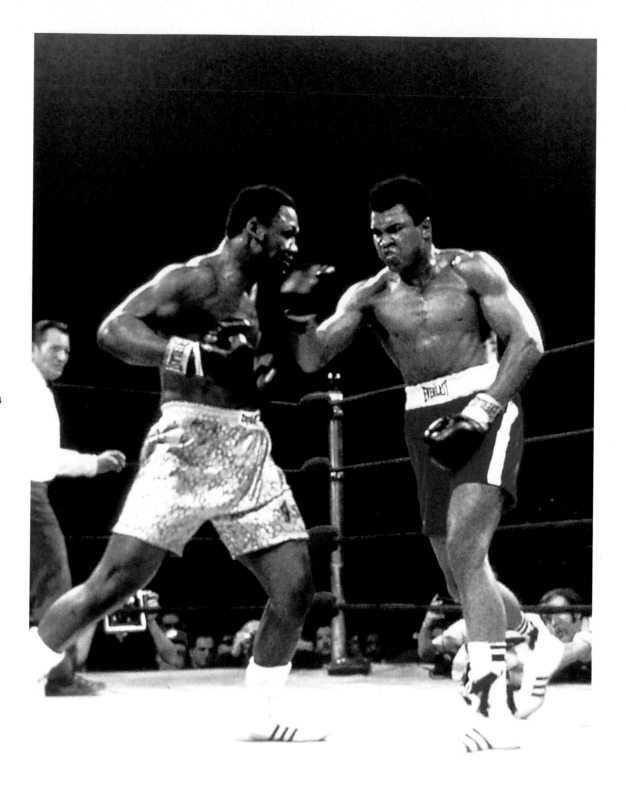

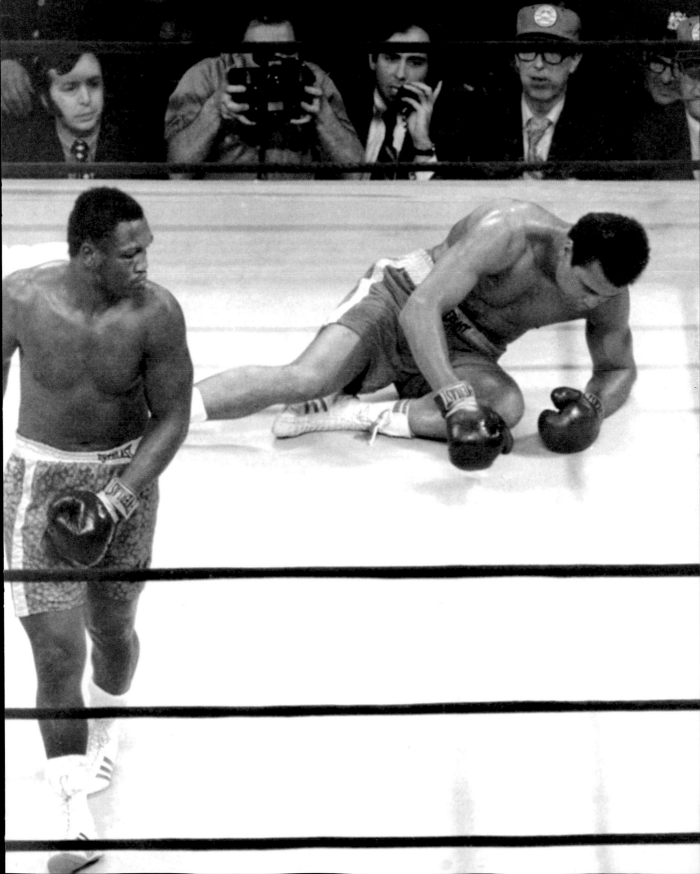

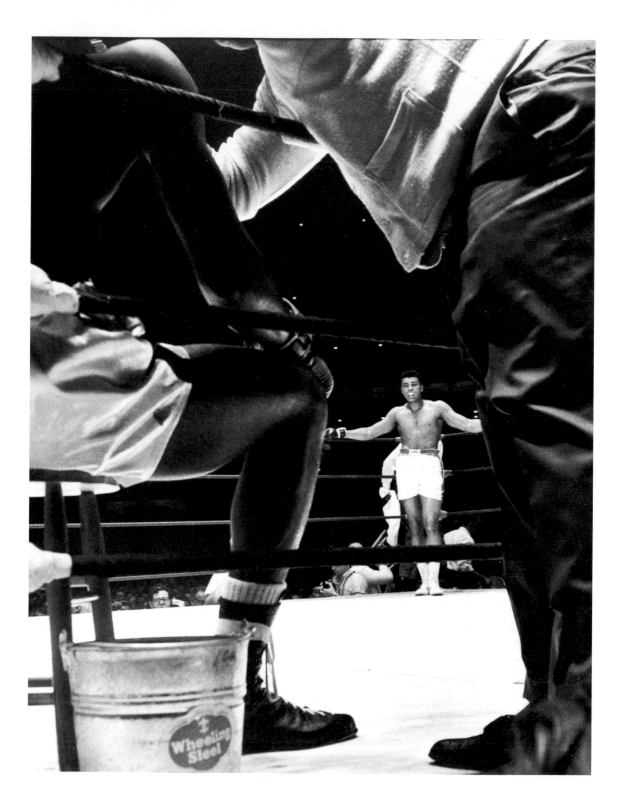

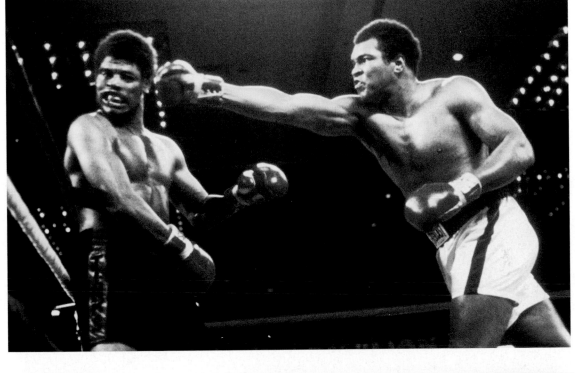

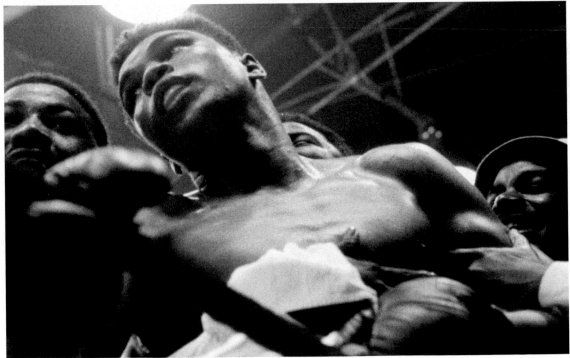

"
Don't count
the days.
**Make the
days count.**
"

"I have wrestled with an alligator, I done tussled with a whale, I done handcuffed lightnin', thrown thunder in jail."

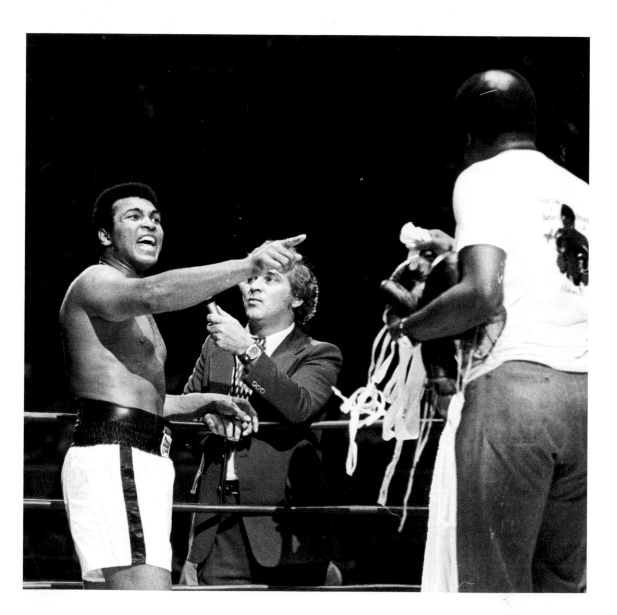

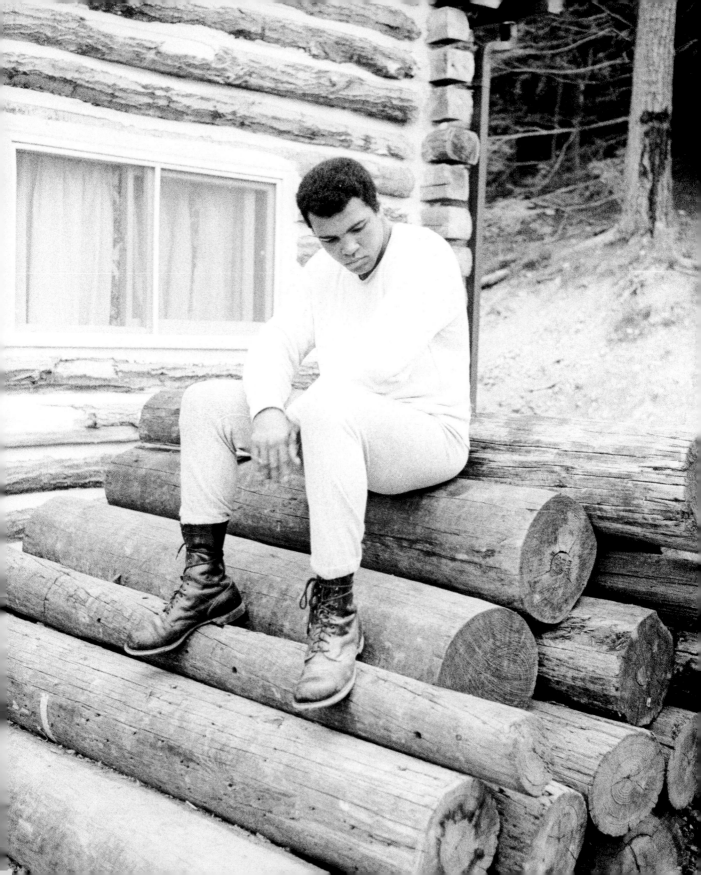

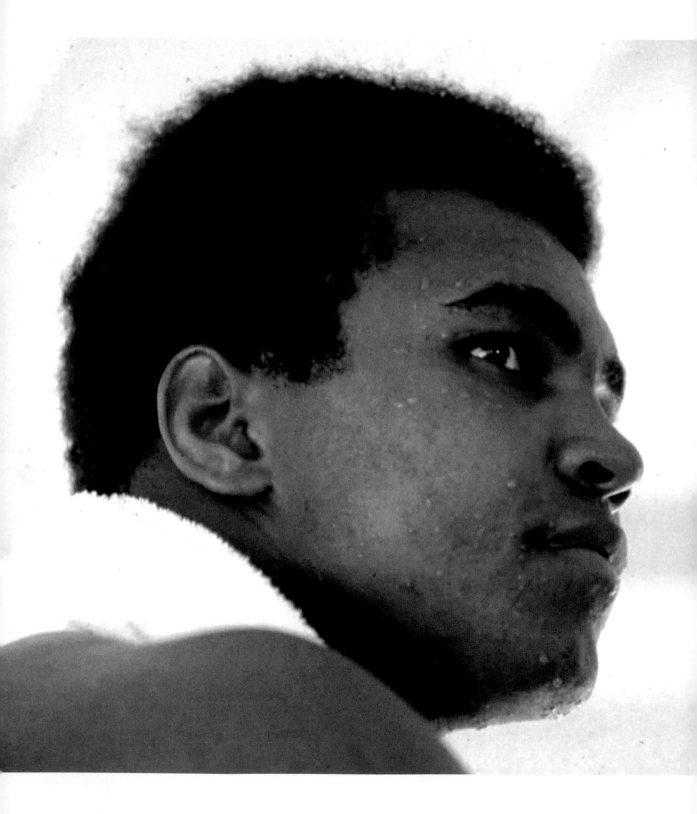

"
HE WHO IS NOT
COURAGEOUS
ENOUGH TO
TAKE RISKS
WILL ACCOMPLISH
NOTHING IN LIFE.
"

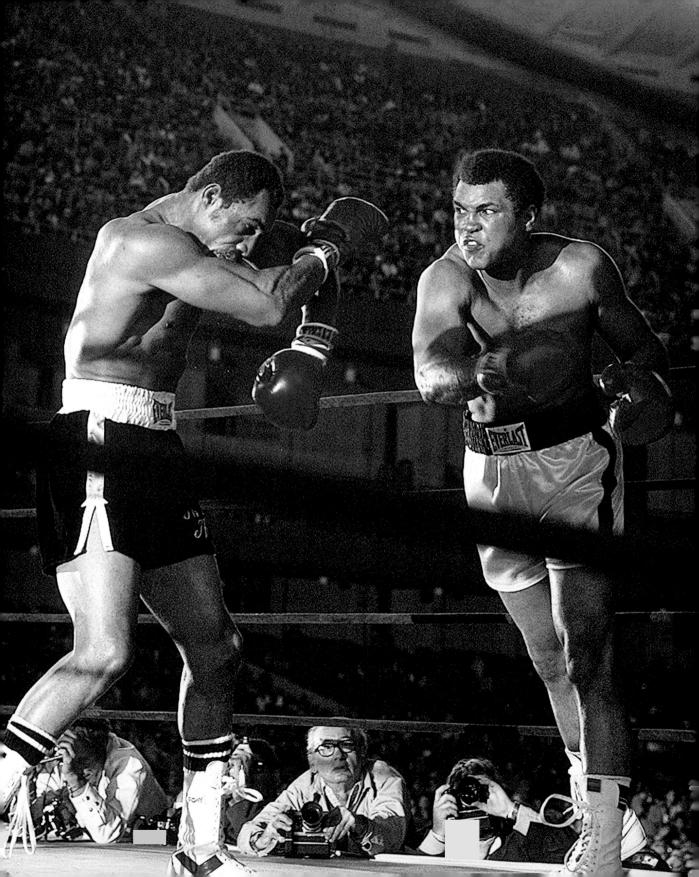

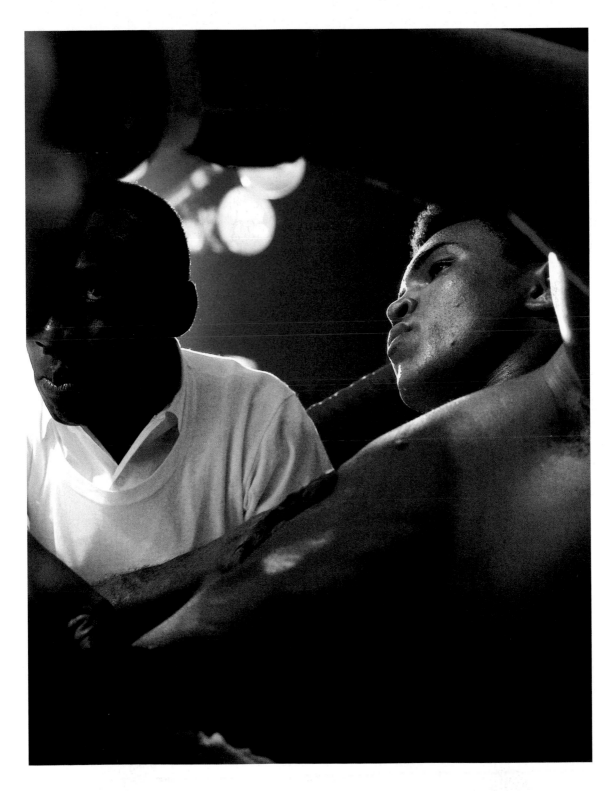

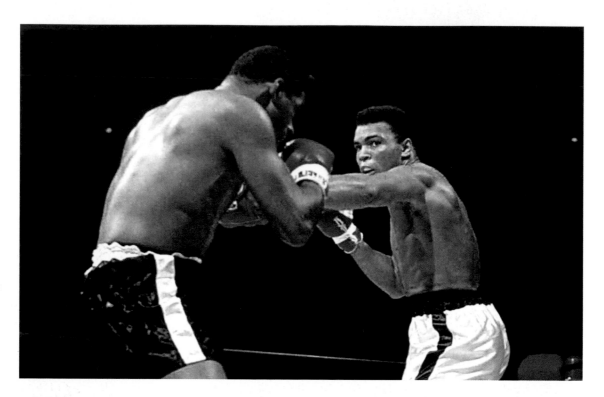

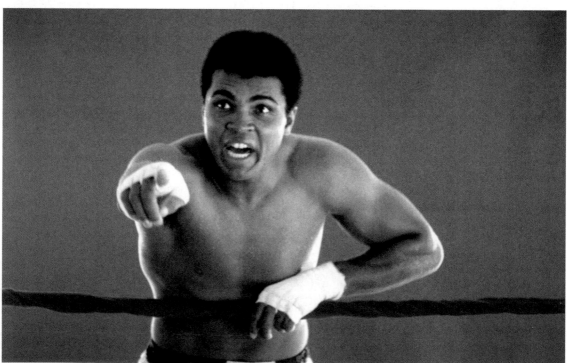

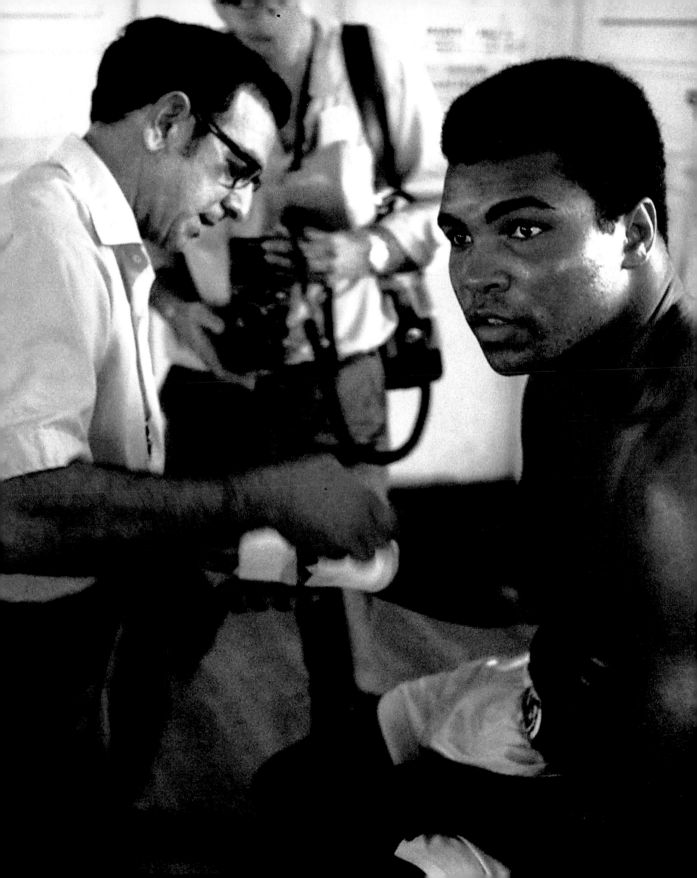

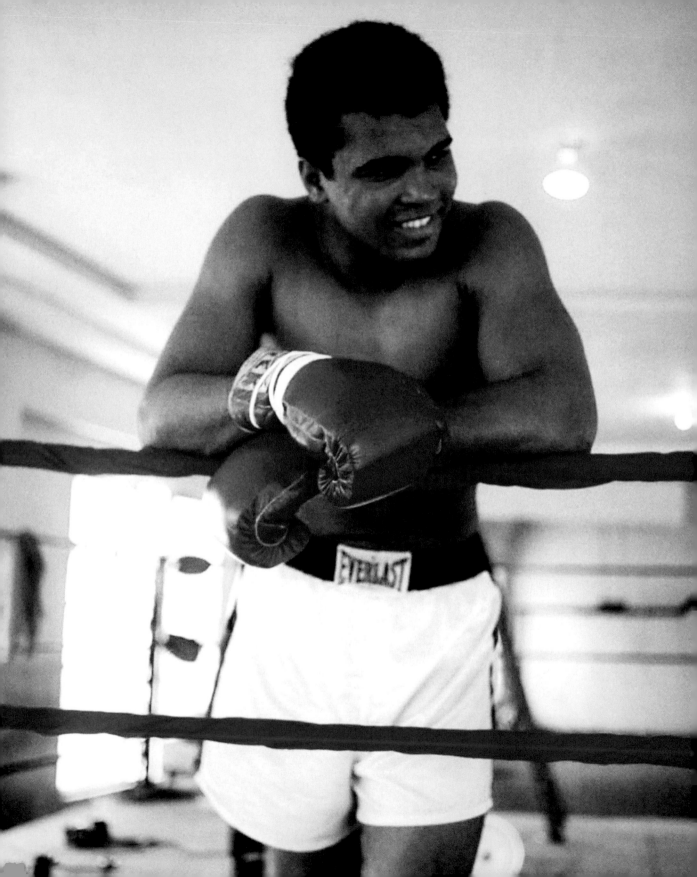

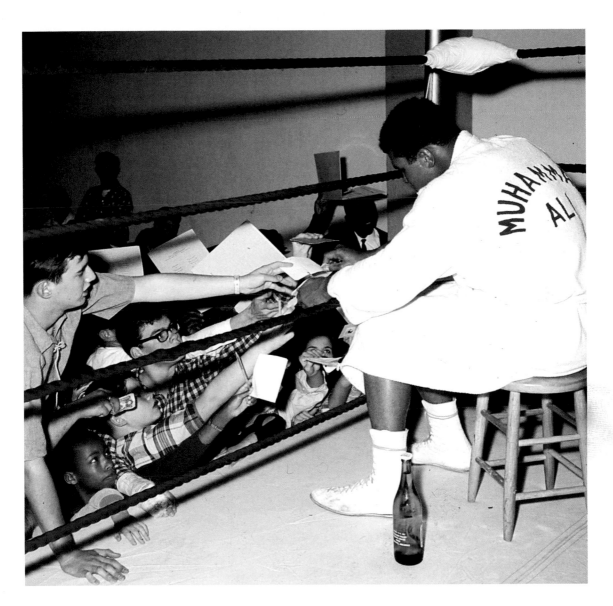

"I'm the most recognized and loved man that ever lived cuz there weren't no satellites when Jesus and Moses were around, so people far away in the villages didn't know about them."

"IT'S HARD TO BE HUMBLE WHEN YOU'RE AS GREAT AS I AM."

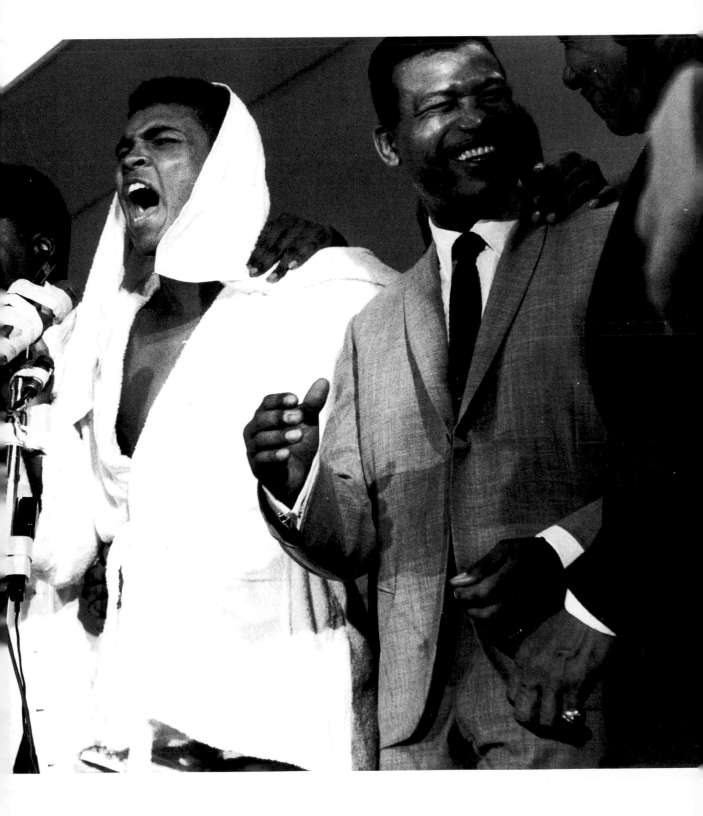

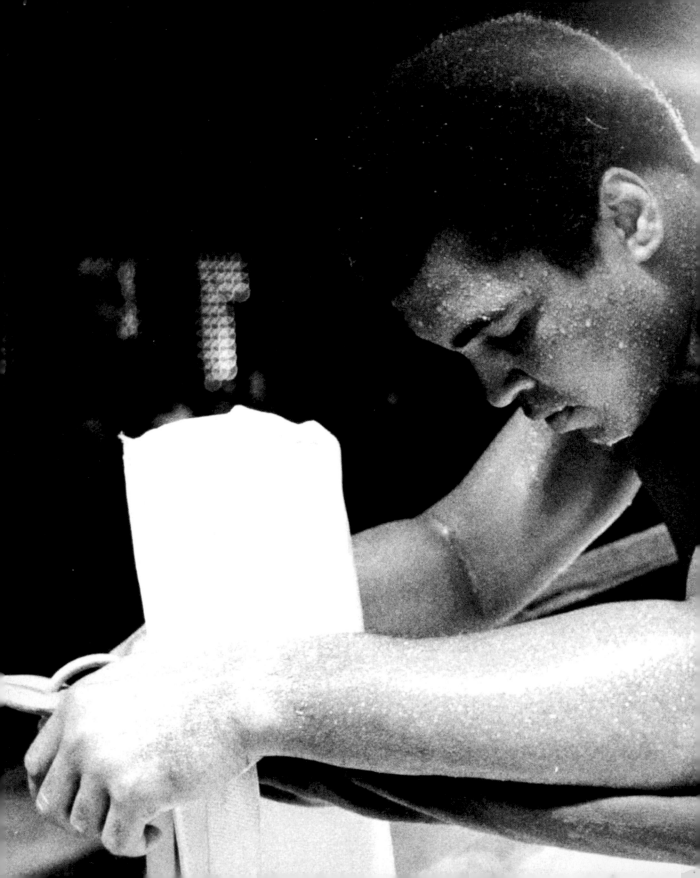

"I am the astronaut of boxing. Joe Louis
and Dempsey were just jet pilots.
I'm in a world of my own."

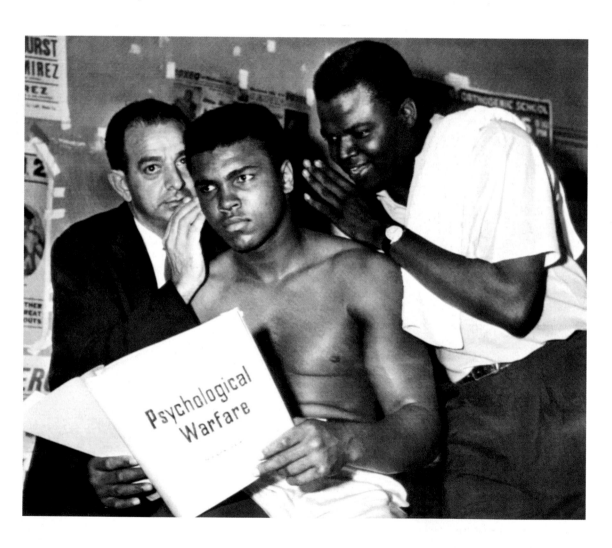

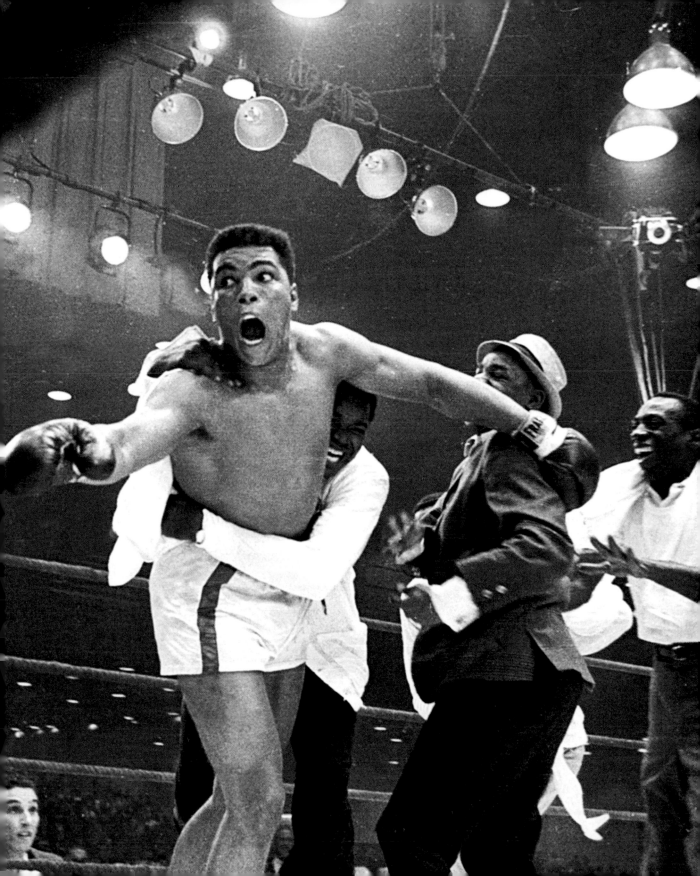

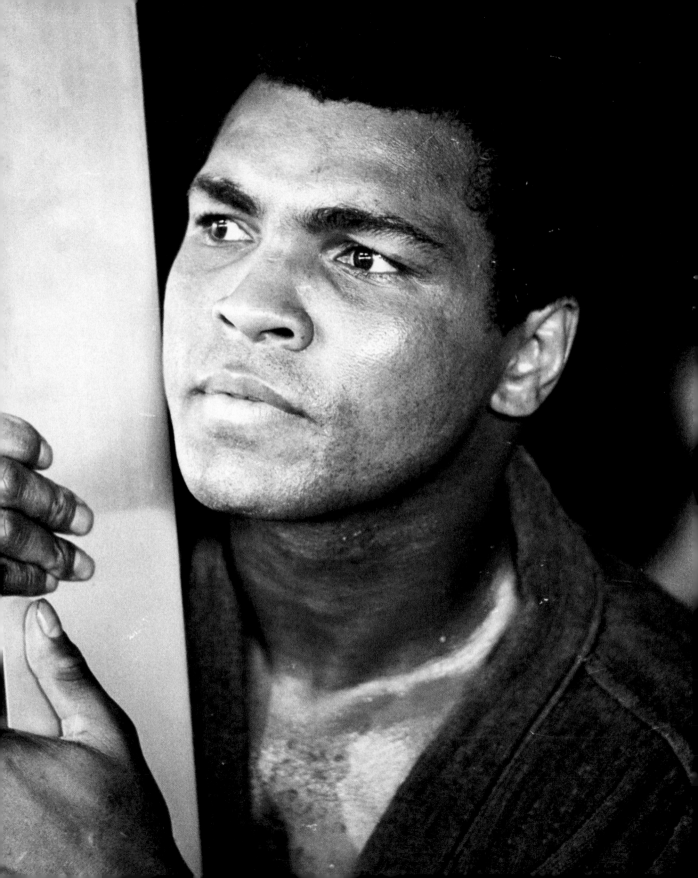

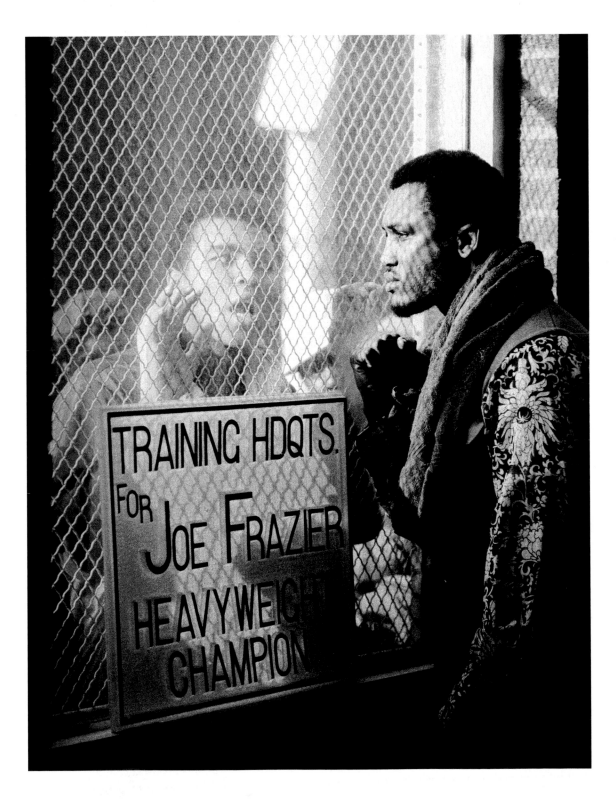

" I'M YOUNG;
I'M HANDSOME;
I'M FAST.
I CAN'T POSSIBLY
BE BEAT.
"

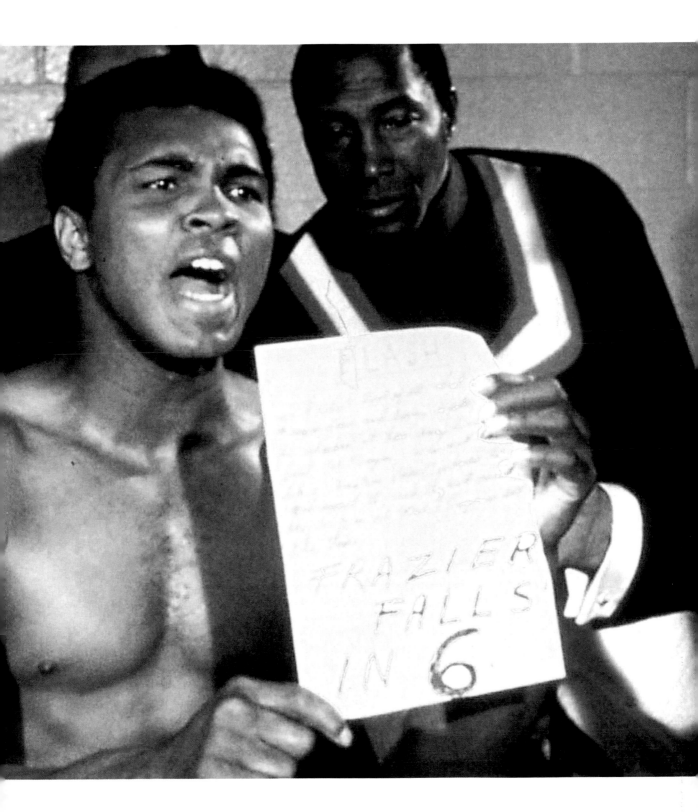

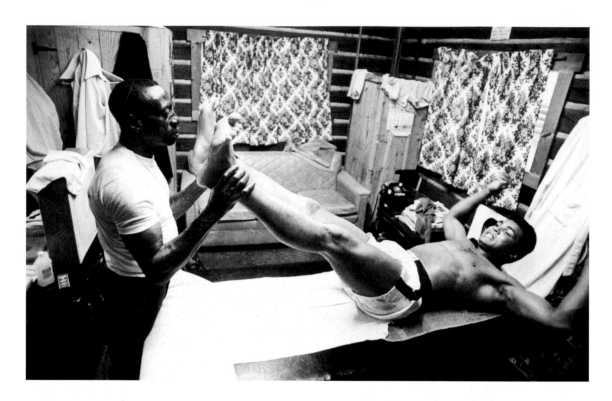

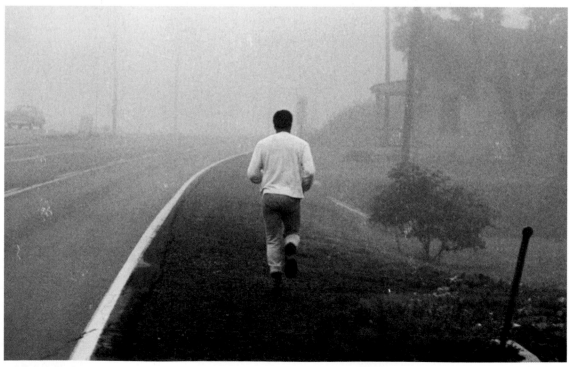

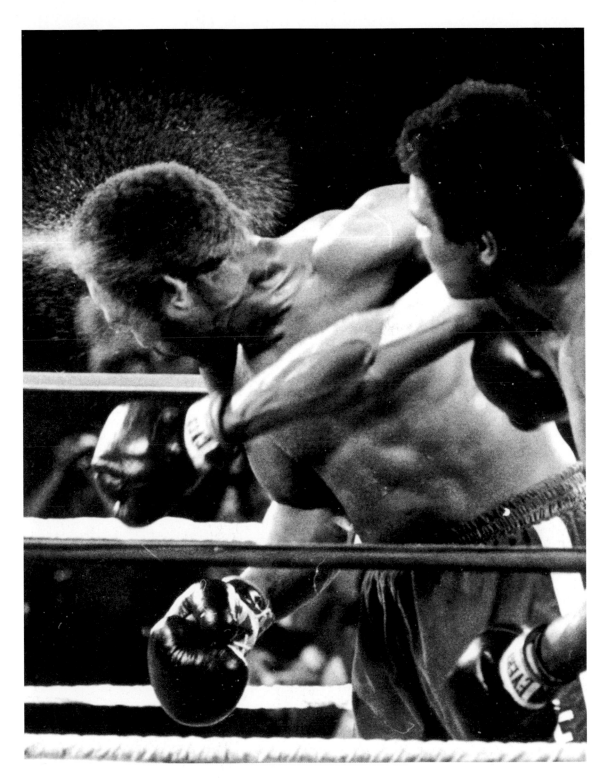

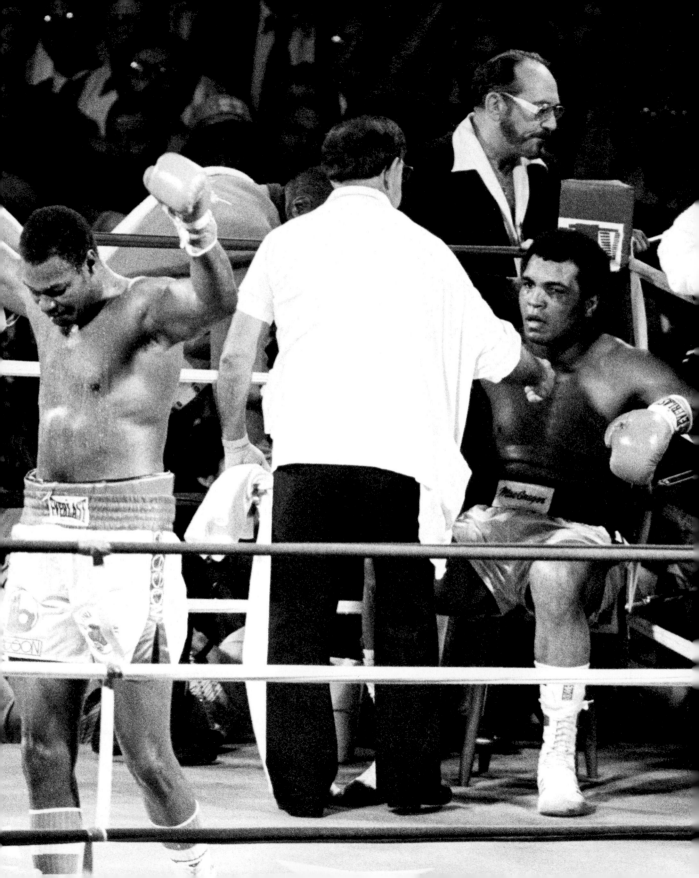

"I'm not the greatest; I'm the double greatest."

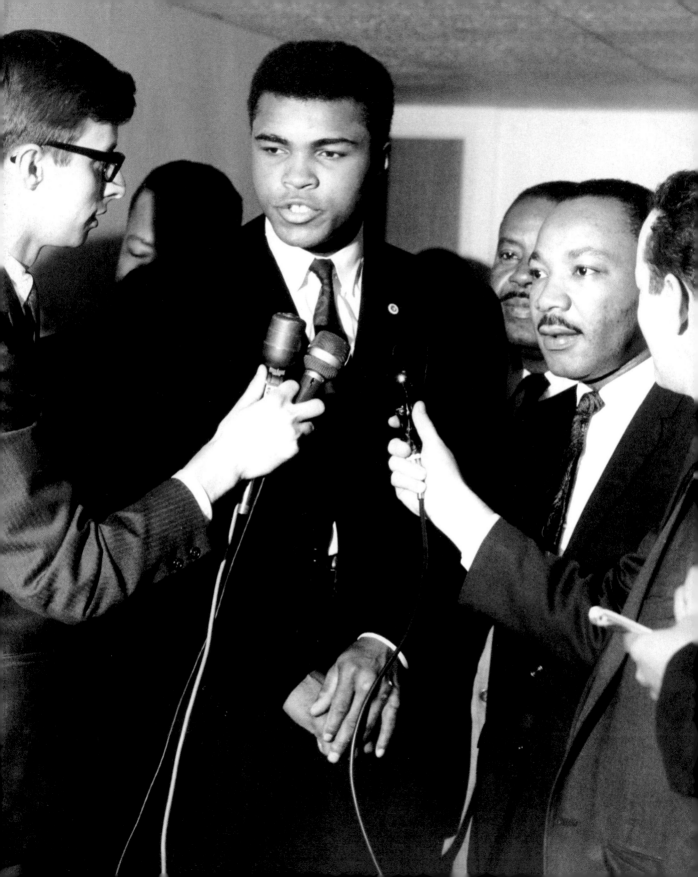

ALI
THE ACTIVIST

"
I know where I'm going and I know the truth, and I don't have
to be what you want me to be. I'm free to be what I want.
"

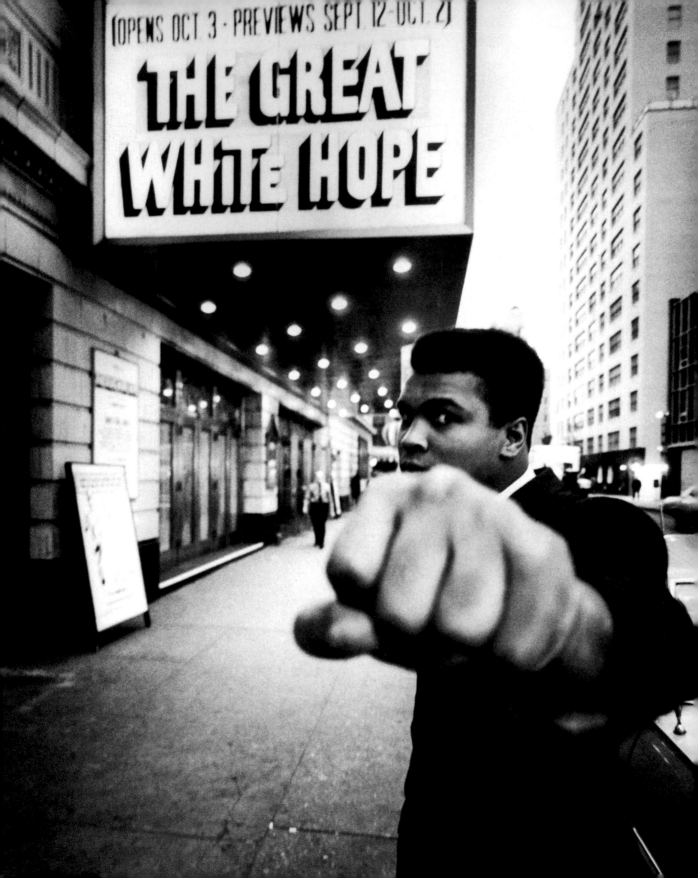

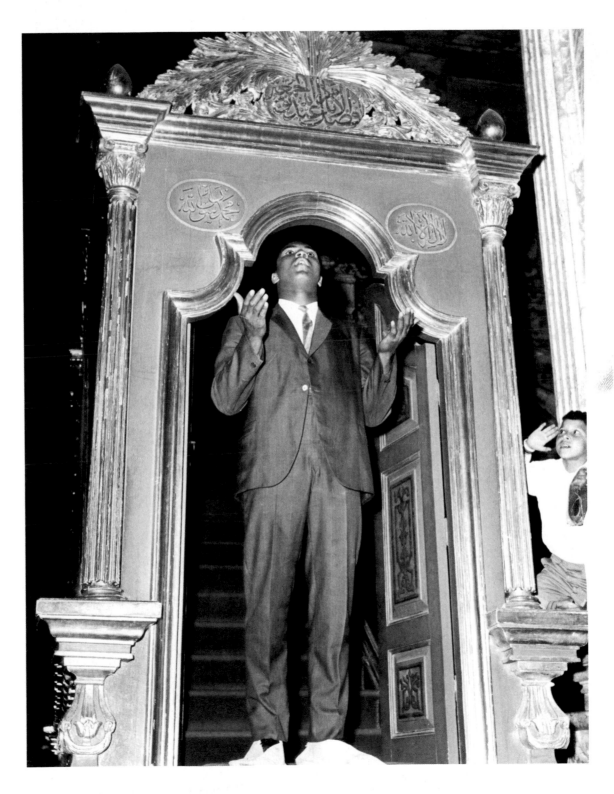

"I am America. I am the part you won't recognize.
 But get used to me. Black, confident, cocky;
 my name, not yours; my religion, not yours;
 my goals, my own; get used to me."

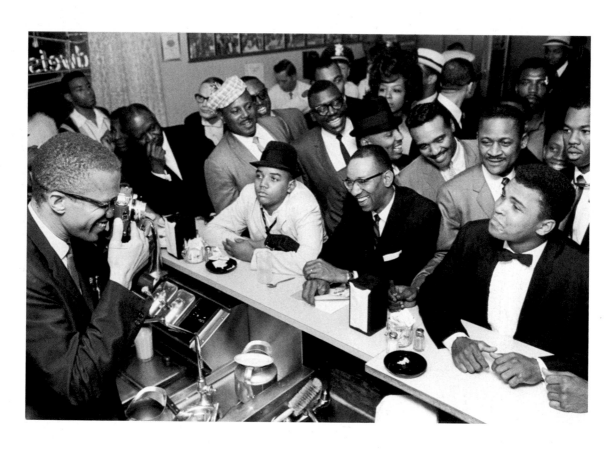

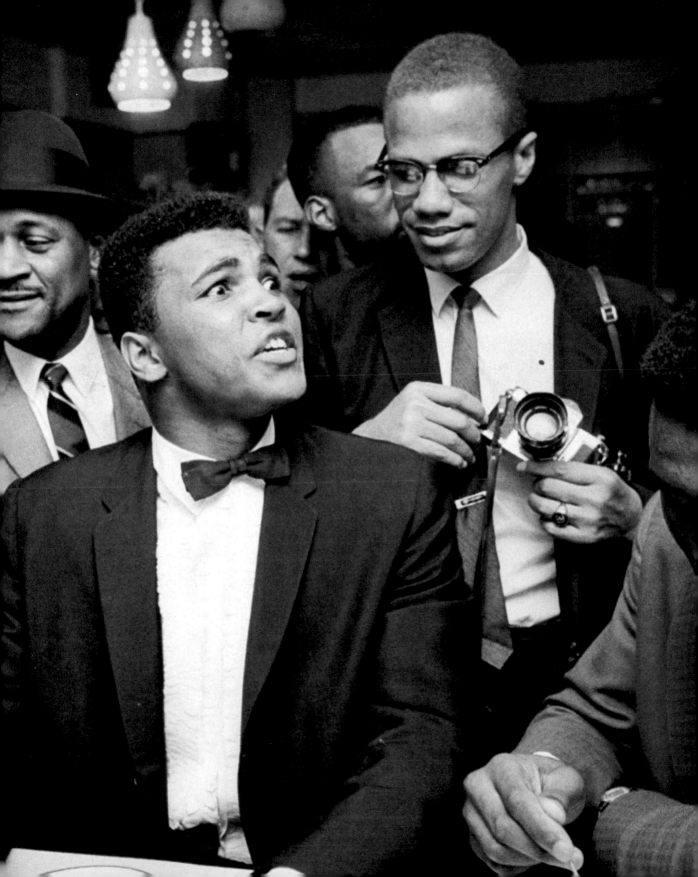

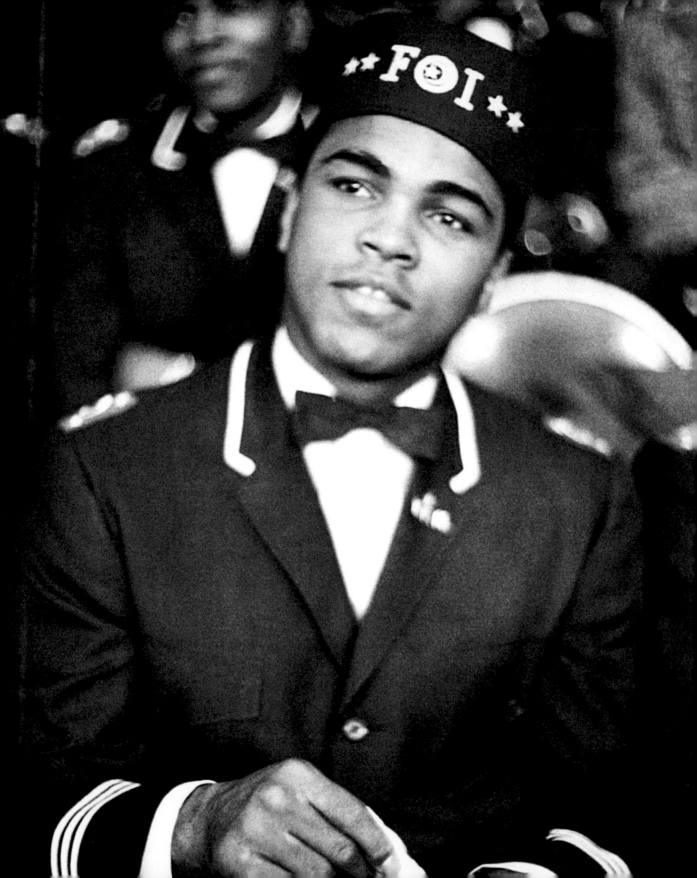

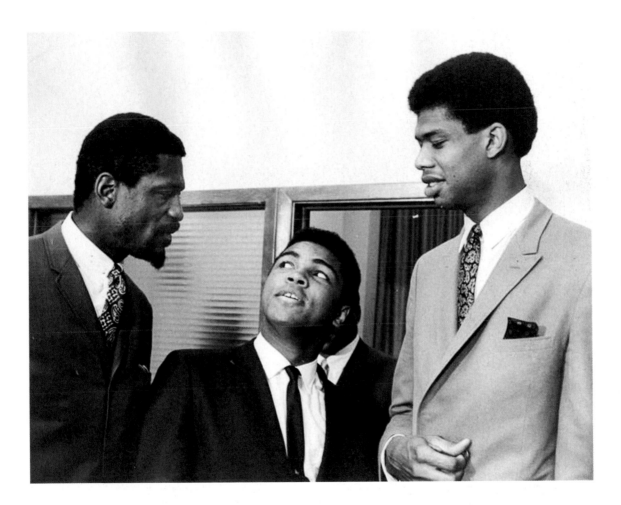

"I have nothing to lose by standing up for my
beliefs. So I'll go to jail. We've been in jail
for four hundred years."

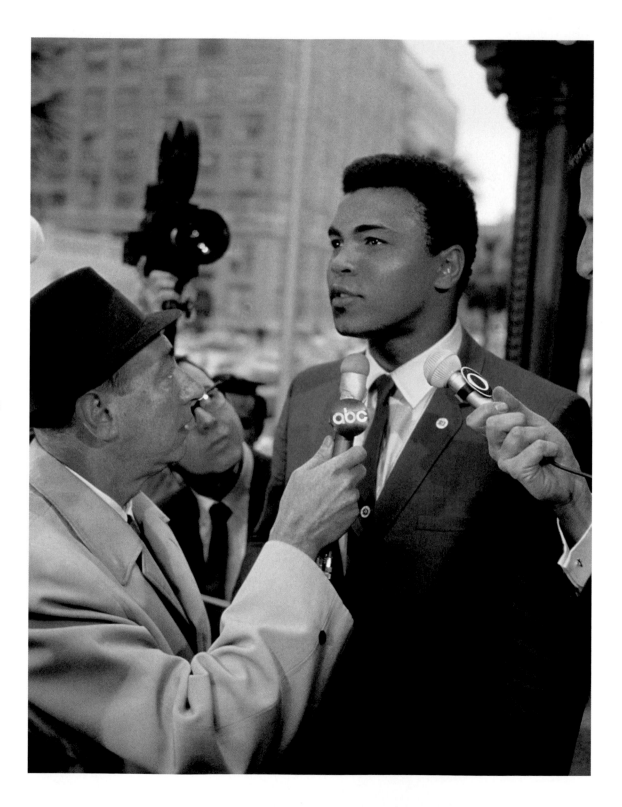

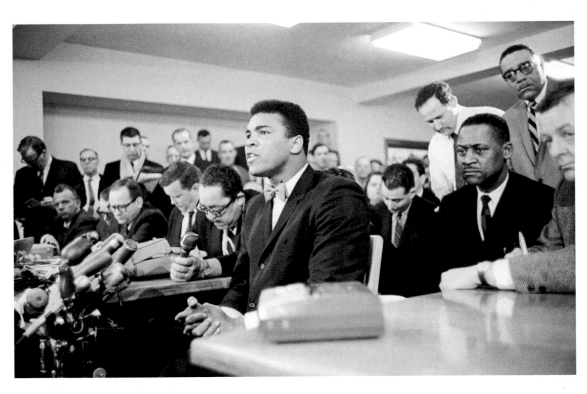

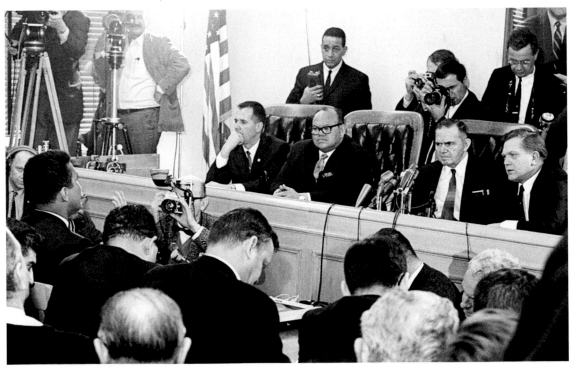

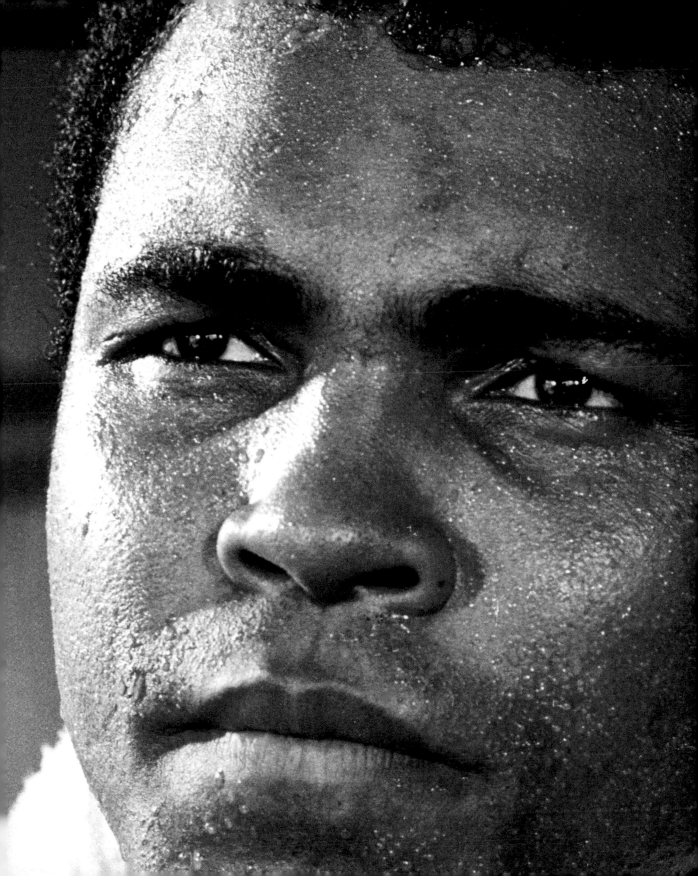

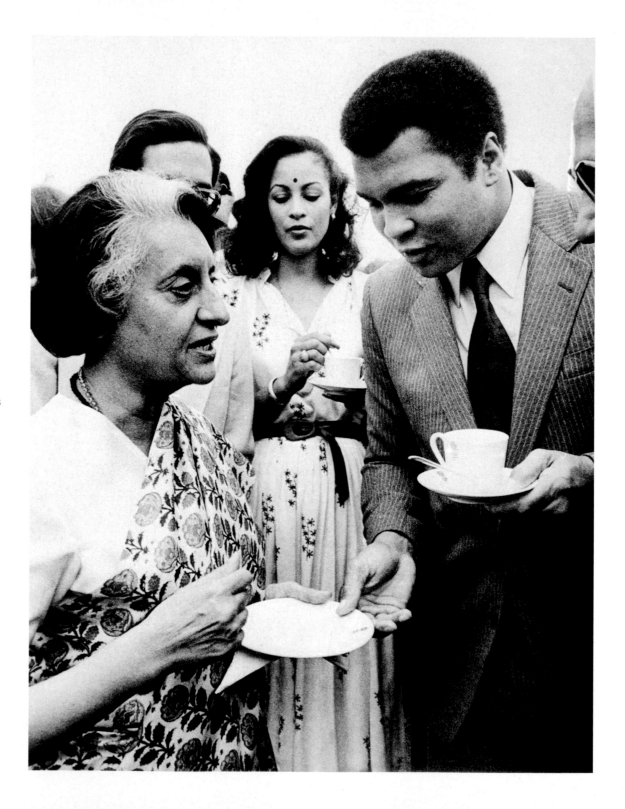

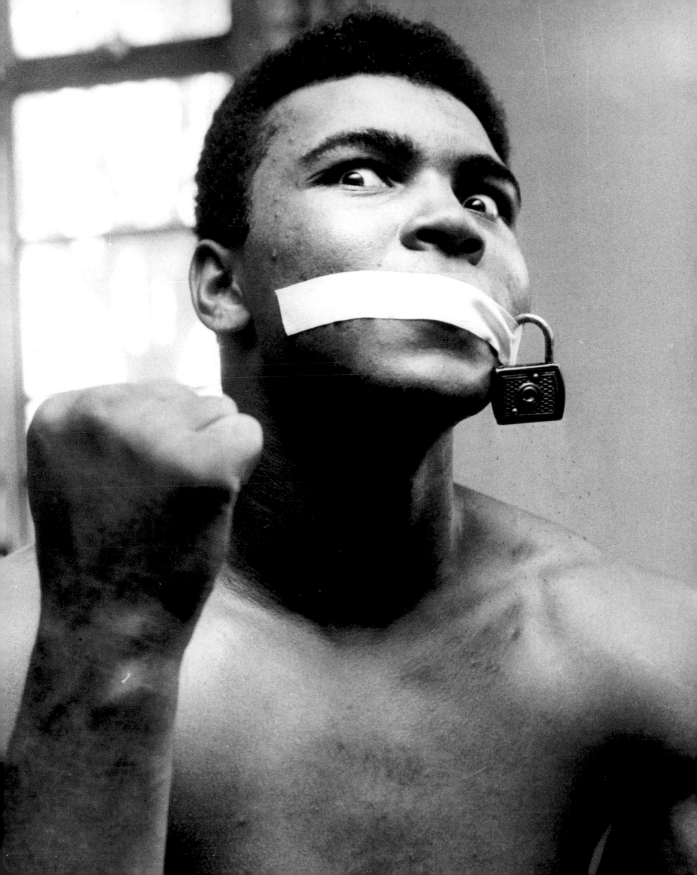

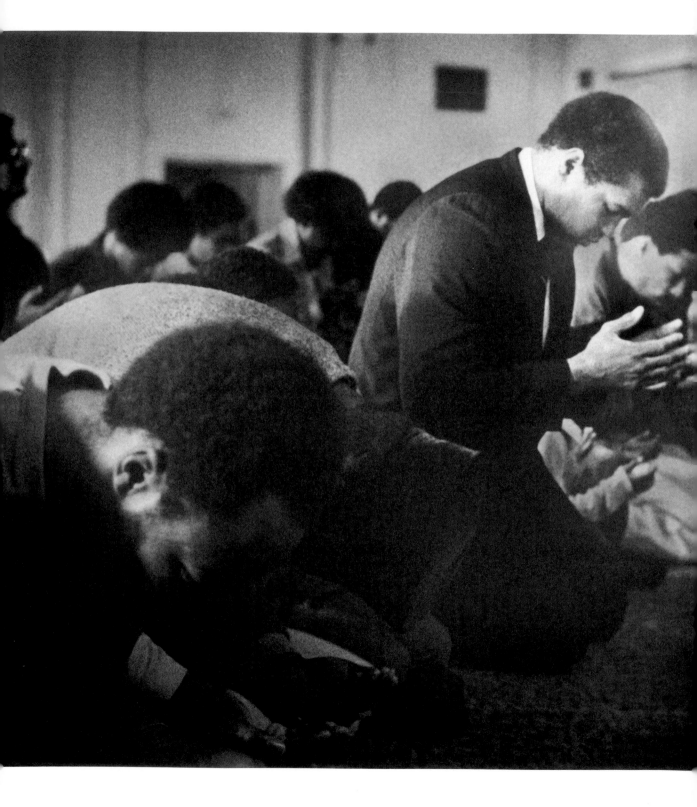

"

CASSIUS CLAY IS A
SLAVE NAME. I DIDN'T
CHOOSE IT, AND I
DIDN'T WANT IT.
I AM MUHAMMAD ALI,
A FREE NAME—
IT MEANS BELOVED
OF GOD—AND I INSIST
PEOPLE USE IT
WHEN SPEAKING
TO ME AND OF ME.

"

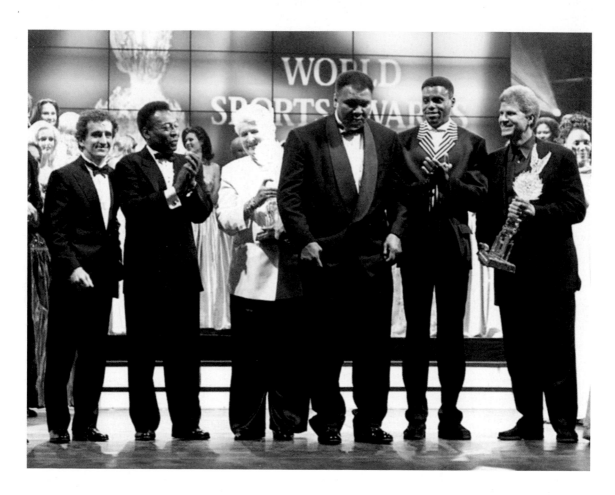

MUHAMMAD ALI'S RECIPE FOR LIFE

"He took a few cups of love.

He took one tablespoon of patience.

One teaspoon of generosity.

One pint of kindness.

He took one quart of laughter.

One pinch of concern.

And then he mixed willingness with happiness.

He added lots of faith.

And he stirred it up well.

Then he spread it over a span of a lifetime.

And he served it to each and every deserving person he met."

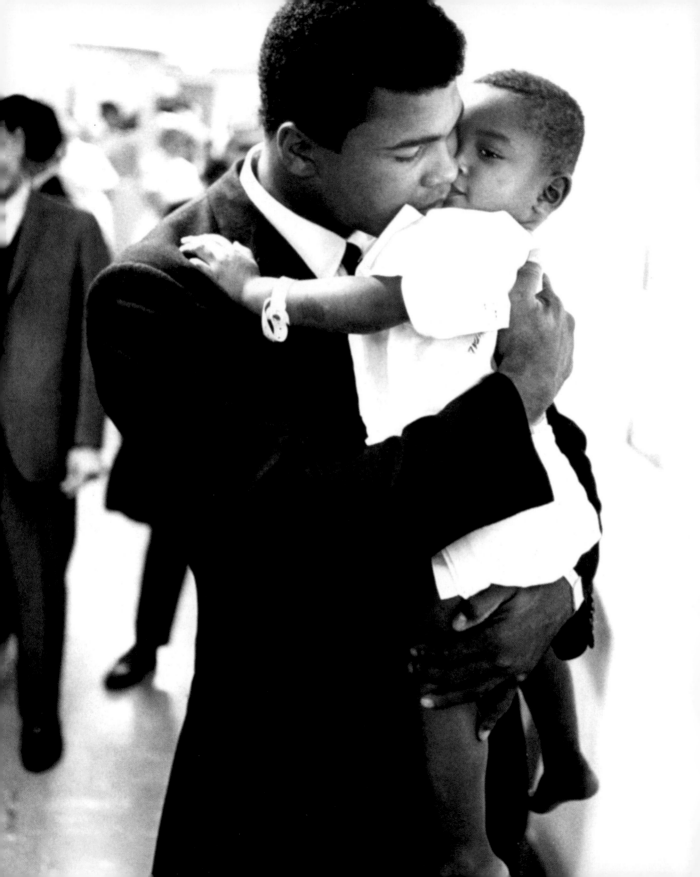

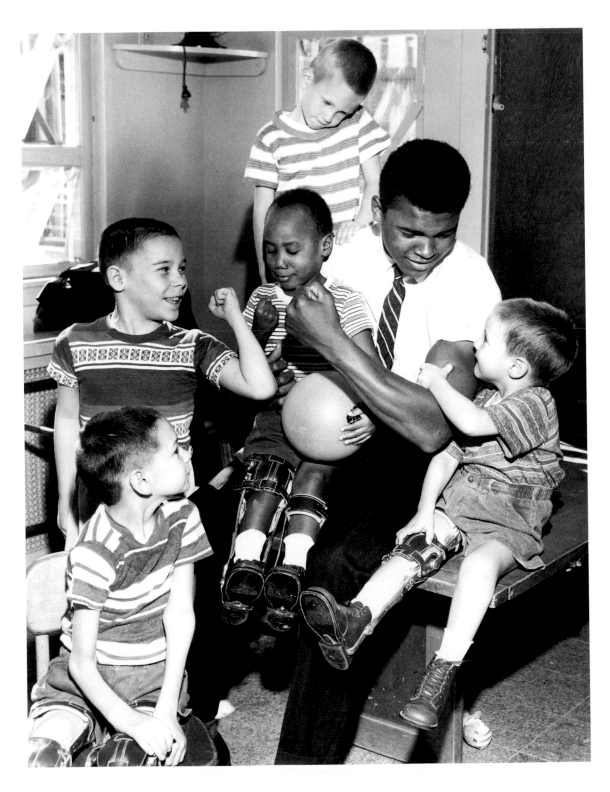

"

Service to others
is the rent you pay
for your room
here on earth.

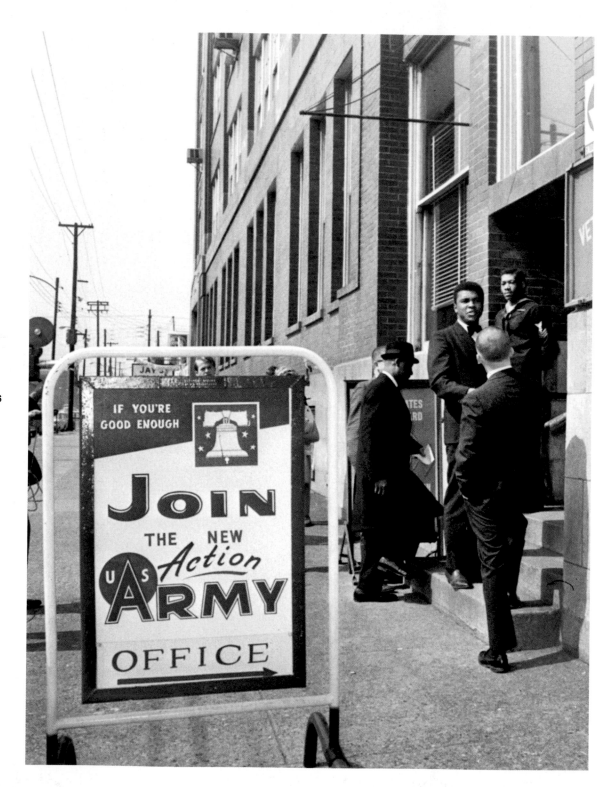

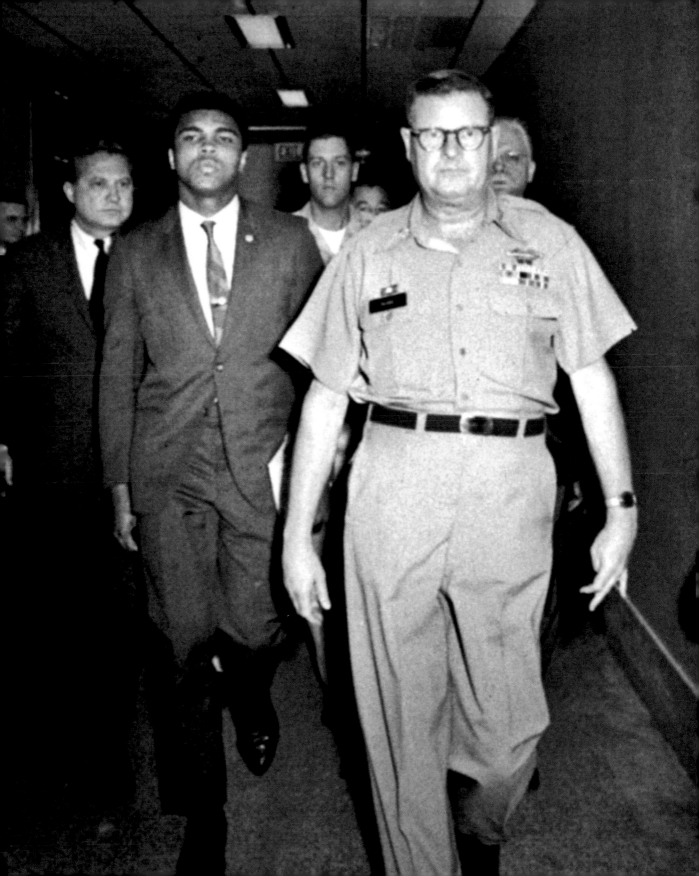

"WHY SHOULD THEY ASK ME TO PUT ON A UNIFORM AND GO TEN THOUSAND MILES FROM HOME AND DROP BOMBS AND BULLETS ON BROWN PEOPLE IN VIETNAM WHILE SO-CALLED NEGRO PEOPLE IN LOUISVILLE ARE TREATED LIKE DOGS AND DENIED SIMPLE HUMAN RIGHTS?"

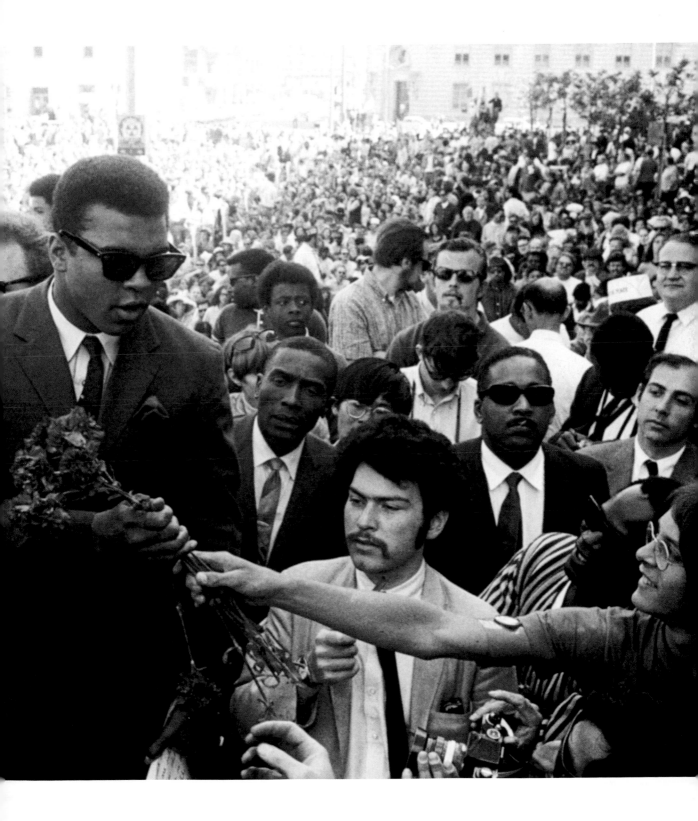

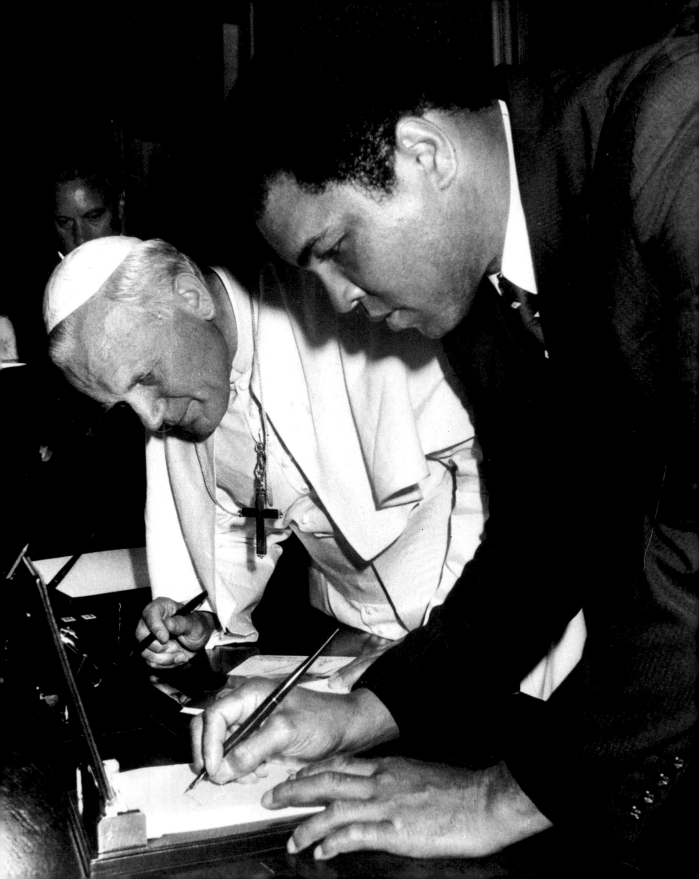

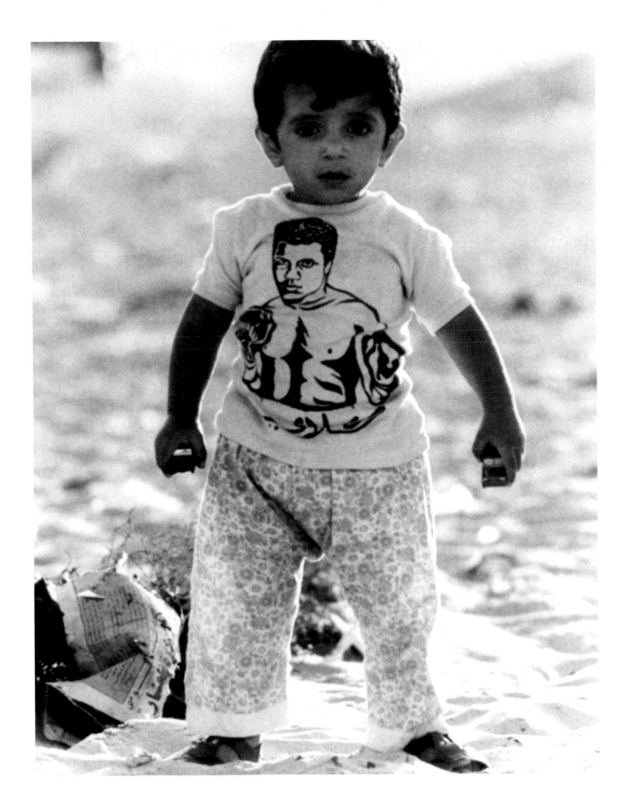

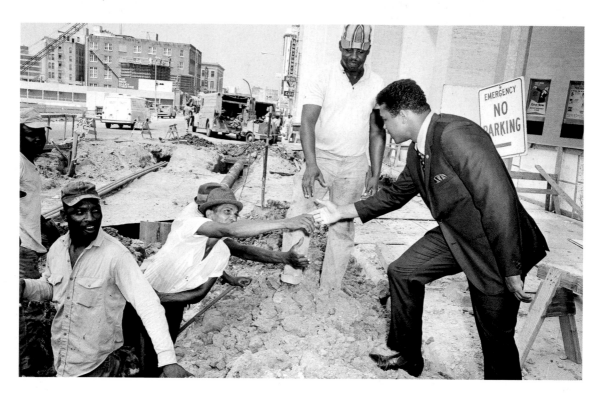

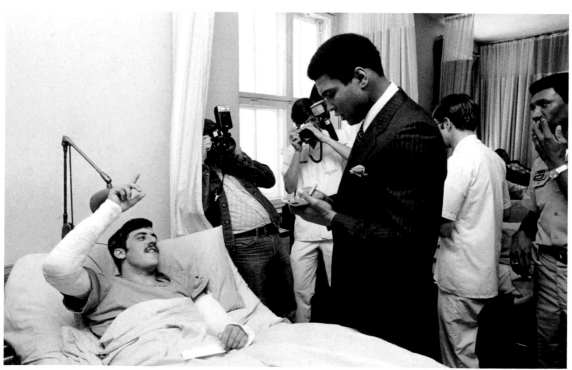

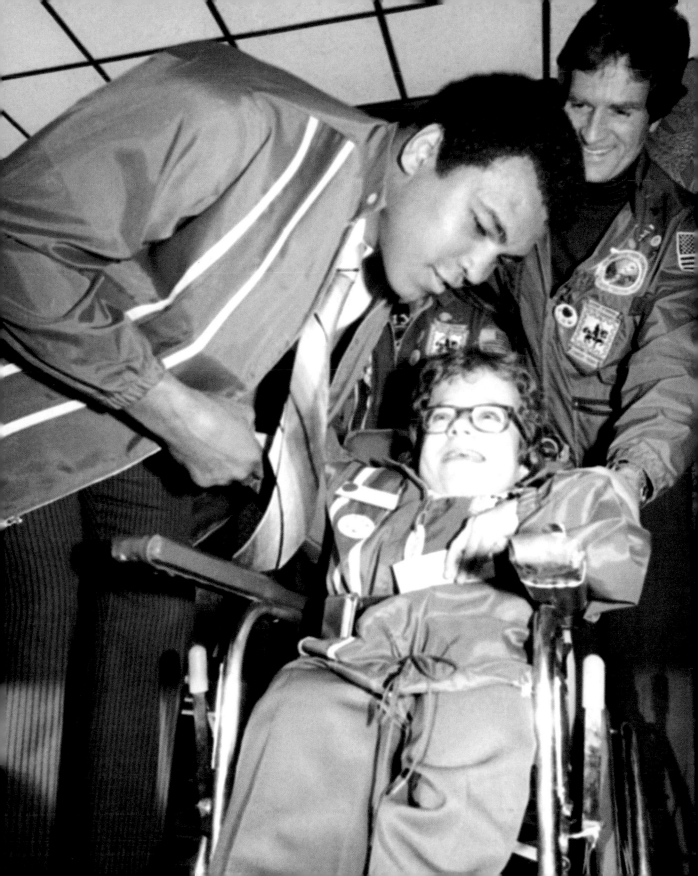

" IF YOU LOVE GOD, YOU CAN'T LOVE ONLY SOME OF HIS CHILDREN. "

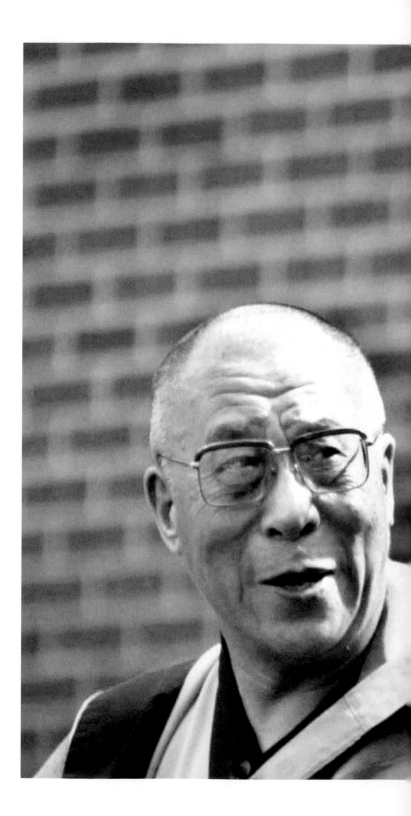

W. P. MARSHALL
CHAIRMAN OF THE BOARD

TELEGRAM
®

The filing time shown in the date line on domestic telegrams is LOCAL TIME at point of origin. Time

331P CST NOV 2 67 NSA478

NS CA205 PD CHICAGO ILL 2 314P CST

MARTIN LUTHER KING

 COUNTY JAIL BHAM

HOPE THAT YOU ARE COMFORTABLE NOT SUFFERING

 MUHAMMAD ALI

(22).

"I'm not involved in a power struggle between black and white. I'm not trying to
get power over white. I'm involved in a freedom struggle. Not a power struggle.
We're not trying to take power away or rule anybody—we're just trying to
get up from under the rulers."

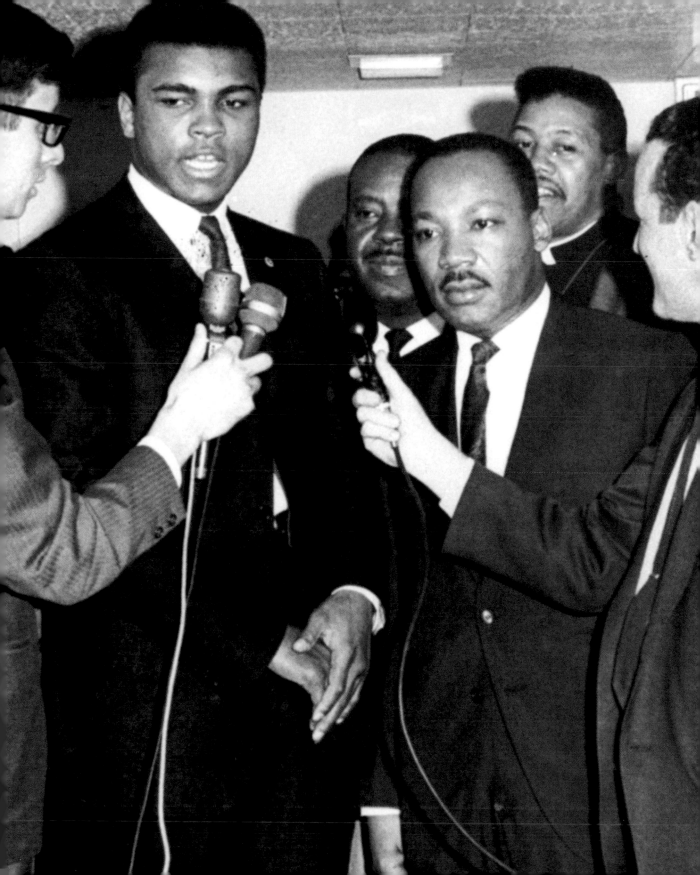

Impossible is just a big word thrown around by small men who find it easier to live in the world they've been given than to explore the power they have to change it.

Impossible is not a fact. It's an opinion. Impossible is not a declaration. It's a dare. Impossible is potential. Impossible is temporary. Impossible is nothing!

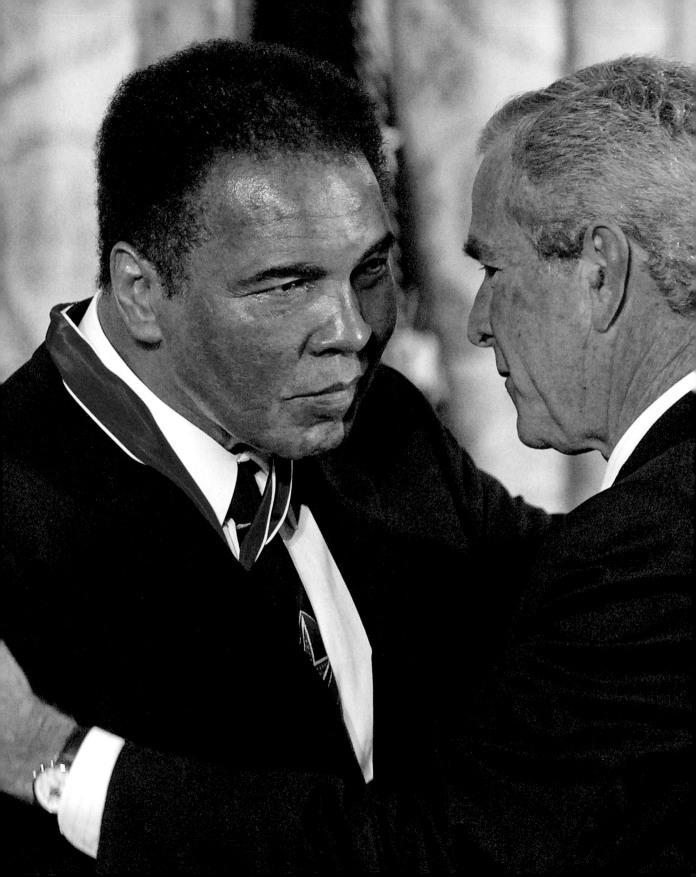

"I'm just hoping that people understand
that Islam is peace and not violence."

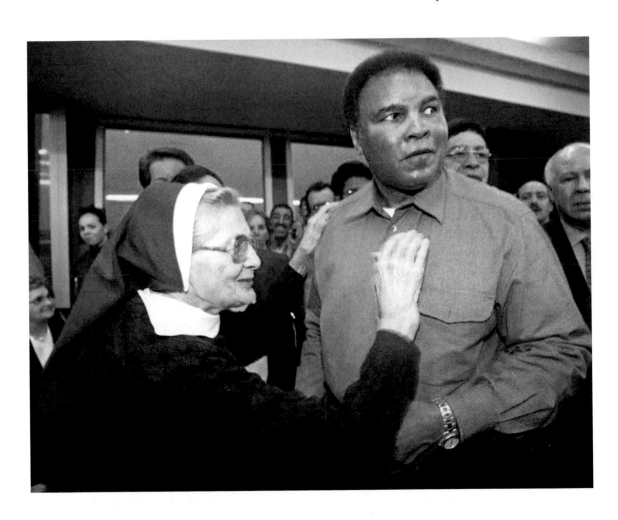

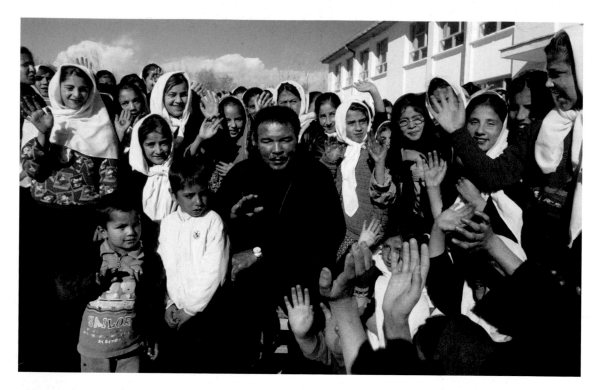

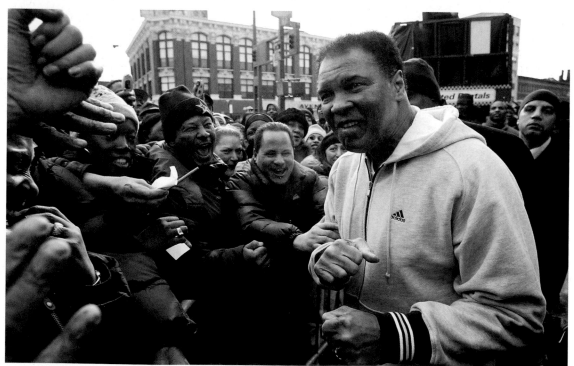

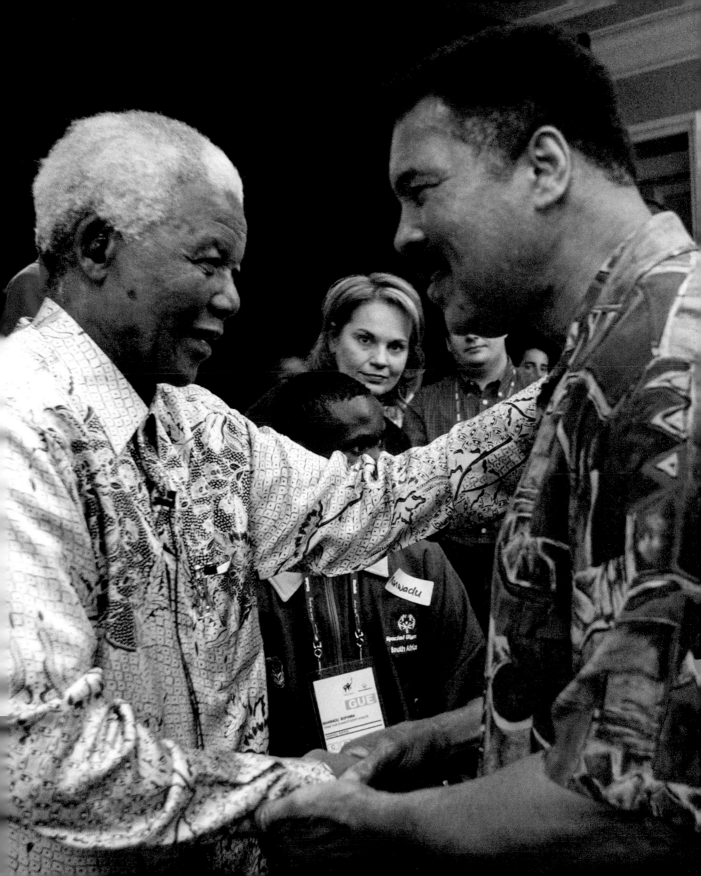

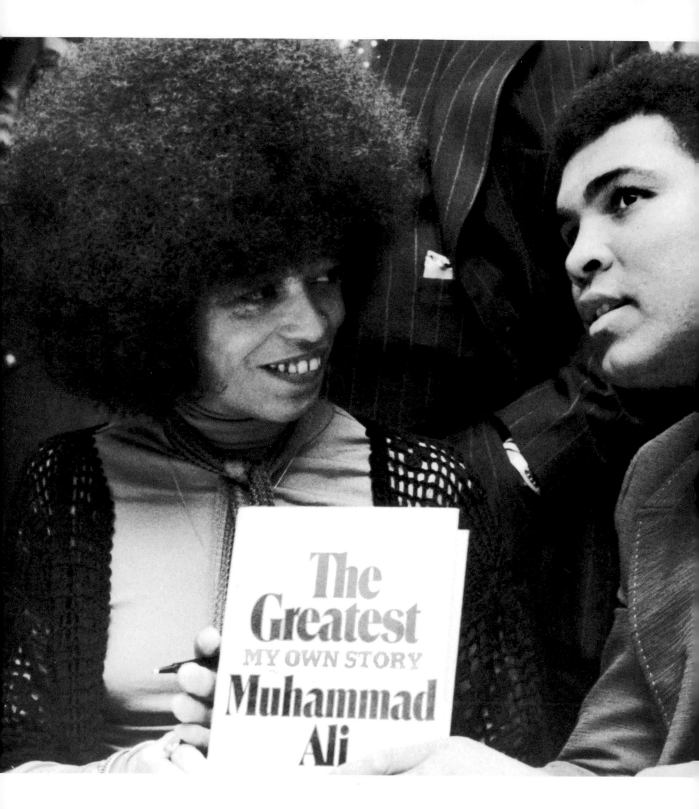

" HATING PEOPLE BECAUSE OF THEIR COLOR IS WRONG. AND IT DOESN'T MATTER WHICH COLOR DOES THE HATING. IT'S JUST PLAIN WRONG. "

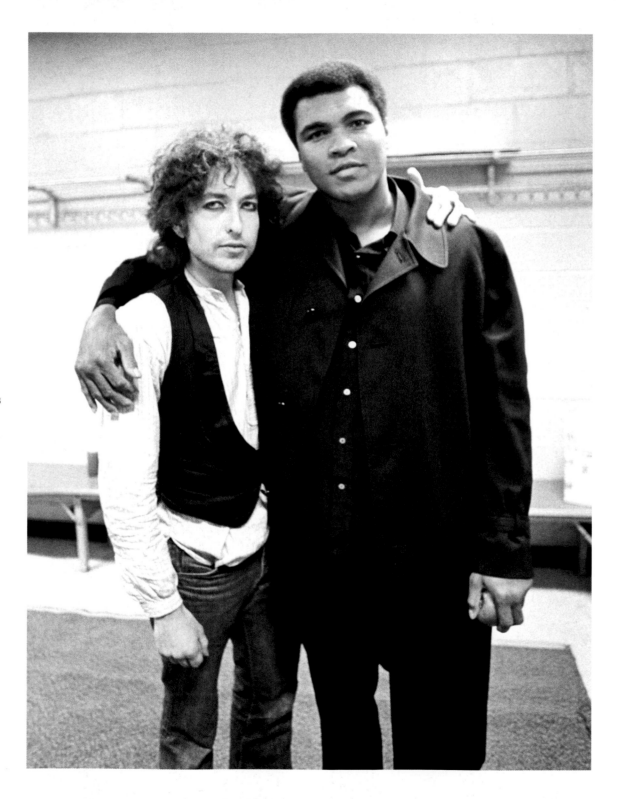

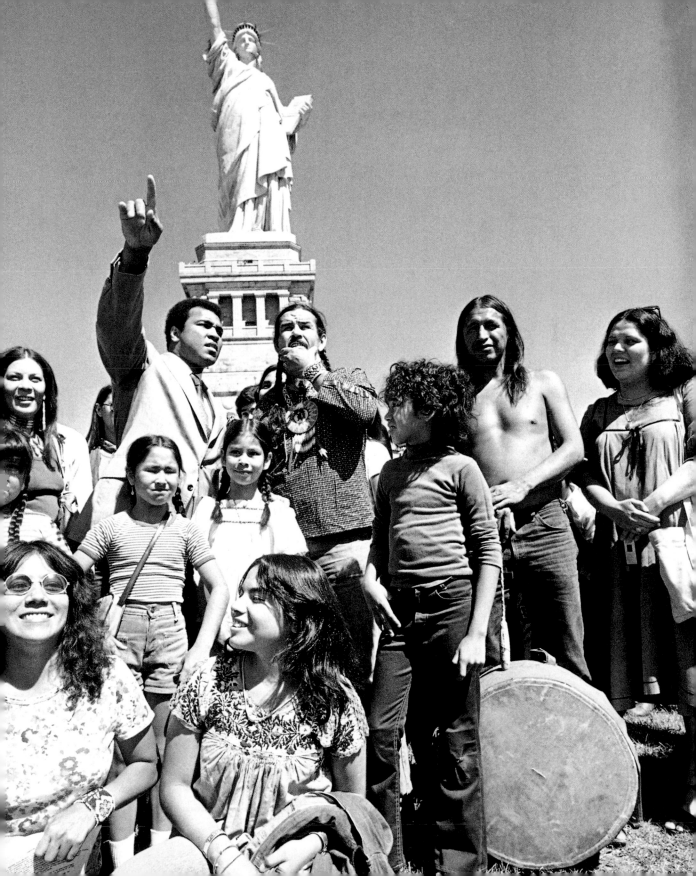

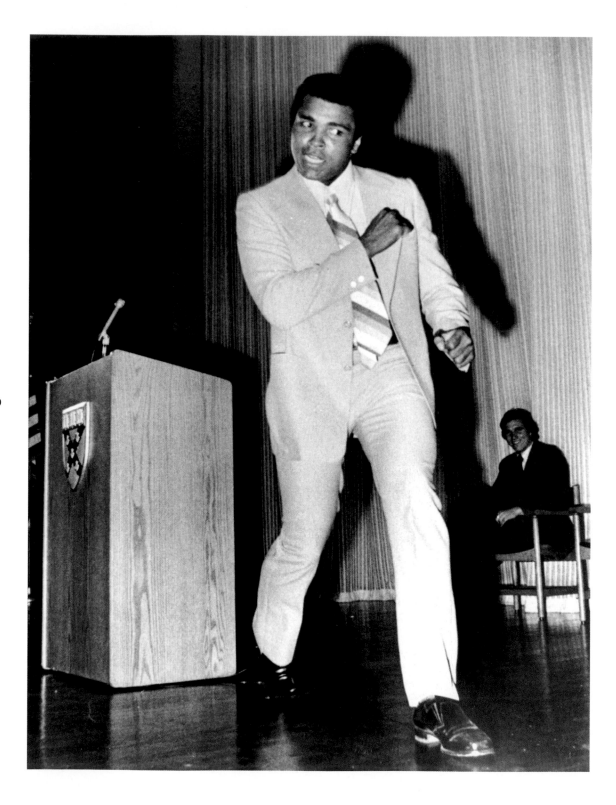

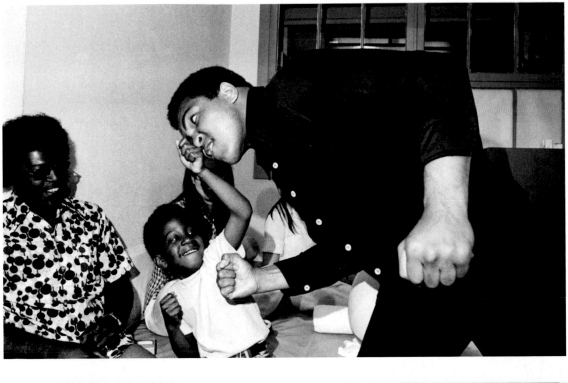

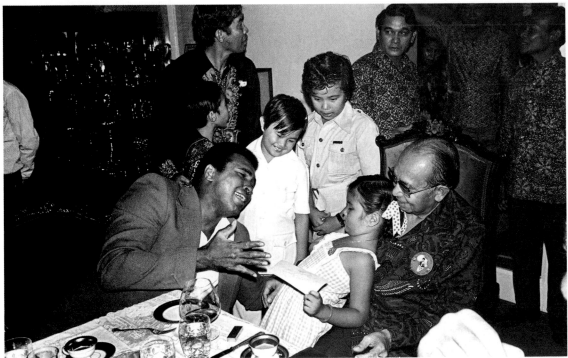

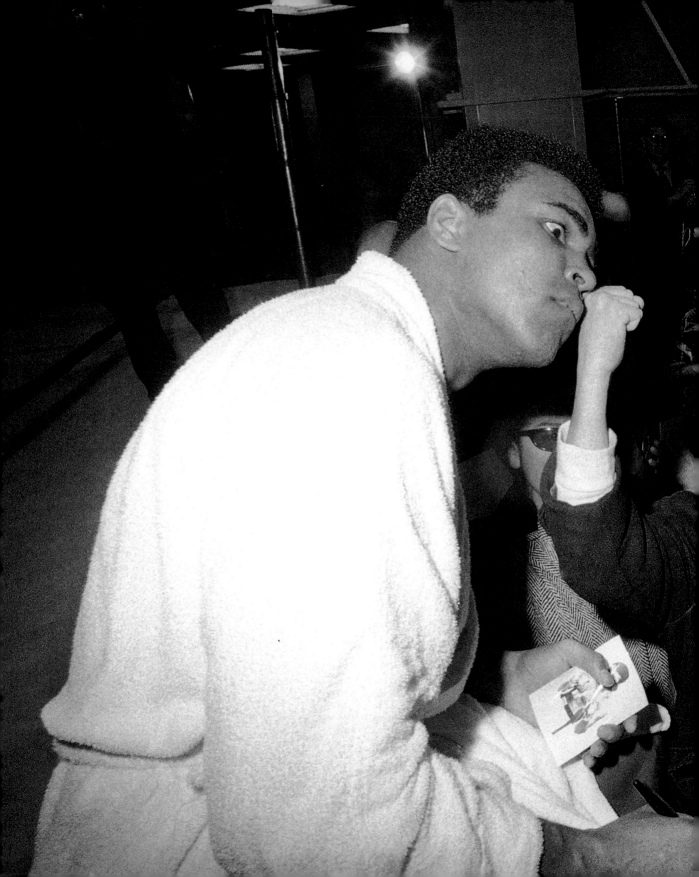

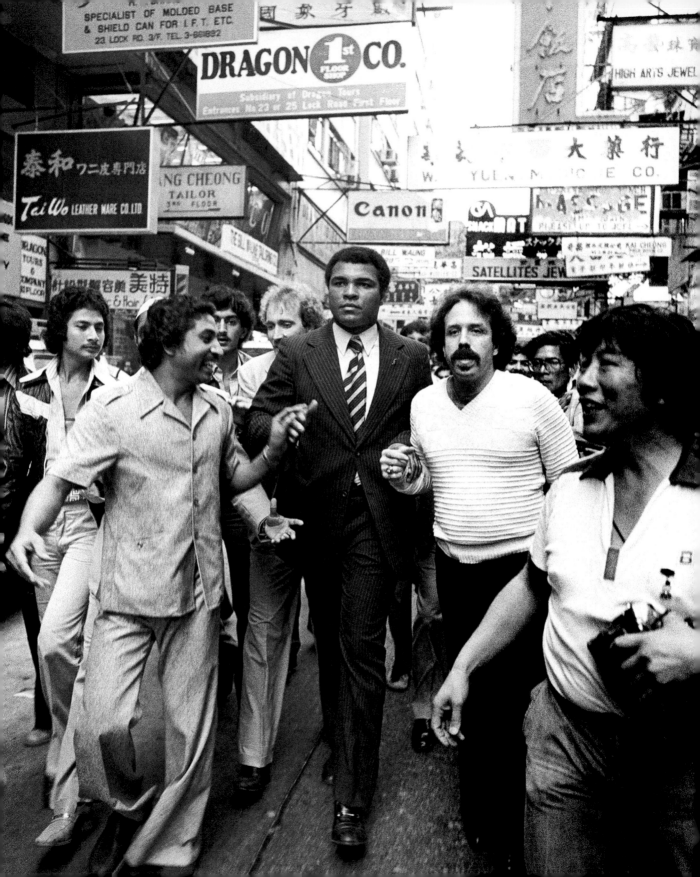

"I'm no leader. I'm a little humble follower."

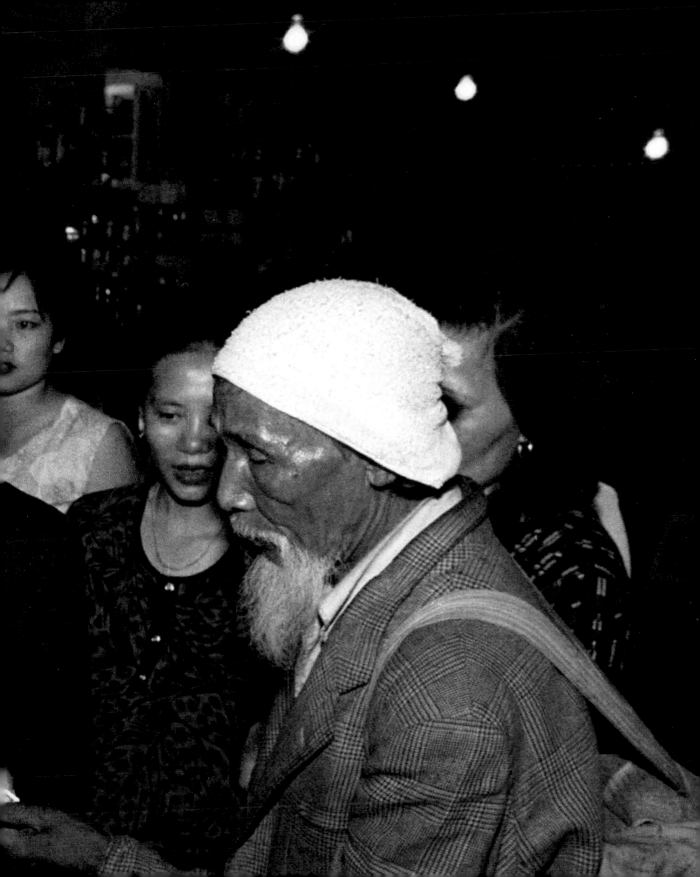

" GOD'S GOT ME HERE
FOR SOMETHING.
I CAN FEEL IT.
I WAS BORN FOR
EVERYTHING THAT
I'M DOING NOW. **"**

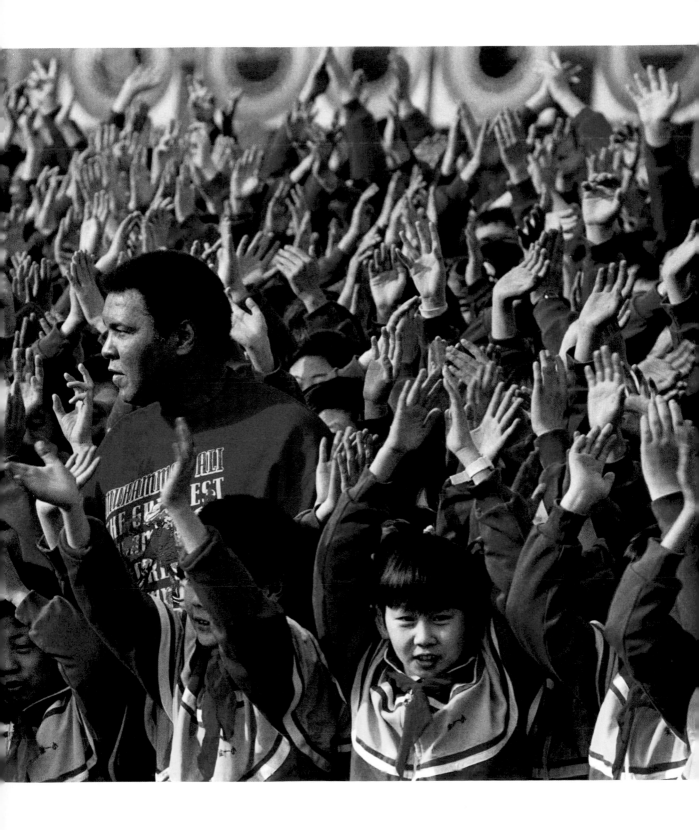

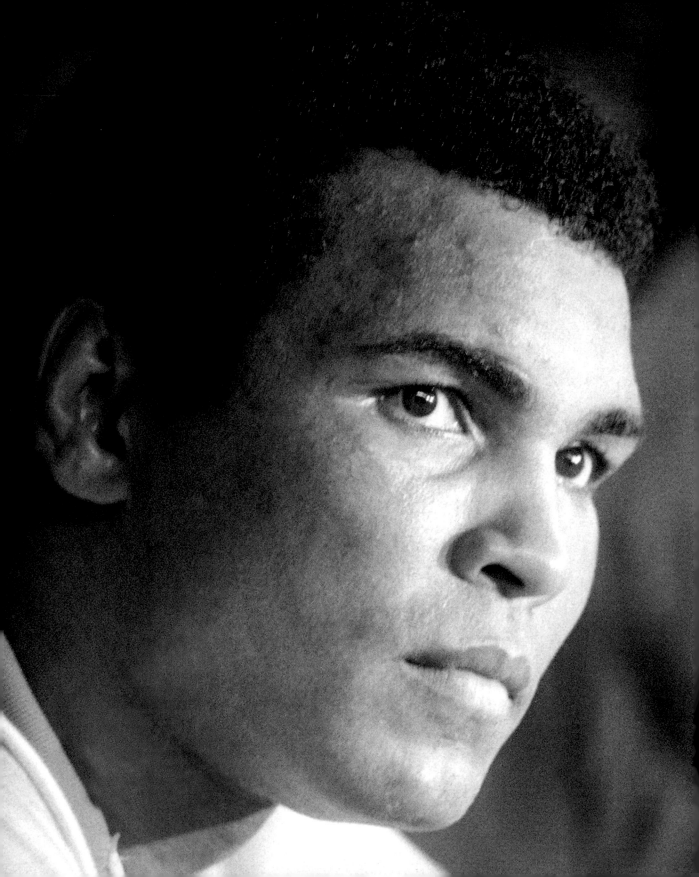

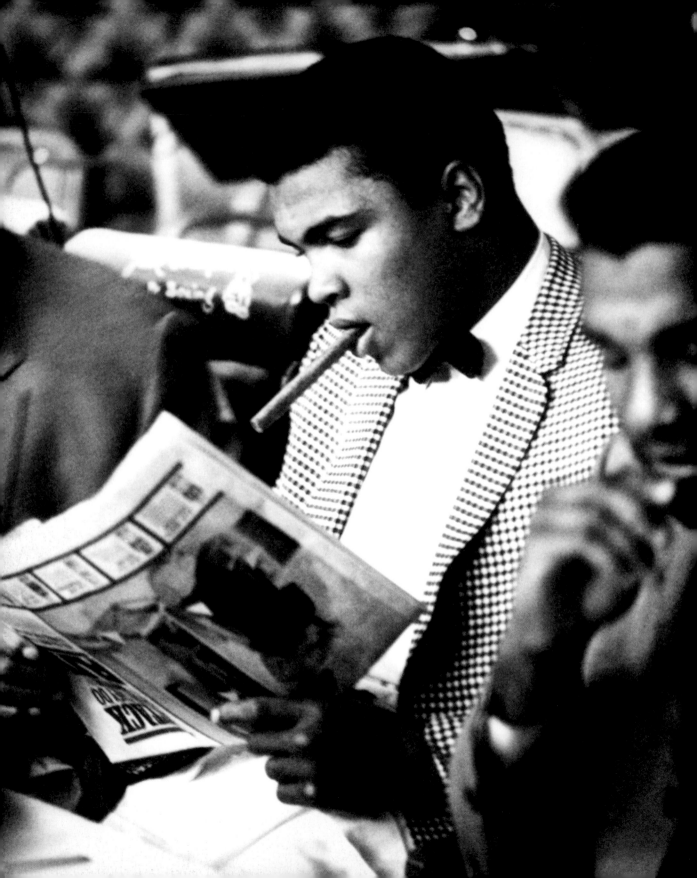

ALI
THE MAN

"

There are more pleasant things to do than beat people up.

"

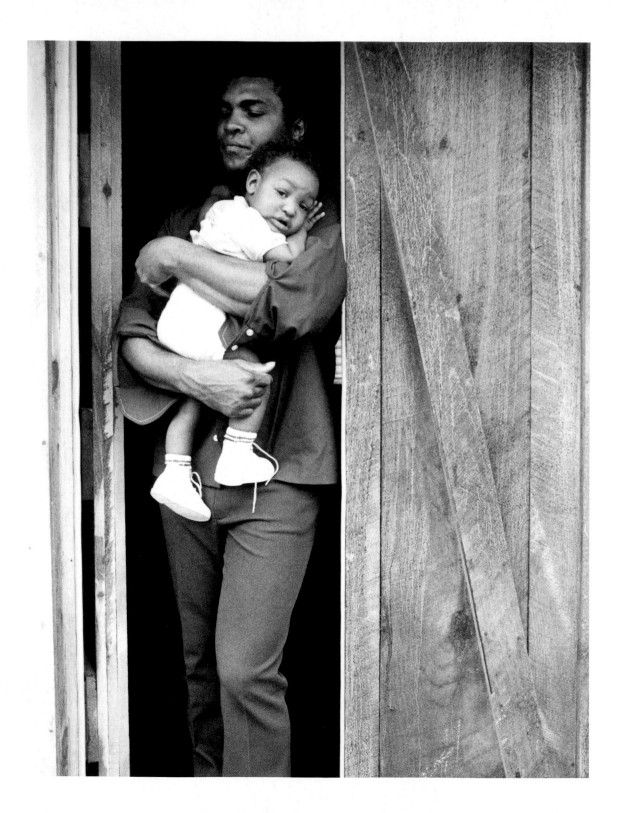

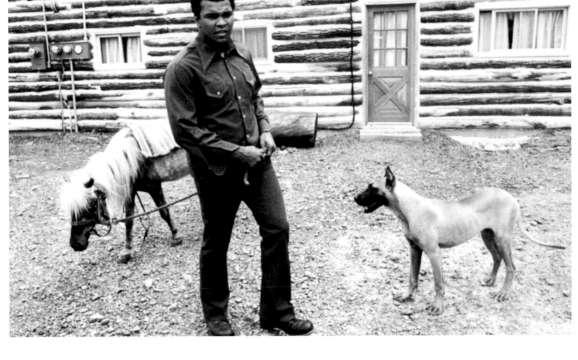

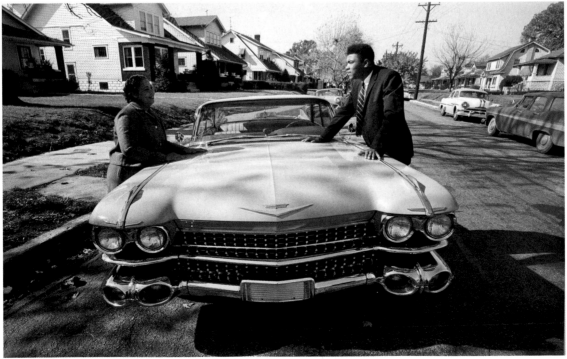

"Old age is just a record of one's whole life."

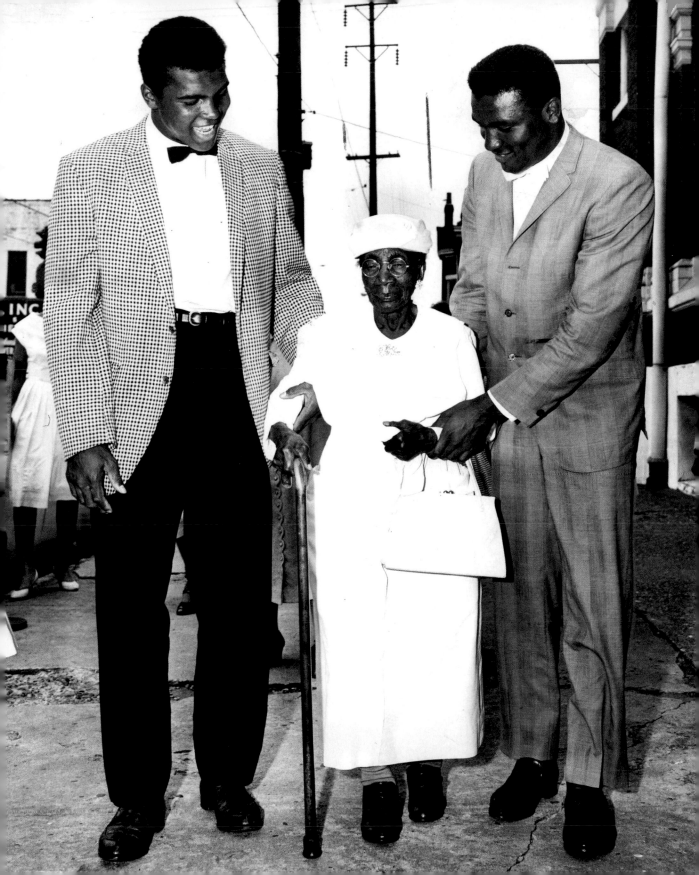

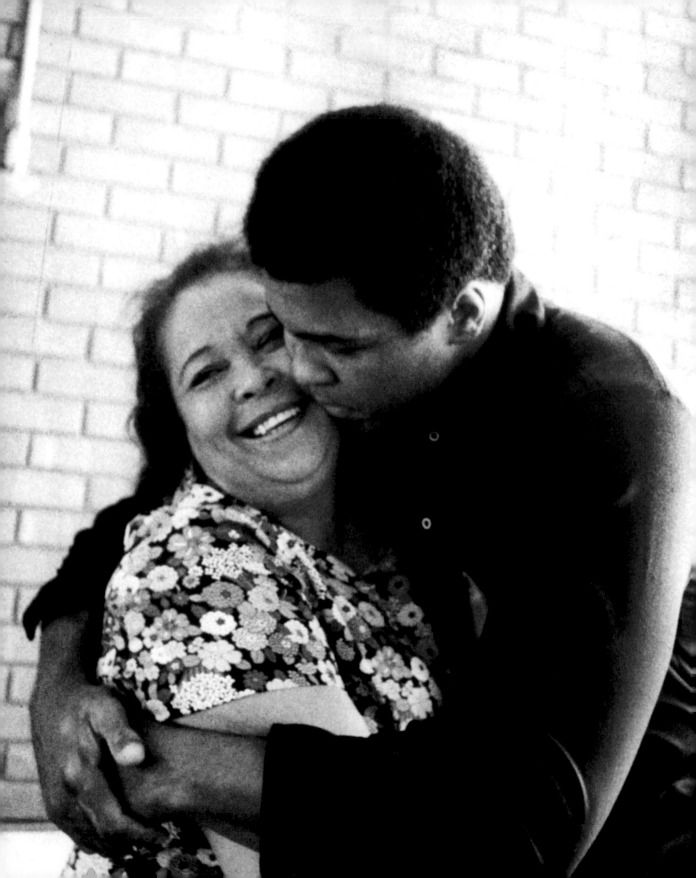

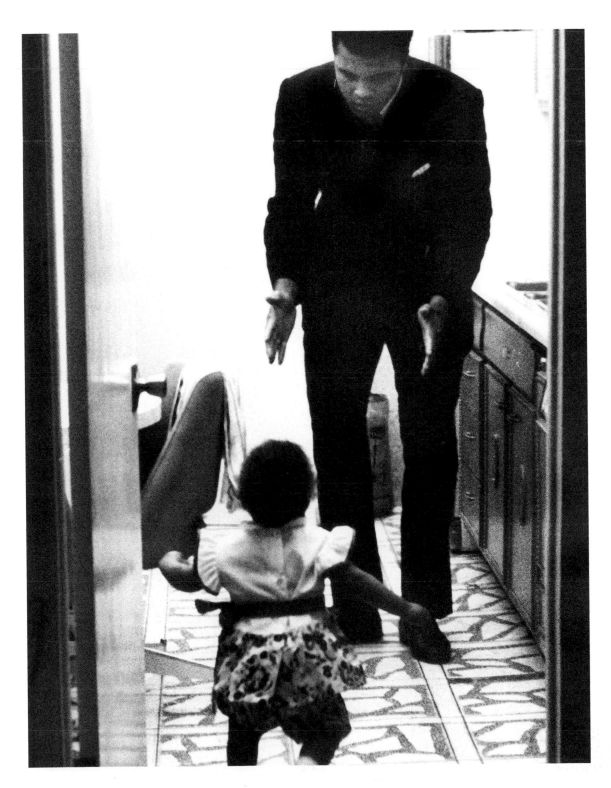

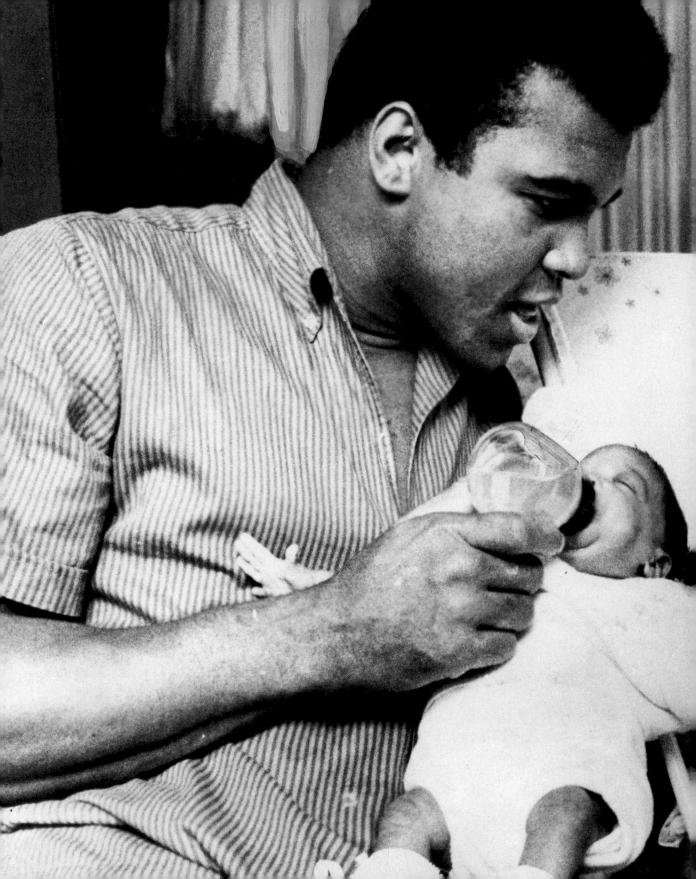

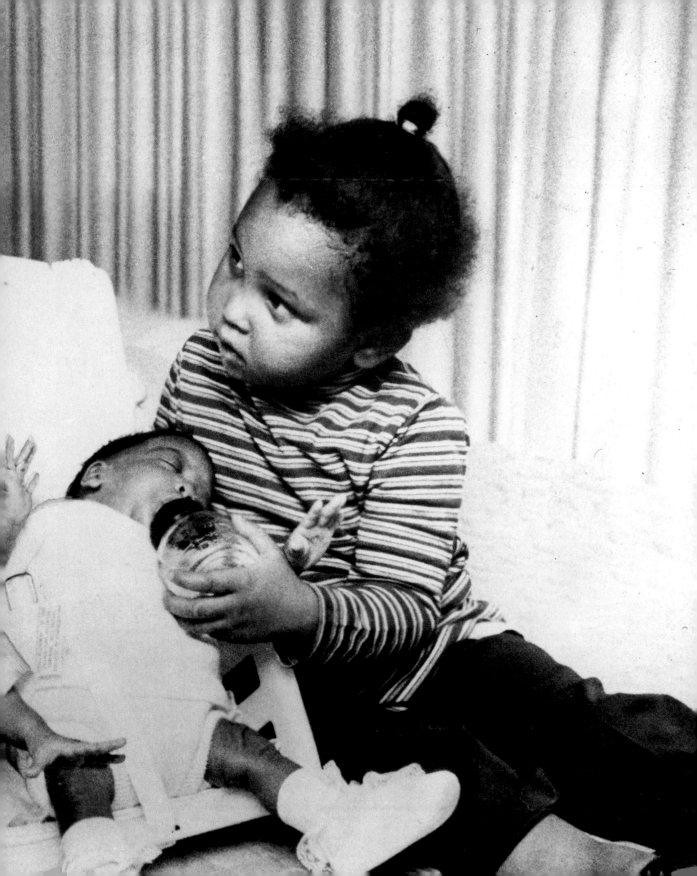

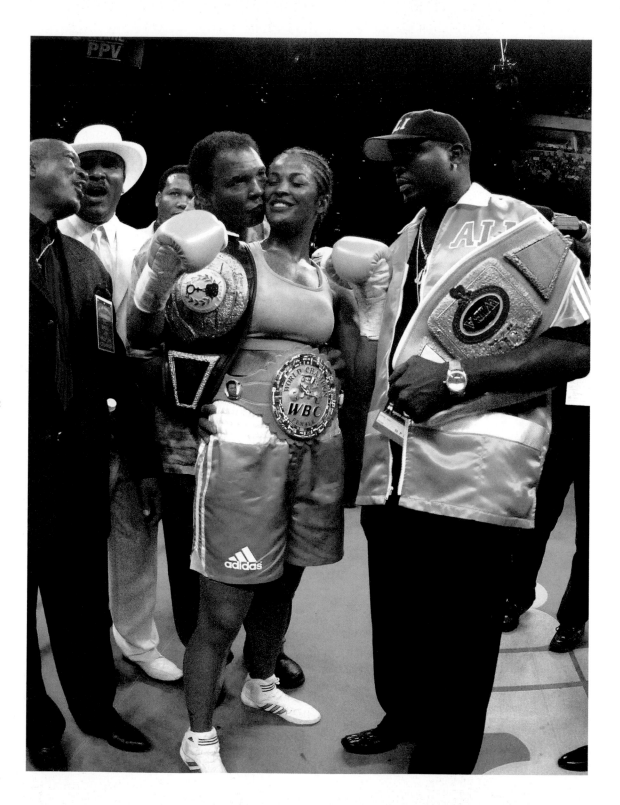

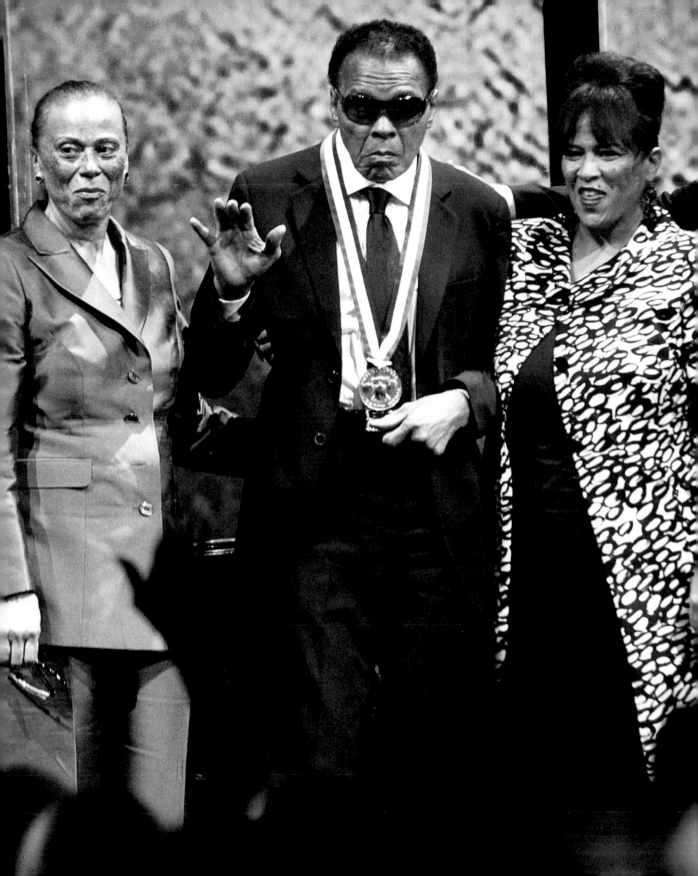

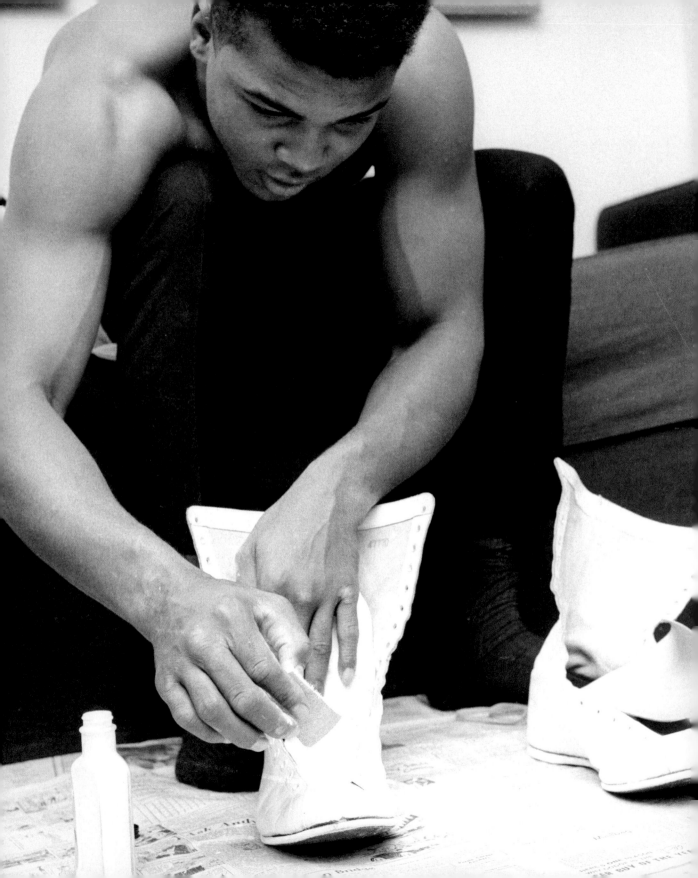

"It isn't the mountains ahead that wear you out.
It's the pebble in your shoe."

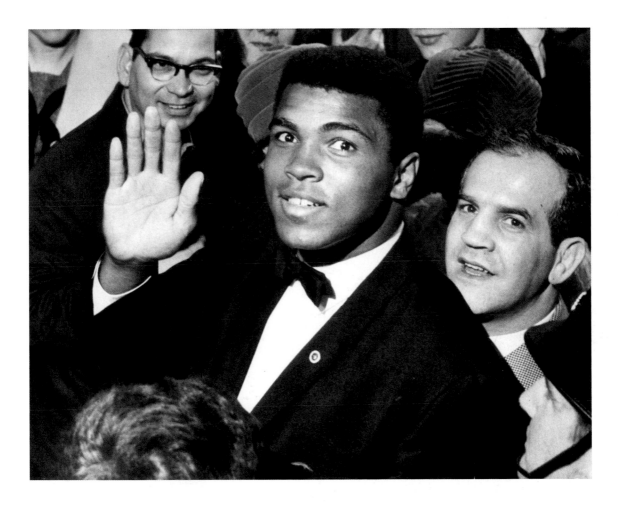

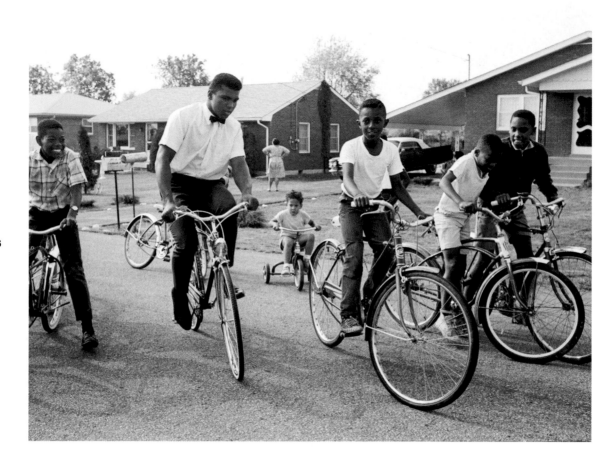

"I had to prove you could be a new kind
of black man. I had to show the world."

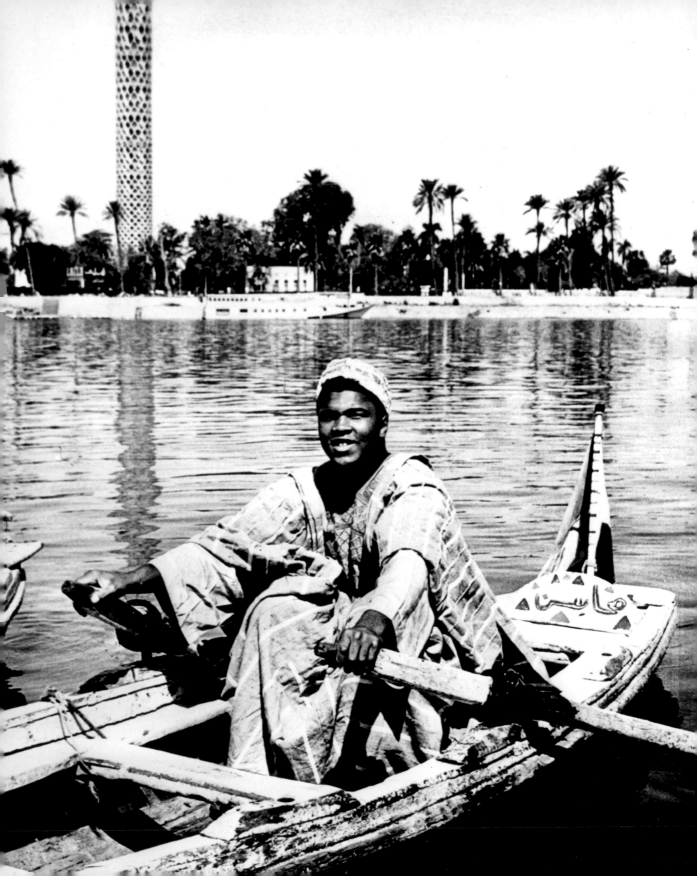

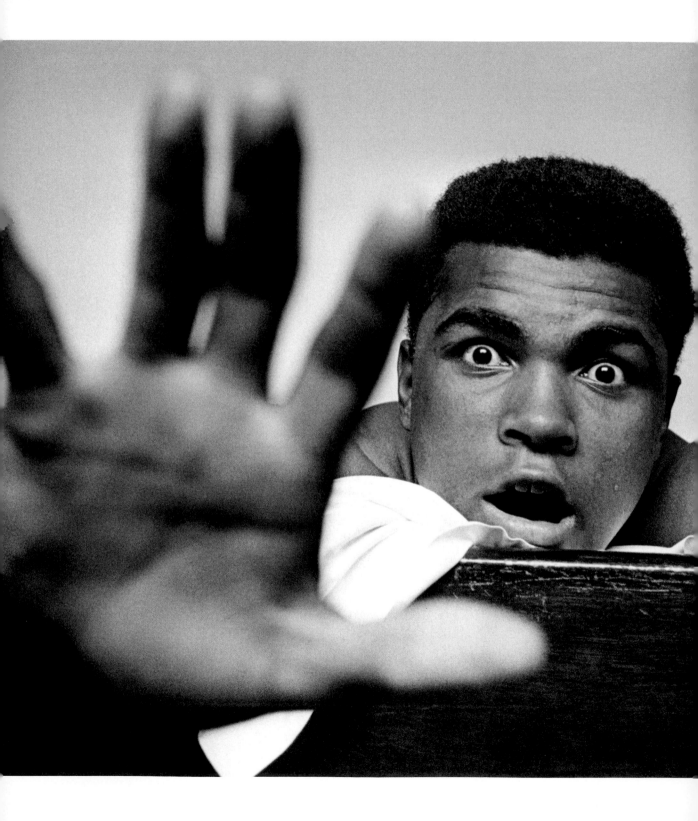

**MY WAY OF
JOKING IS TO
TELL THE TRUTH.
THAT'S THE
FUNNIEST JOKE
IN THE WORLD.**

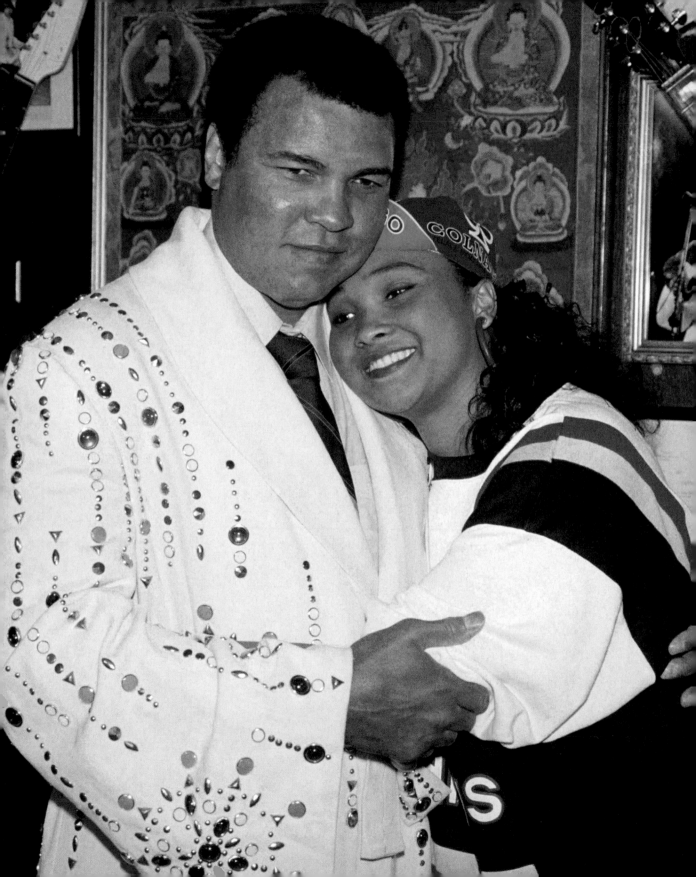

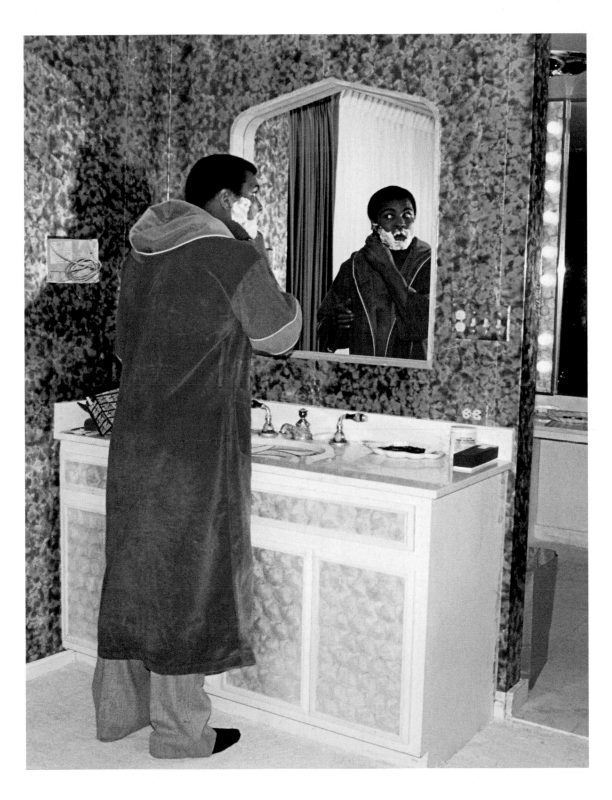

"Silence is golden when you can't think of a good answer."

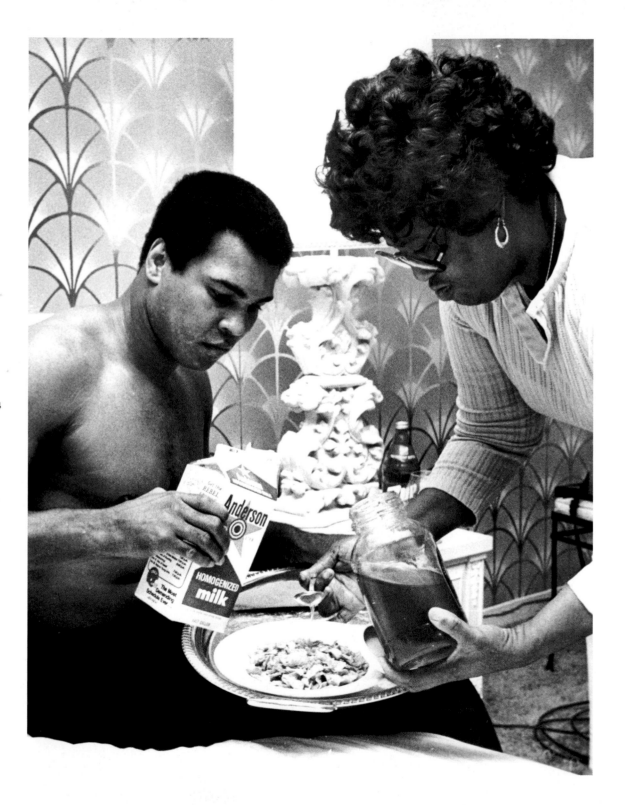

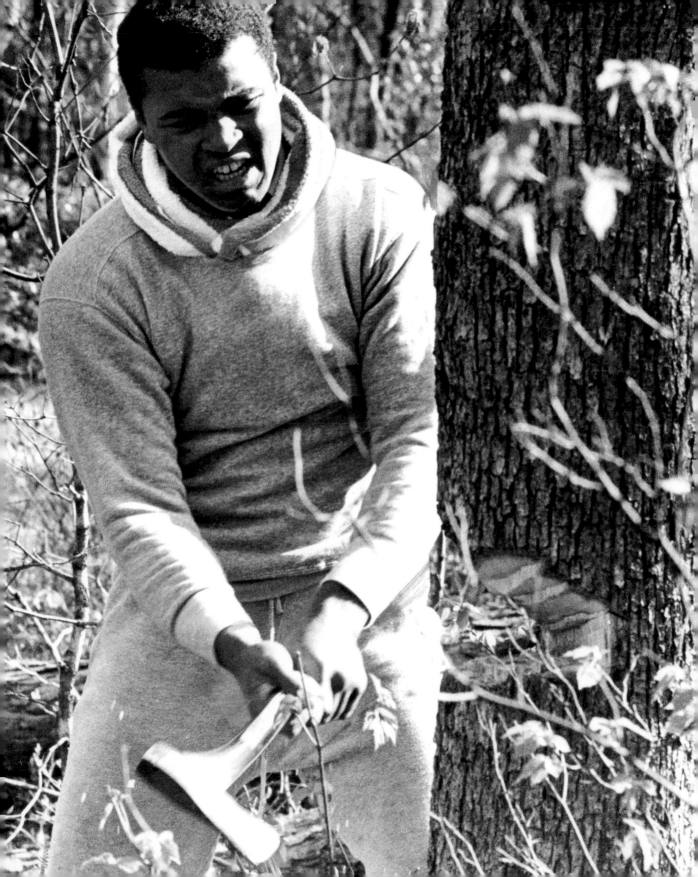

"
THE GREATEST
VICTORY IN LIFE IS
TO RISE ABOVE THE
MATERIAL THINGS
THAT WE ONCE
VALUED MOST.
"

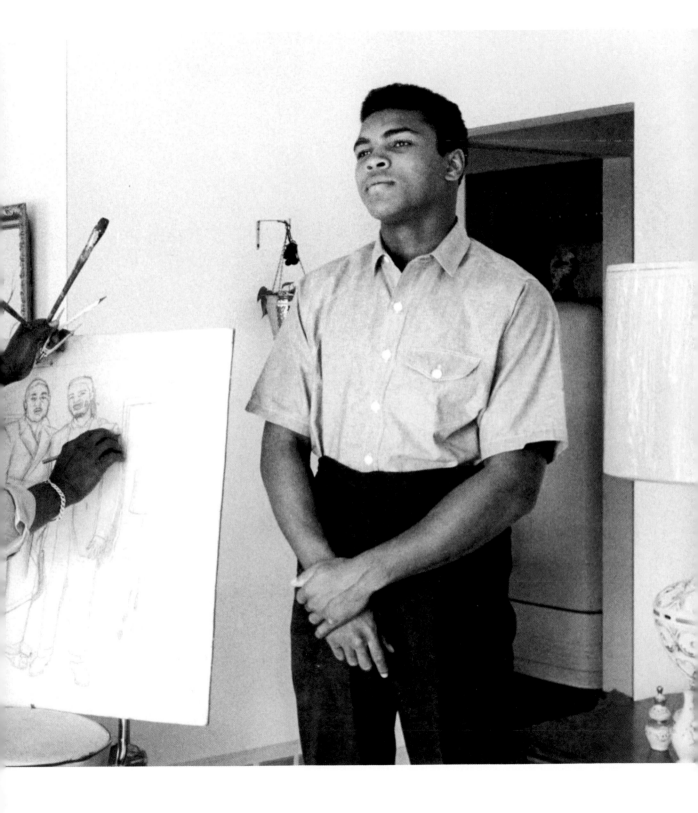

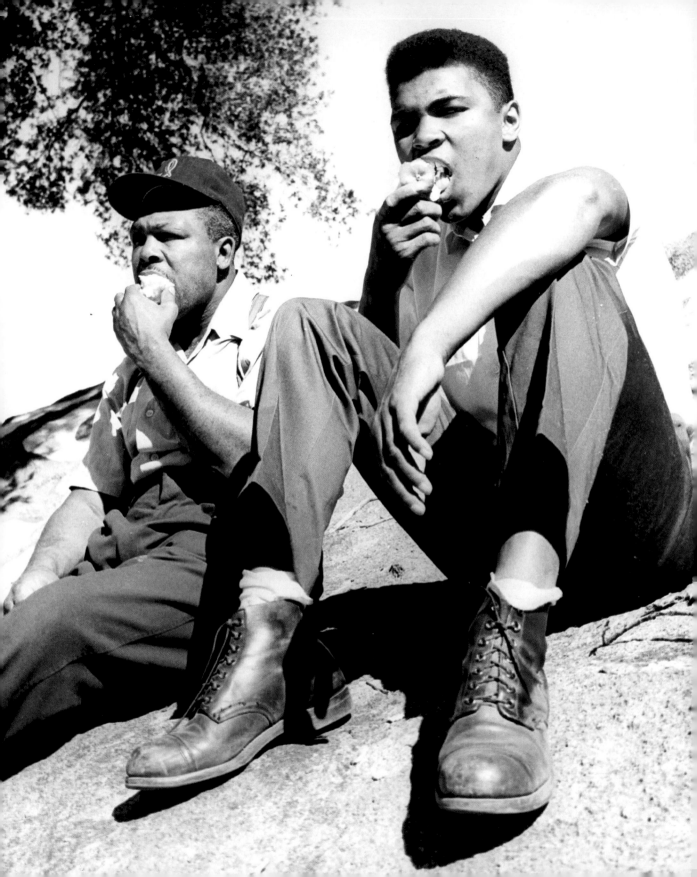

"I'm more at home with my log cabins than I am in my house in Cherry Hill."

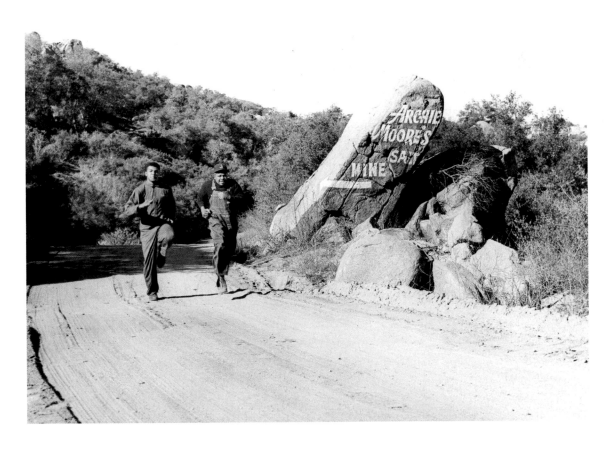

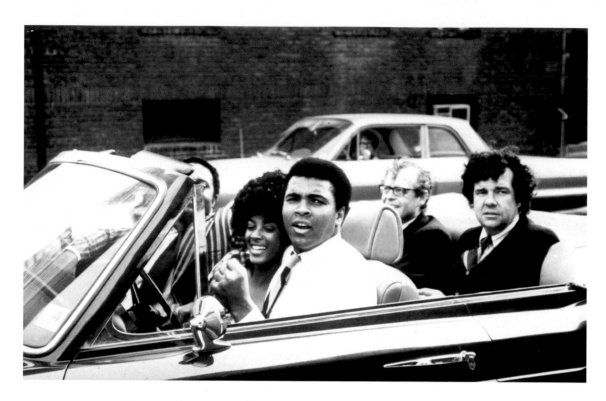

170

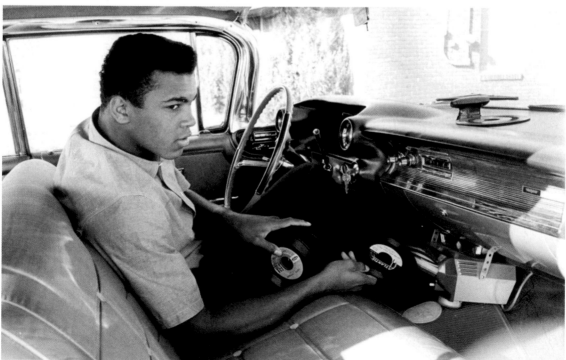

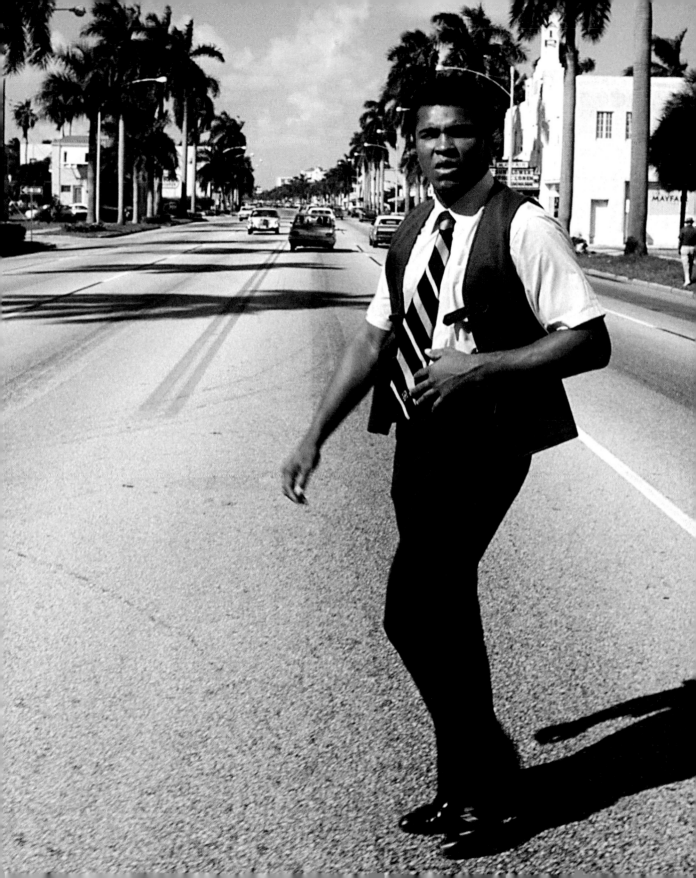

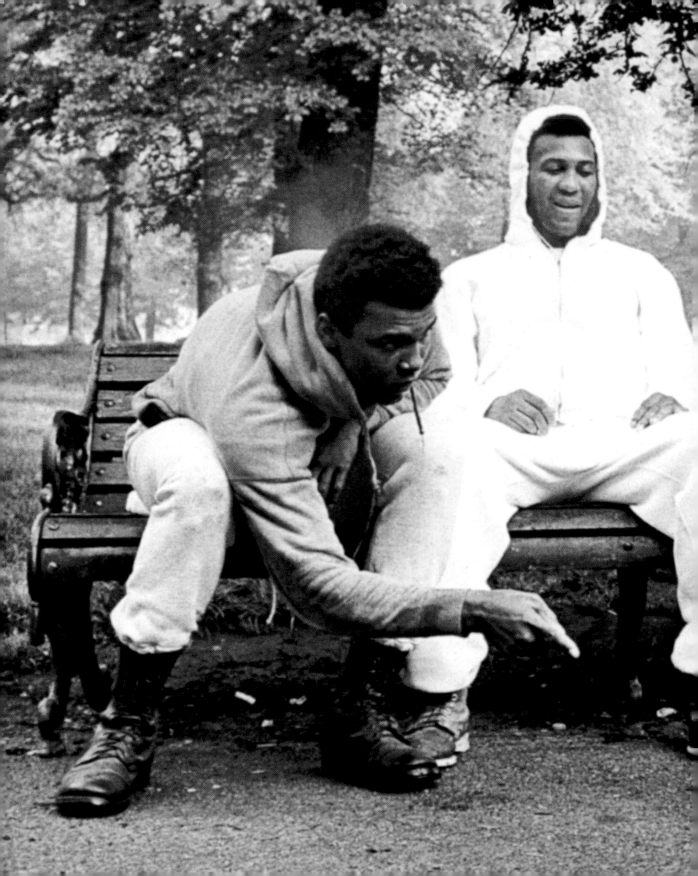

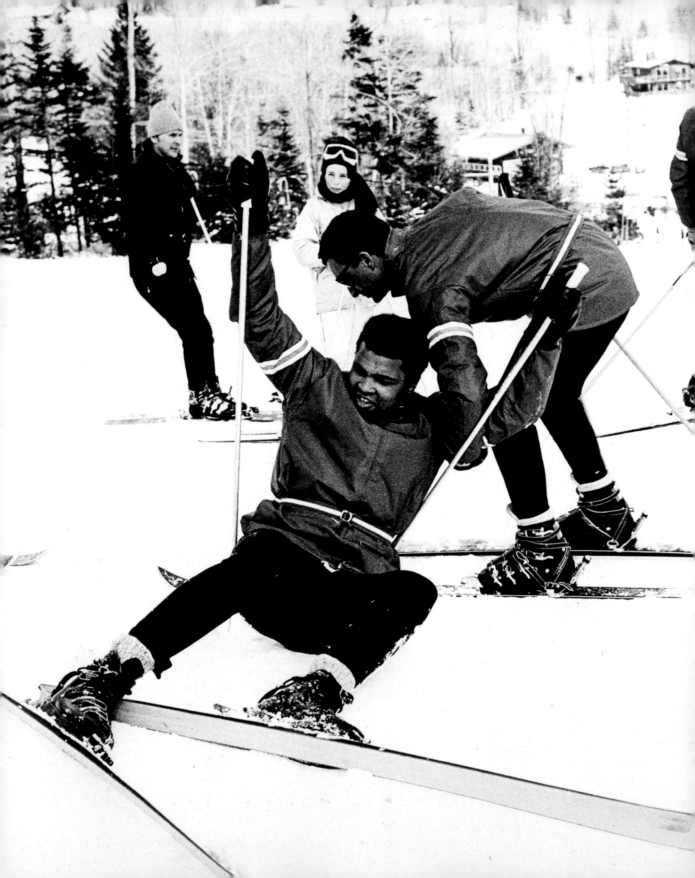

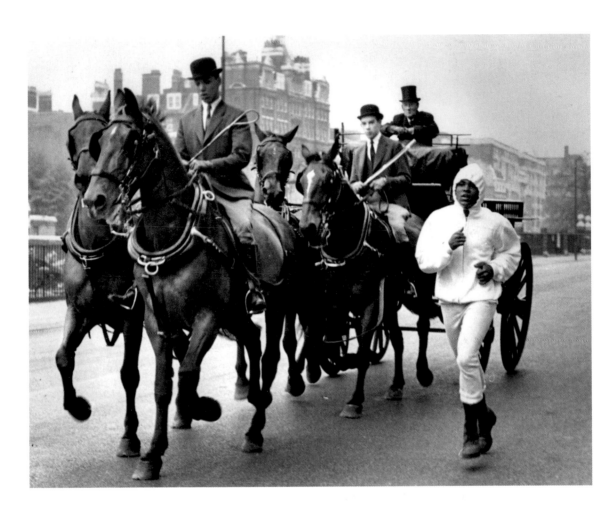

"If my mind can conceive it, and my heart
can believe it, then I can achieve it."

"Boxing was just a means to
introduce me to the world."

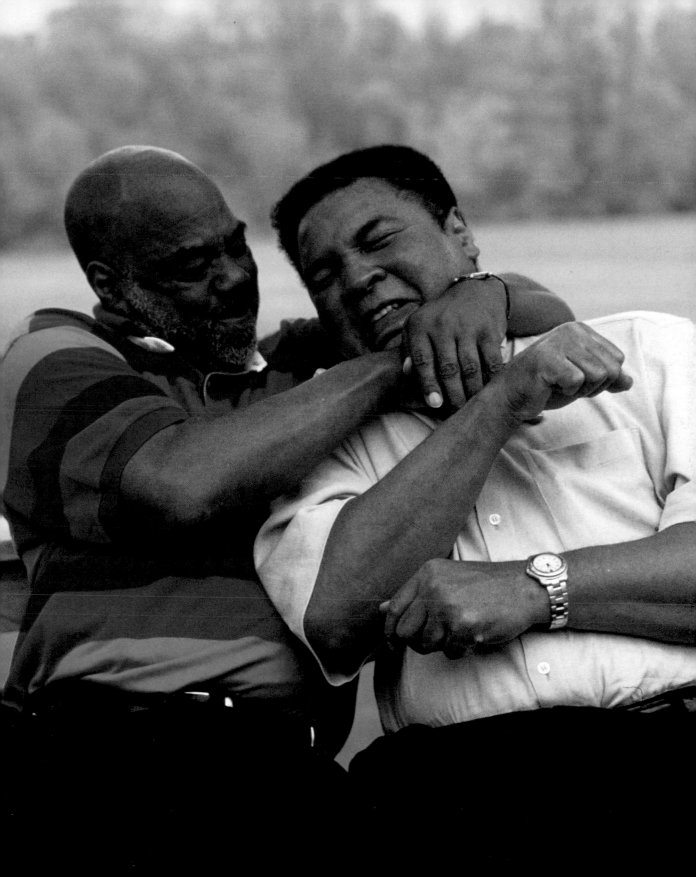

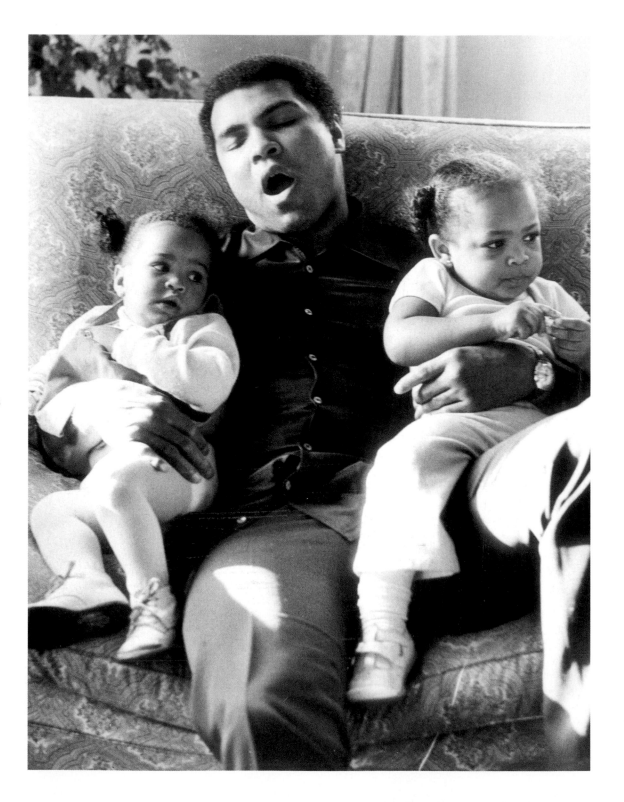

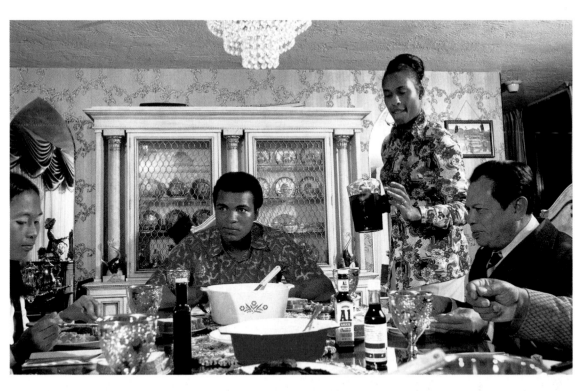

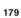

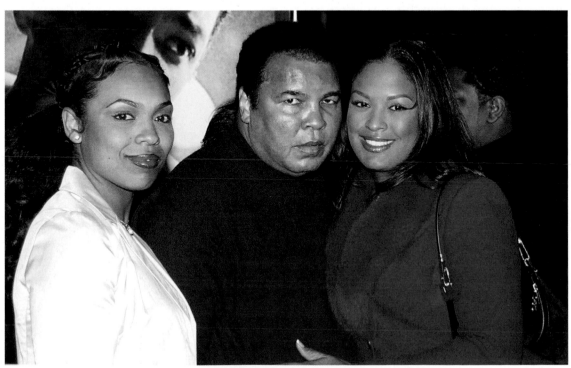

What you're thinking is what you're

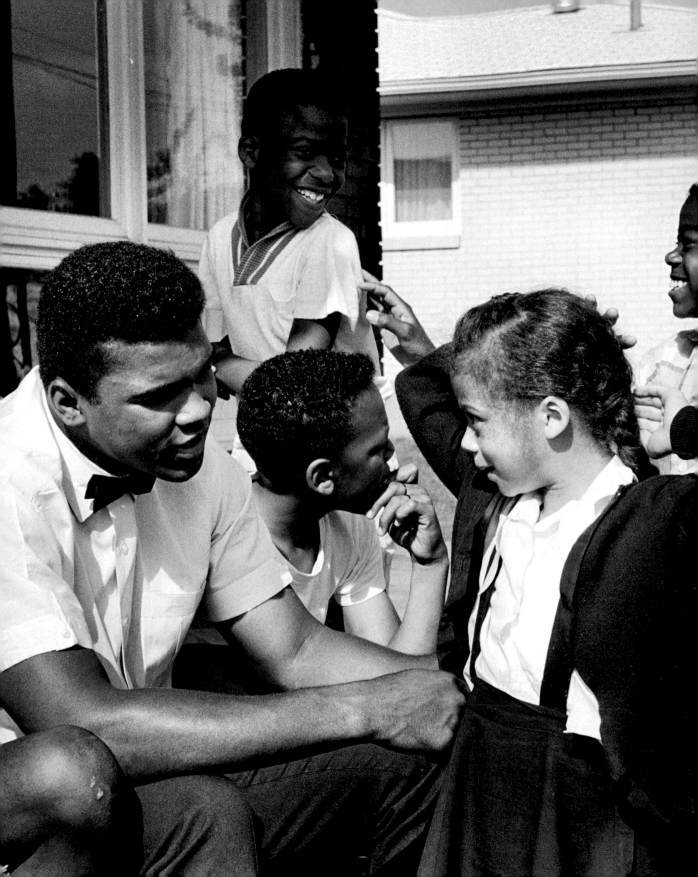

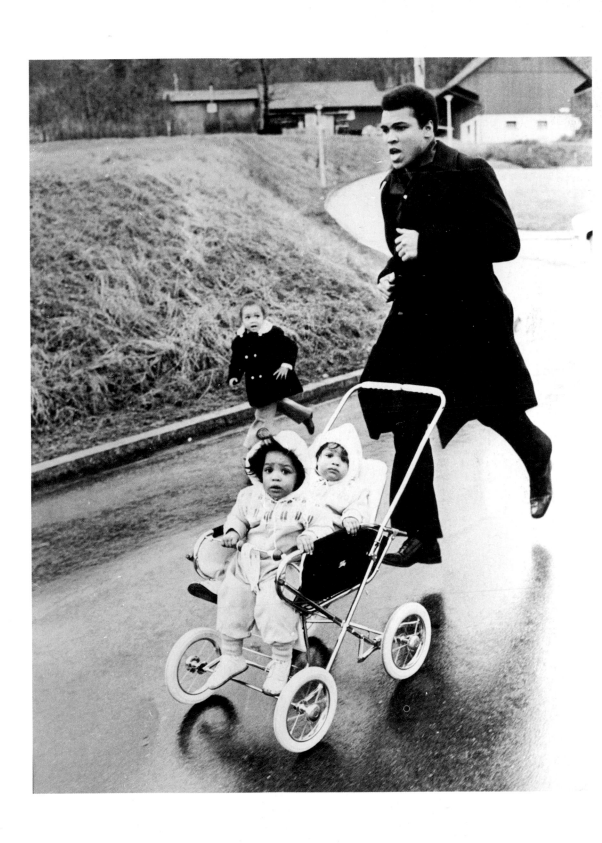

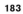

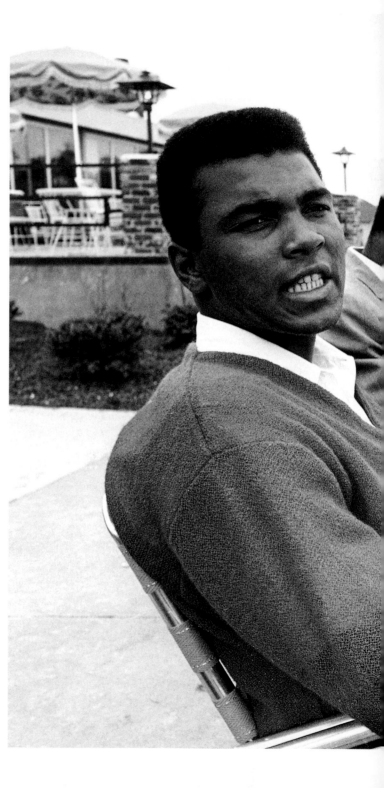

"
IT'S JUST A JOB.
GRASS GROWS,
BIRDS FLY,
WAVES POUND
THE SAND.
I BEAT PEOPLE UP.
"

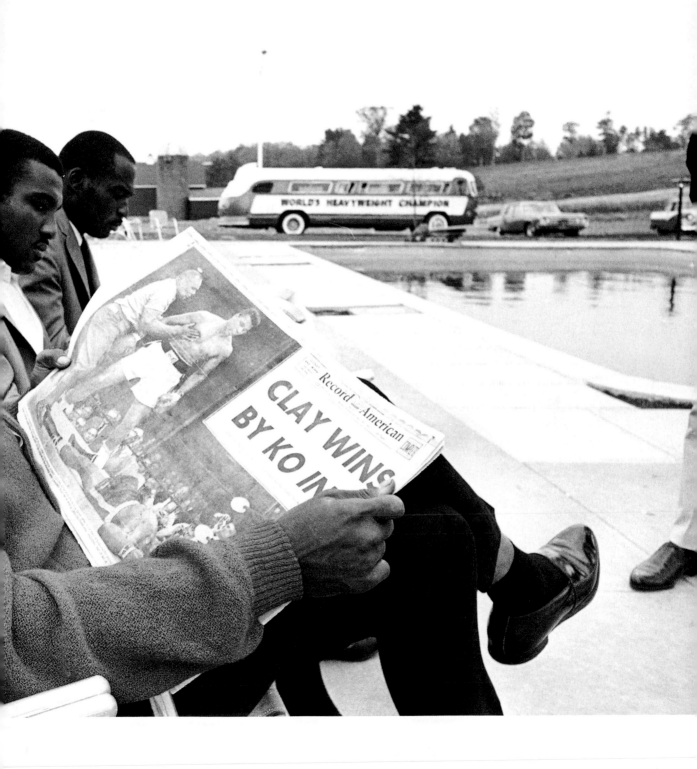

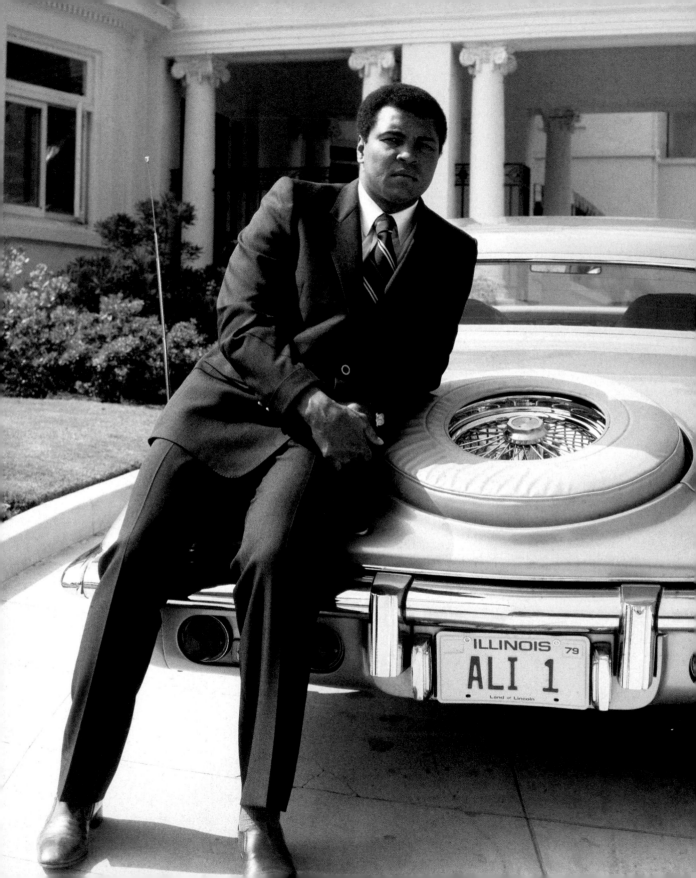

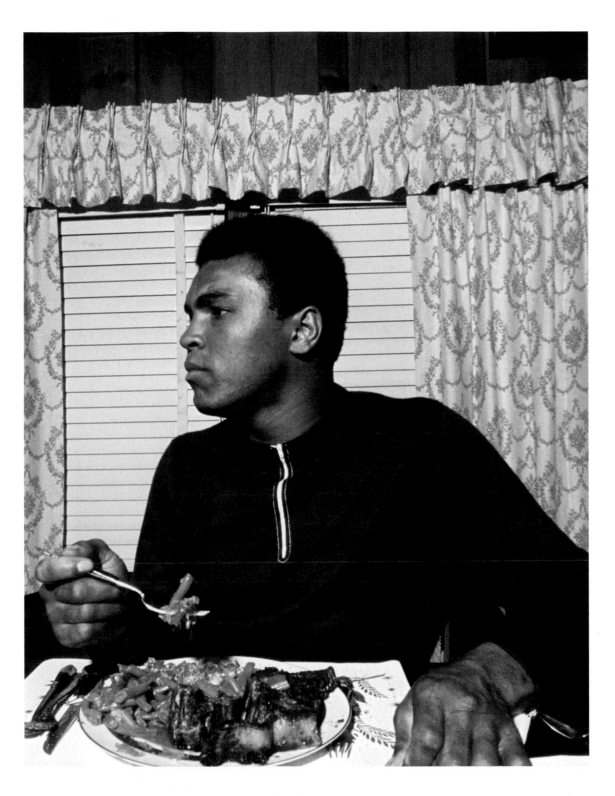

"I never thought of losing, but now that it's happened, the only thing is to do it right. That's my obligation to all the people who believe in me. We all have to take defeats in life."

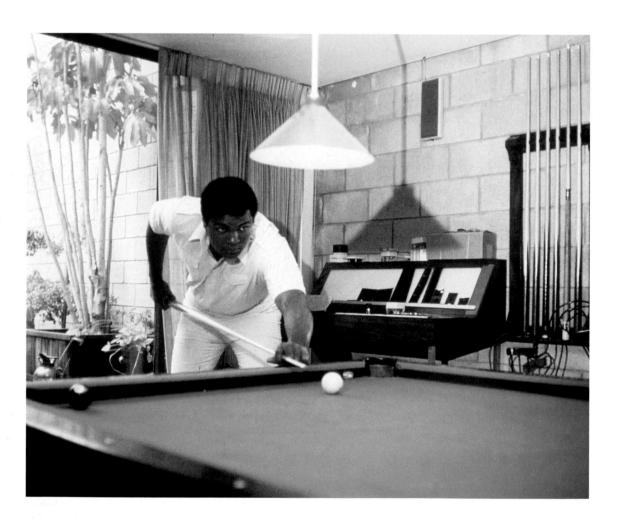

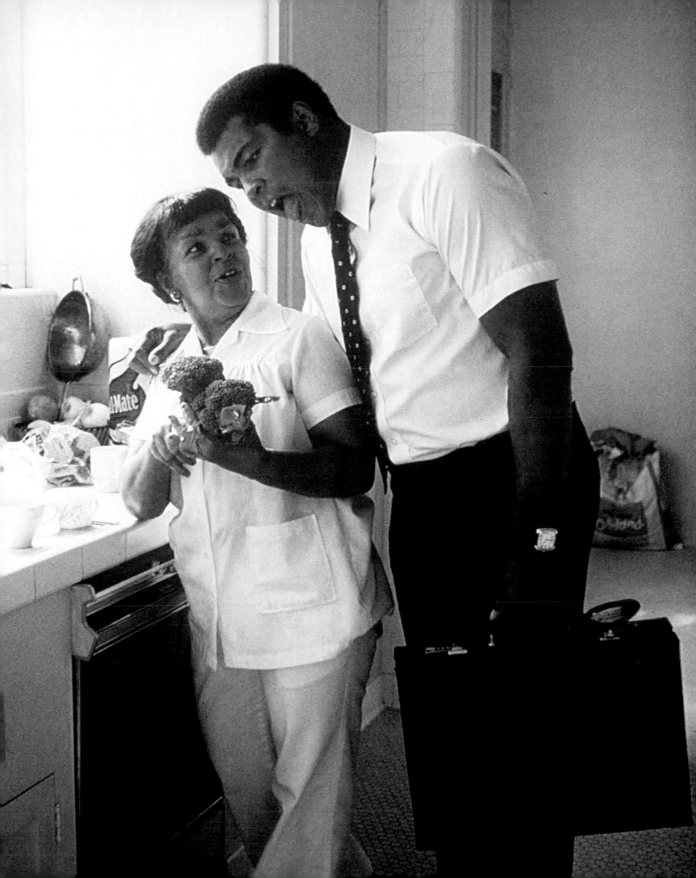

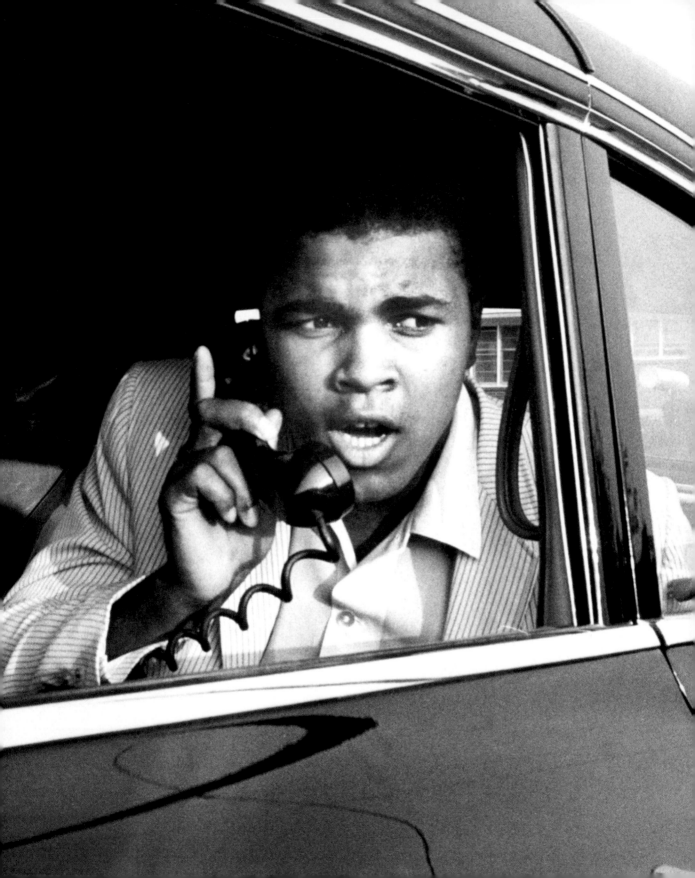

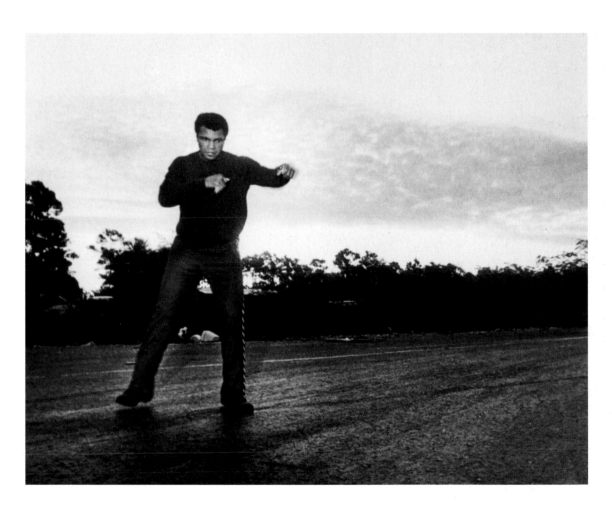

"Rumble, young man, rumble."

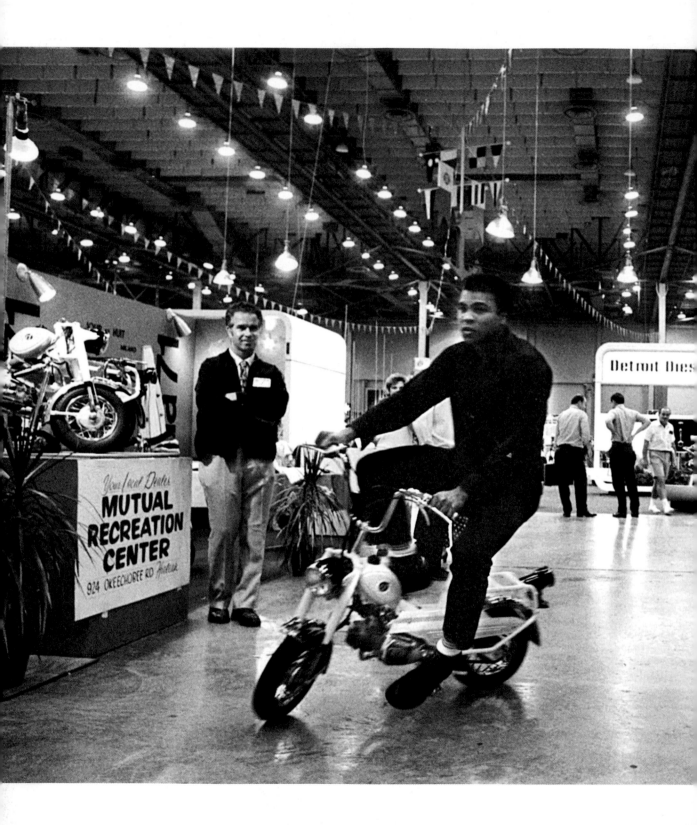

"
THE MAN WHO
HAS NO IMAGINATION
HAS NO WINGS.
"

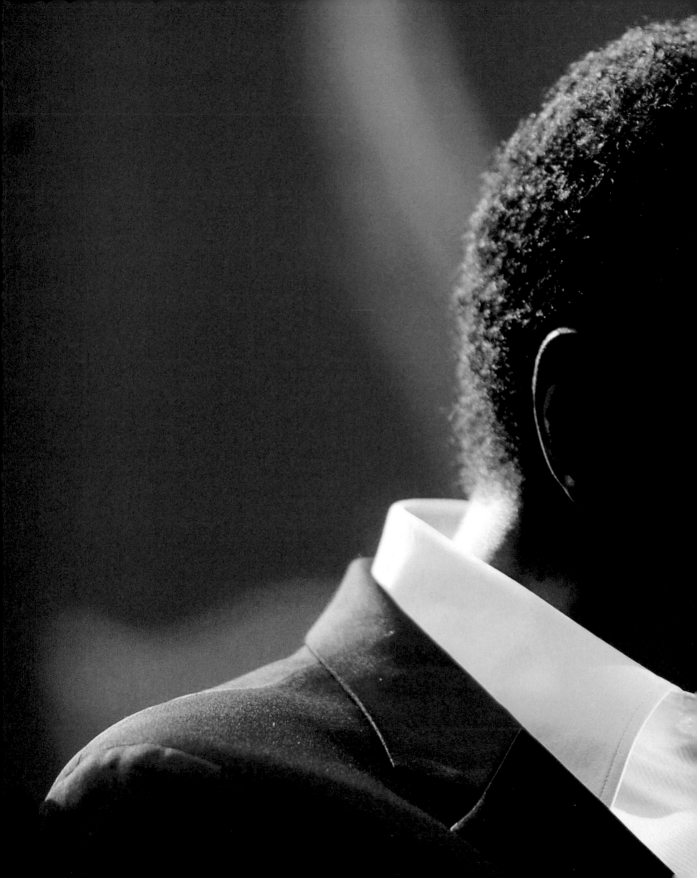

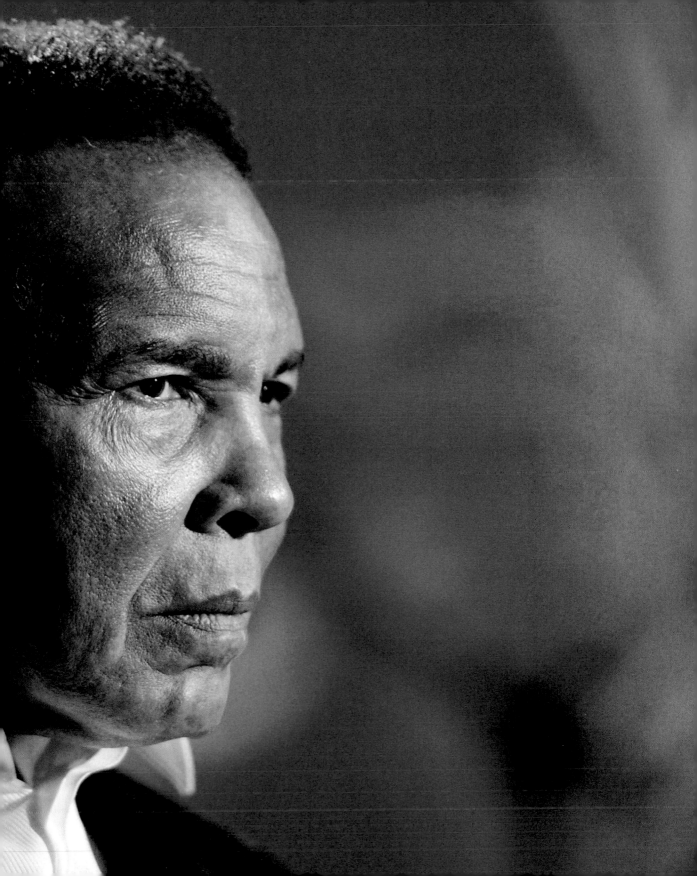

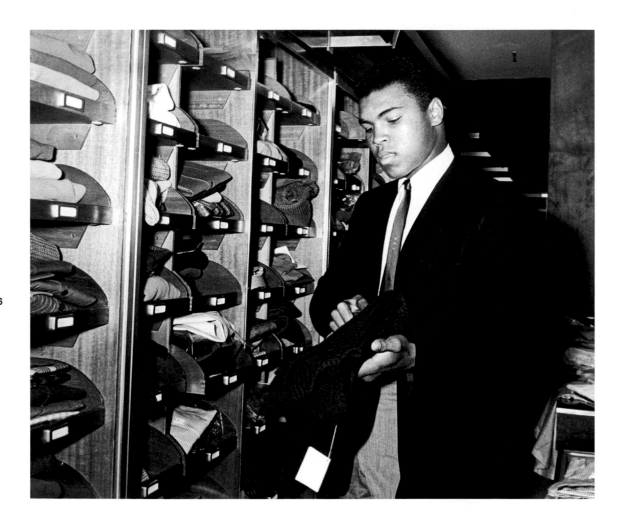

"During my boxing career, you did not see the real
 Muhammad Ali. You just saw a little boxing.
 You saw only a part of me. After I retired from
 boxing my true work began. I have embarked
 on a journey of love."

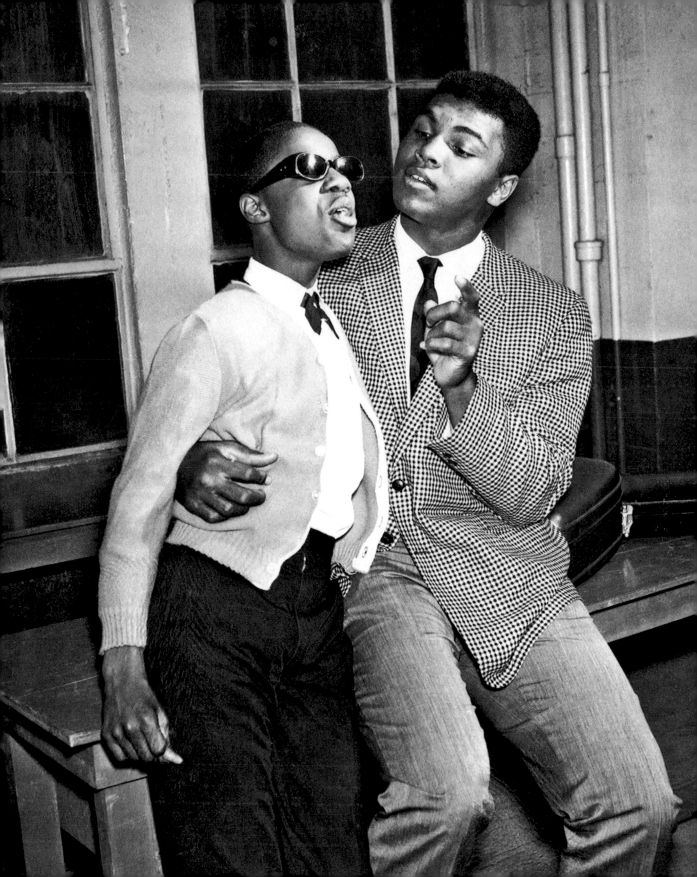

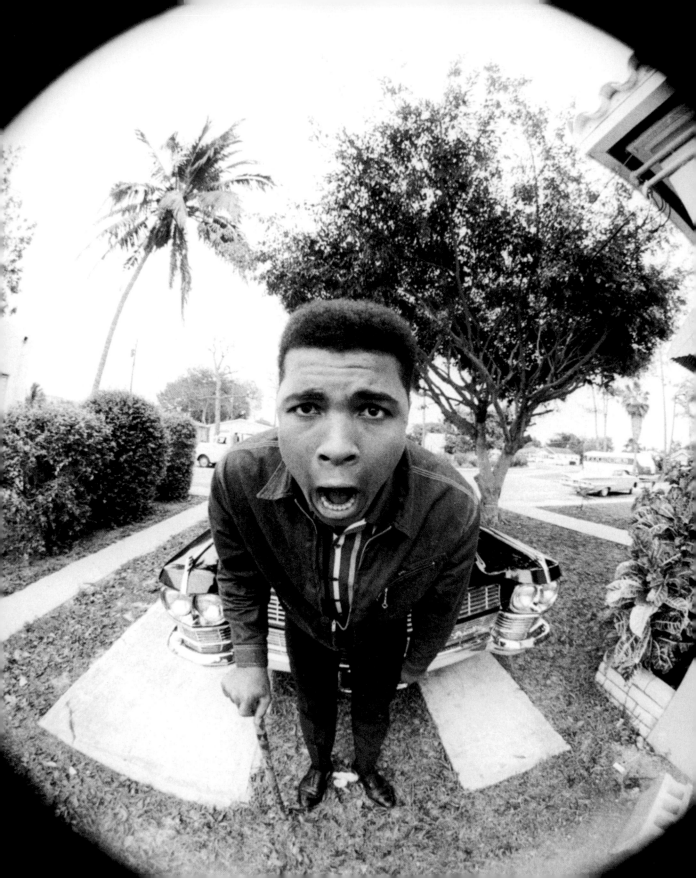

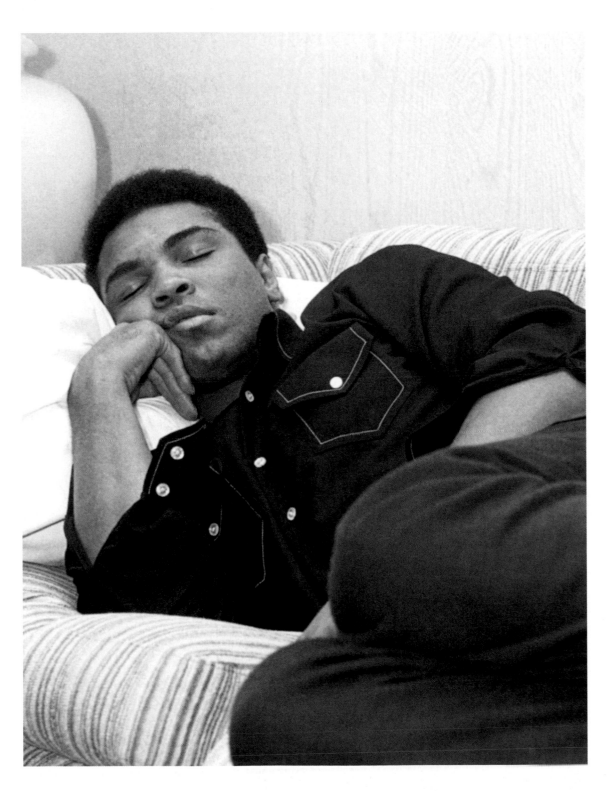

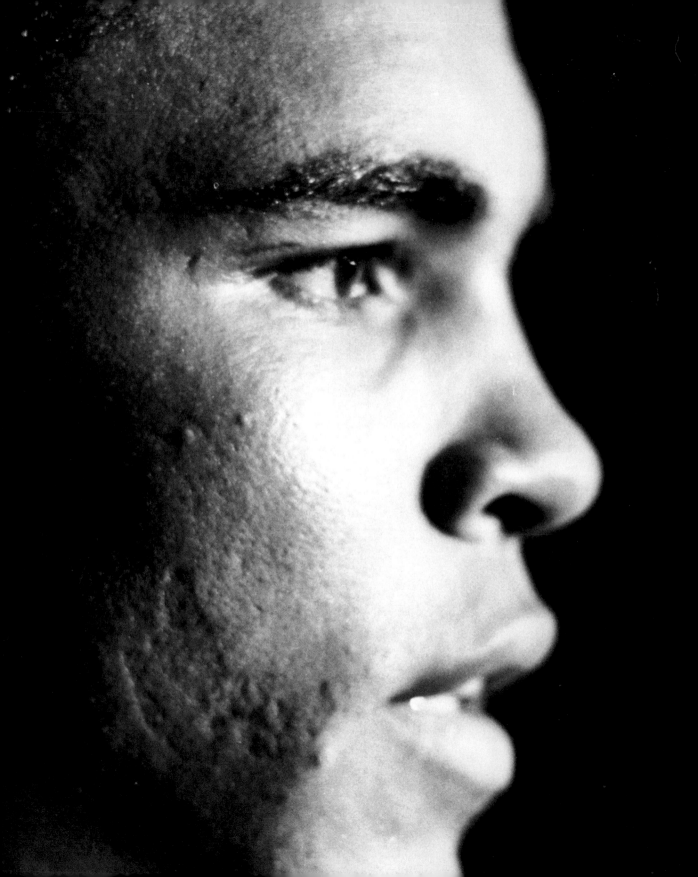

ALI
THE ICON

"
**A man who views the world the same at fifty
as he did at twenty has wasted thirty years of his life.**
"

"If the measure of greatness is to gladden the heart of every human being on the face of the earth, then he truly was the greatest. In every way he was the bravest, the kindest, and the most excellent of men."
— *Bob Dylan*

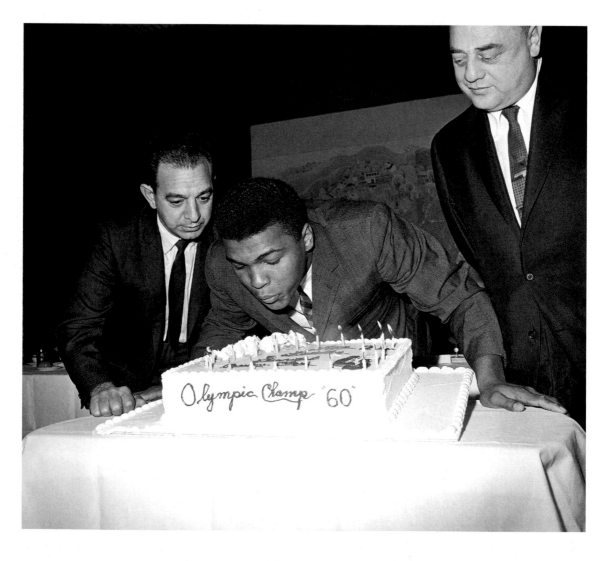

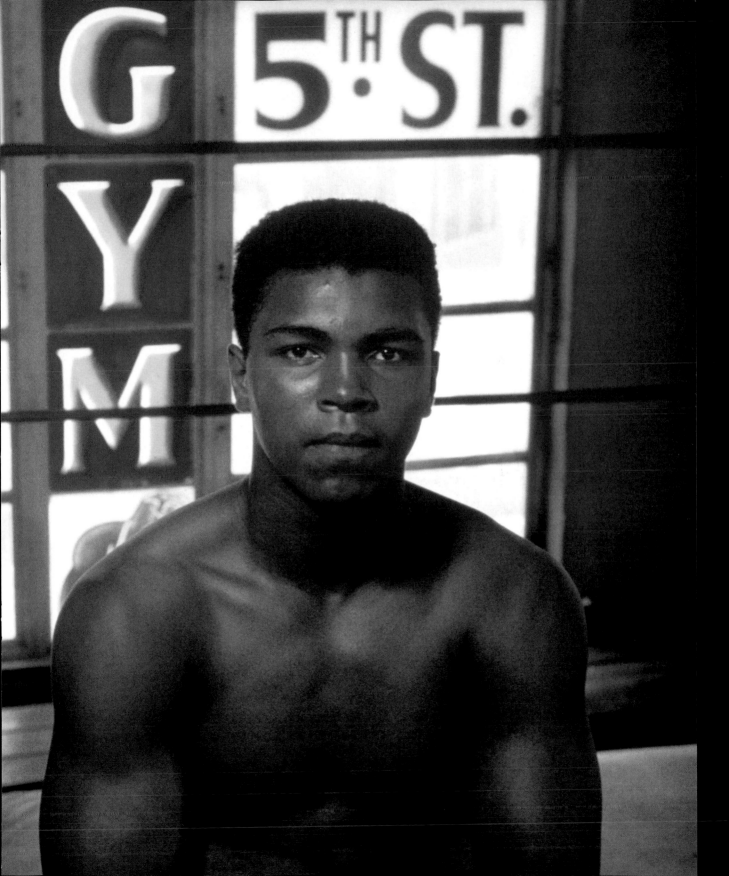

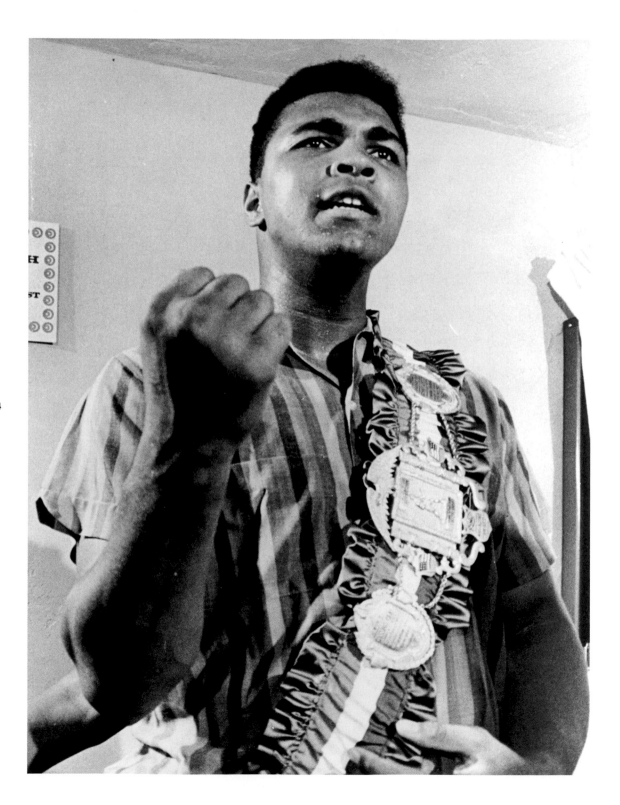

204

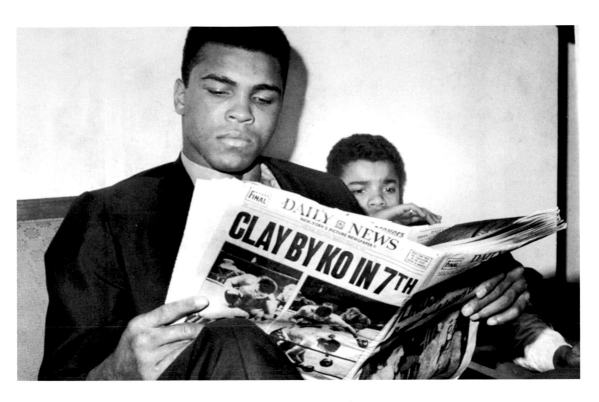

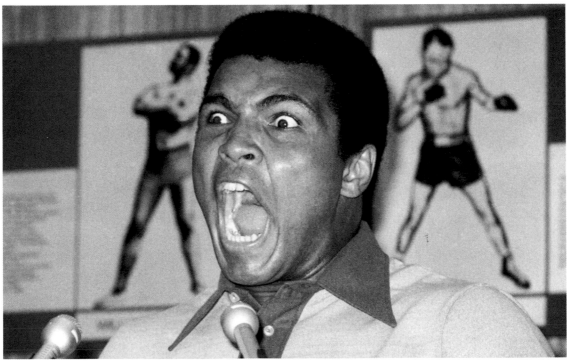

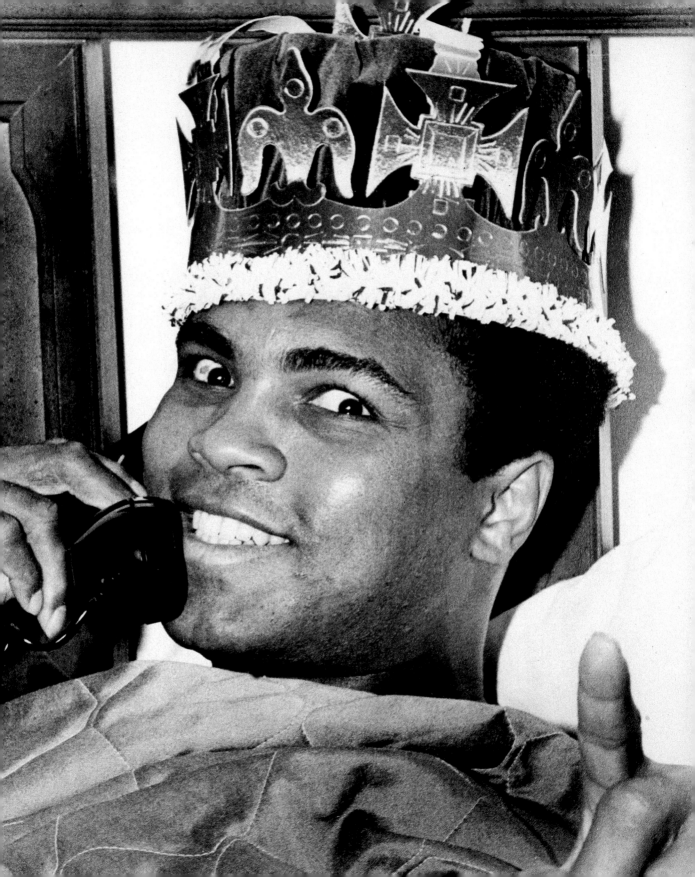

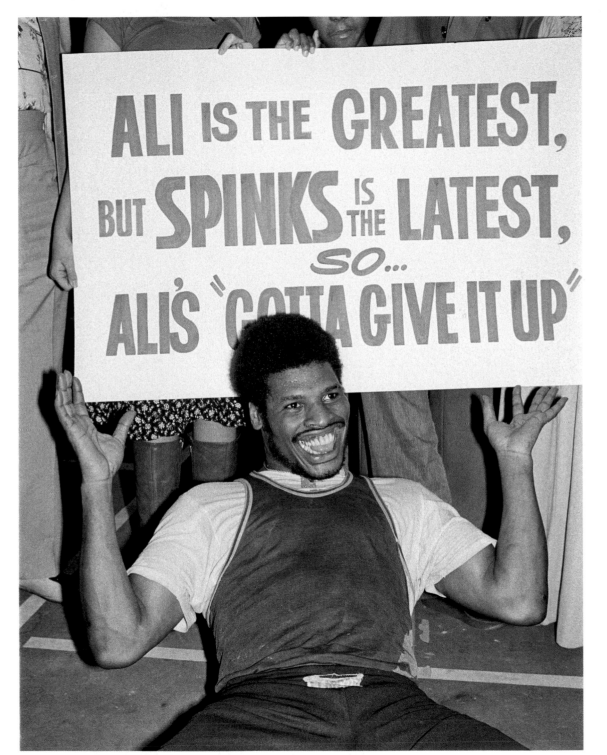

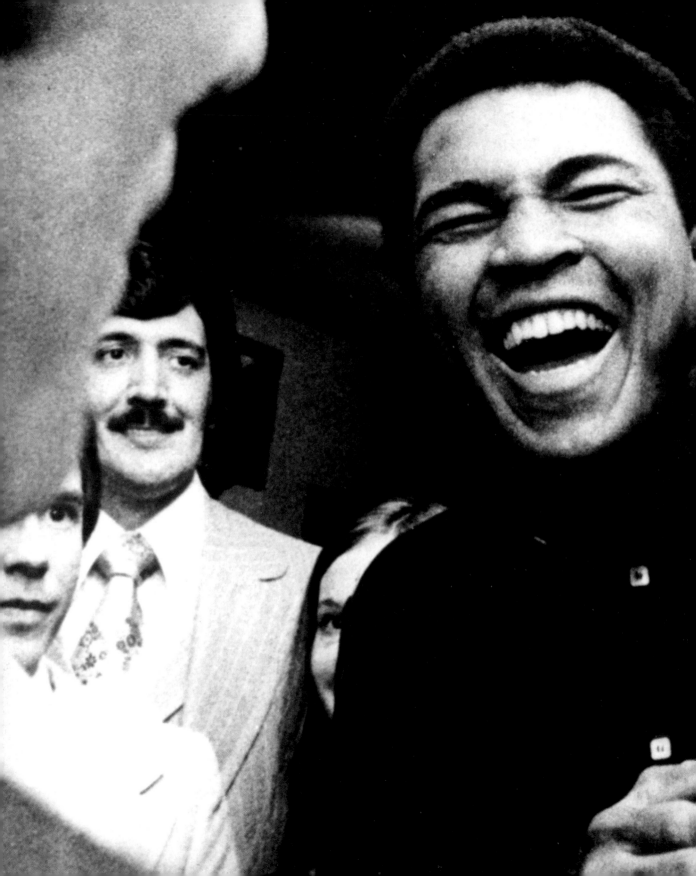

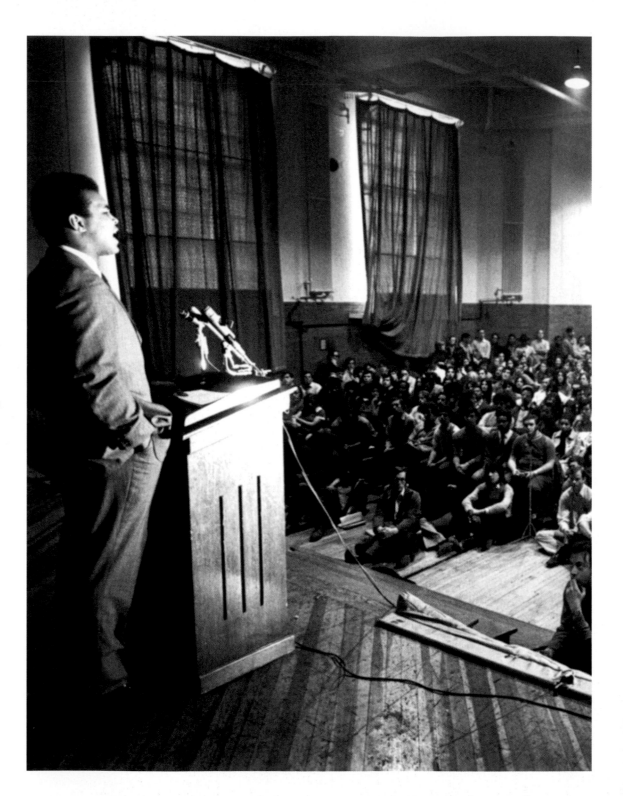

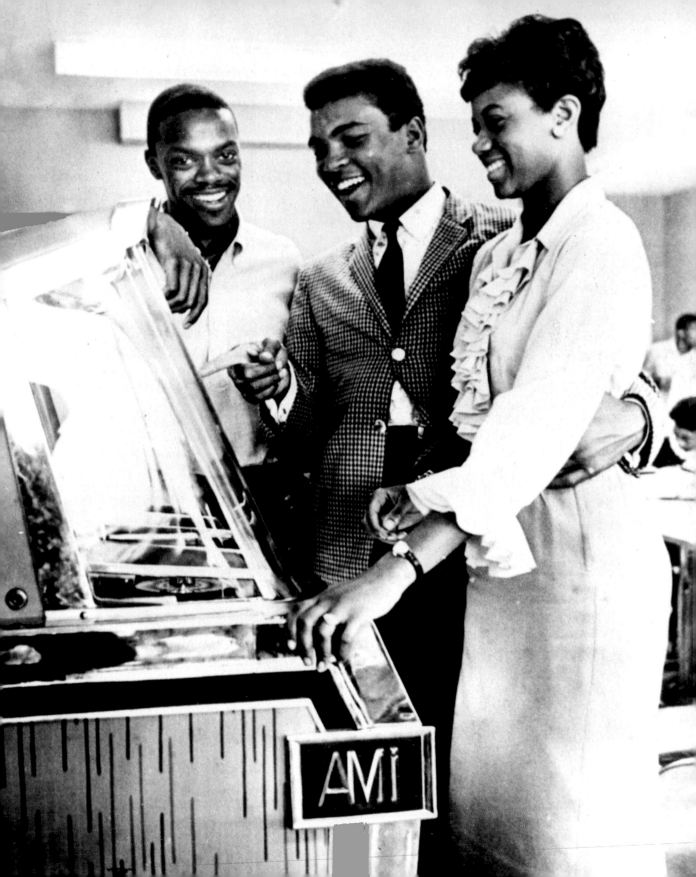

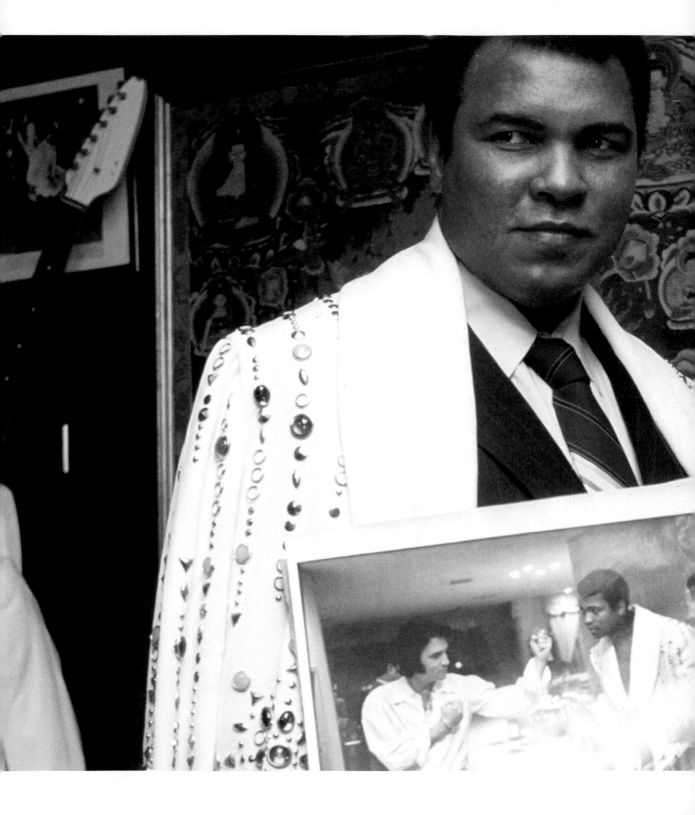

"

I WAS THE ELVIS PRESLEY
OF BOXING.

"

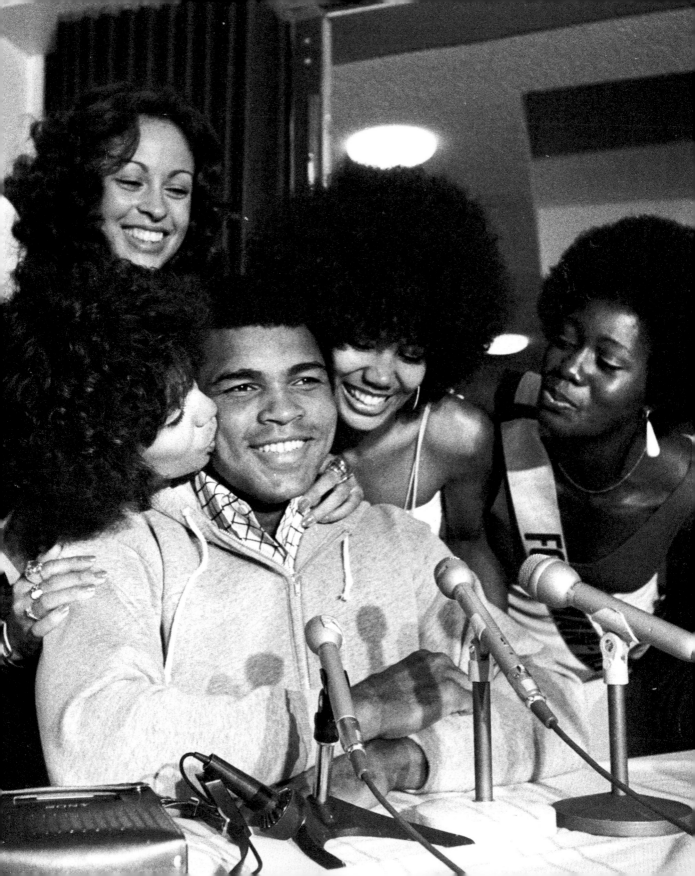

"He was always the funniest guy in the room."
— *Chris Rock*

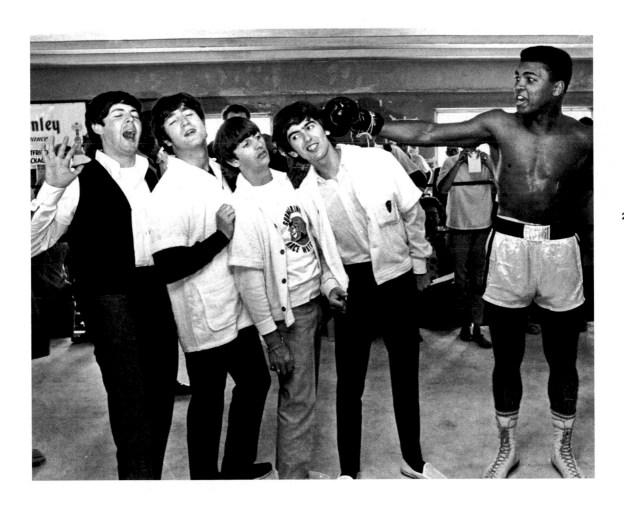

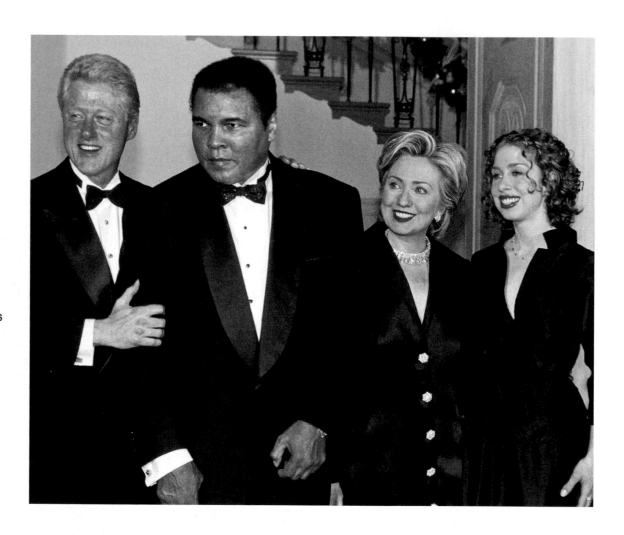

"He decided, very young, to write his own life story.
He decided that he would not be ever disempowered."
— *Bill Clinton*

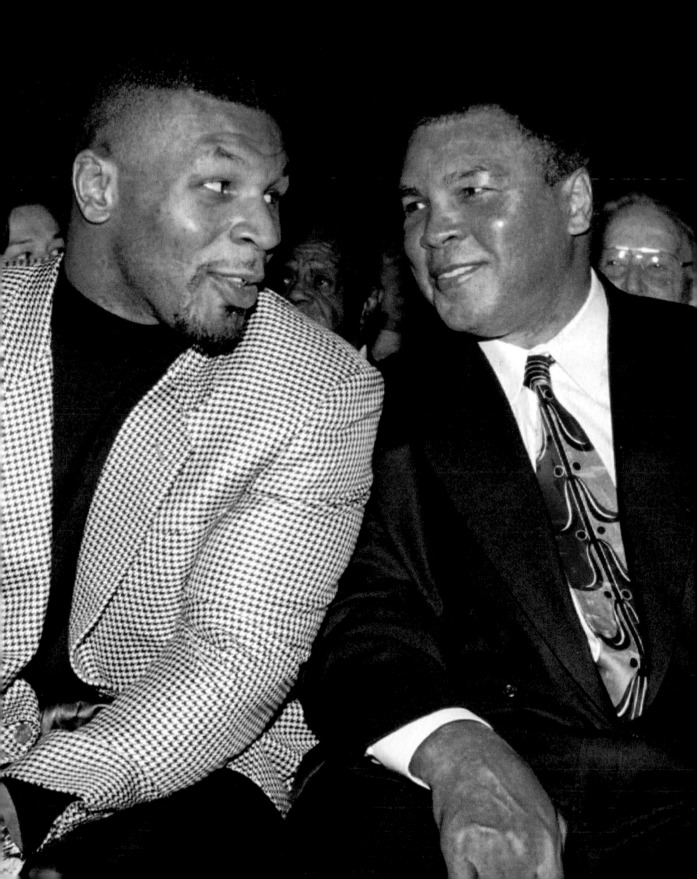

"

Live every day as
if it were your last
**because someday
you're going
to be right.**

"

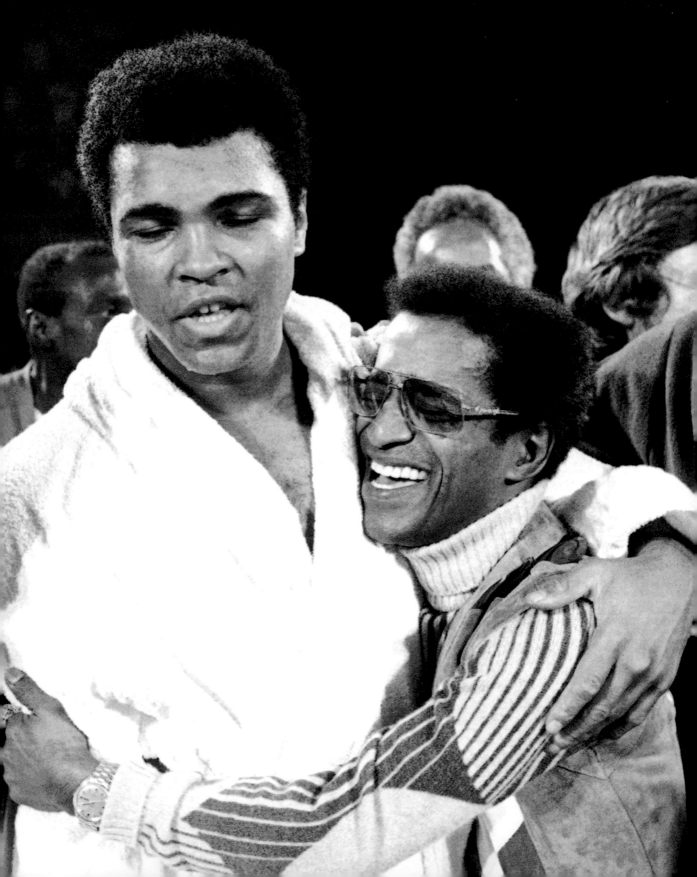

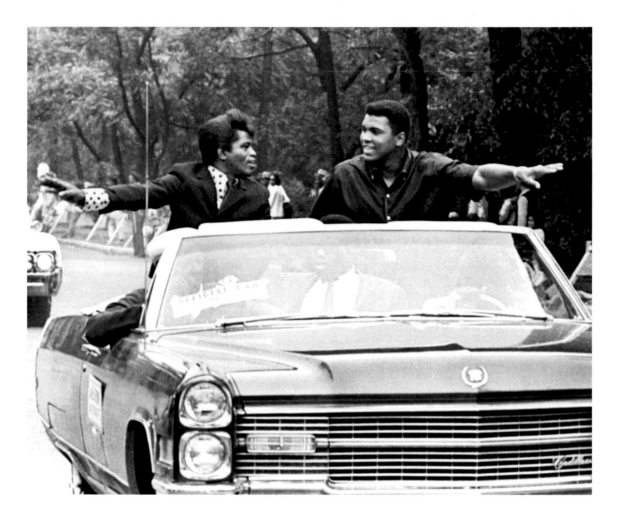

"He was a champion in the ring, but, more than that, a hero beyond
the ring. When champions win, people carry them off the field on
their shoulders. When heroes win, people ride on their shoulders.
We rode on Muhammad Ali's shoulders."
— *Rev. Jesse Jackson*

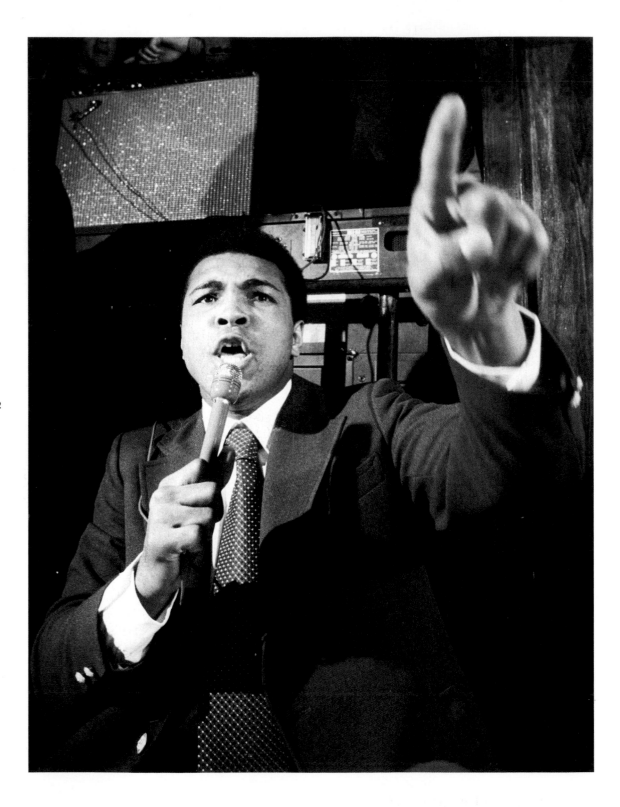

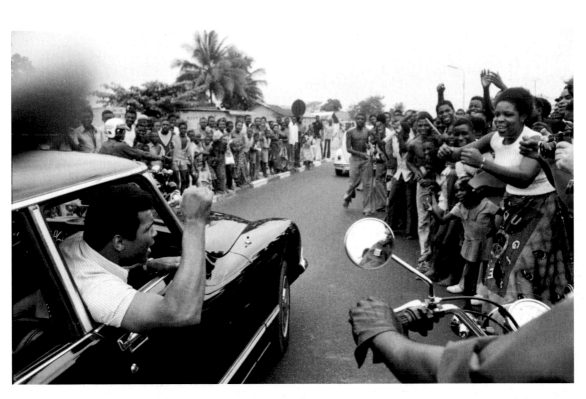

" I SHOOK UP THE WORLD. "

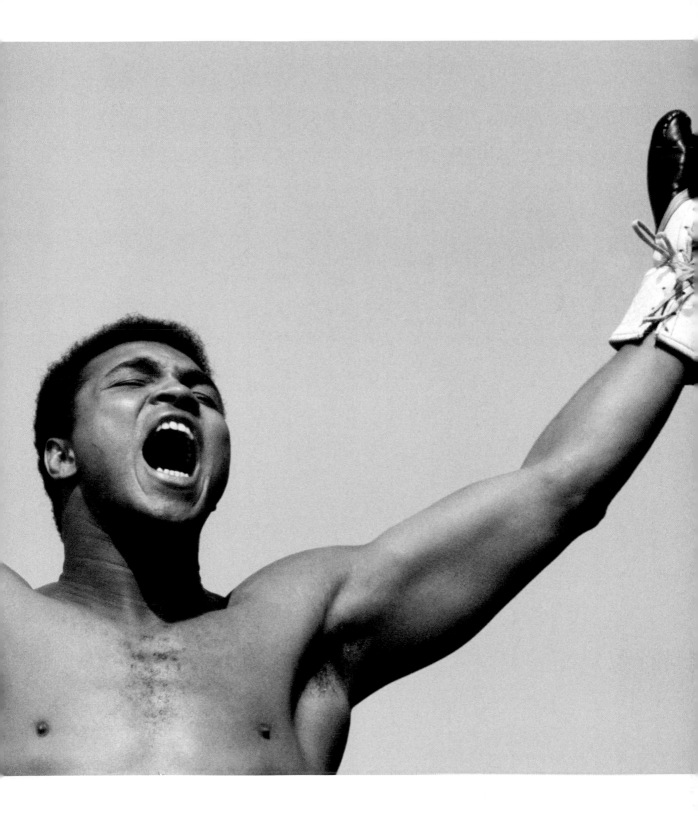

"Muhammad's unwavering courage, conviction, and perseverance
will continue to live on in those he impacted."
— *Derek Jeter*

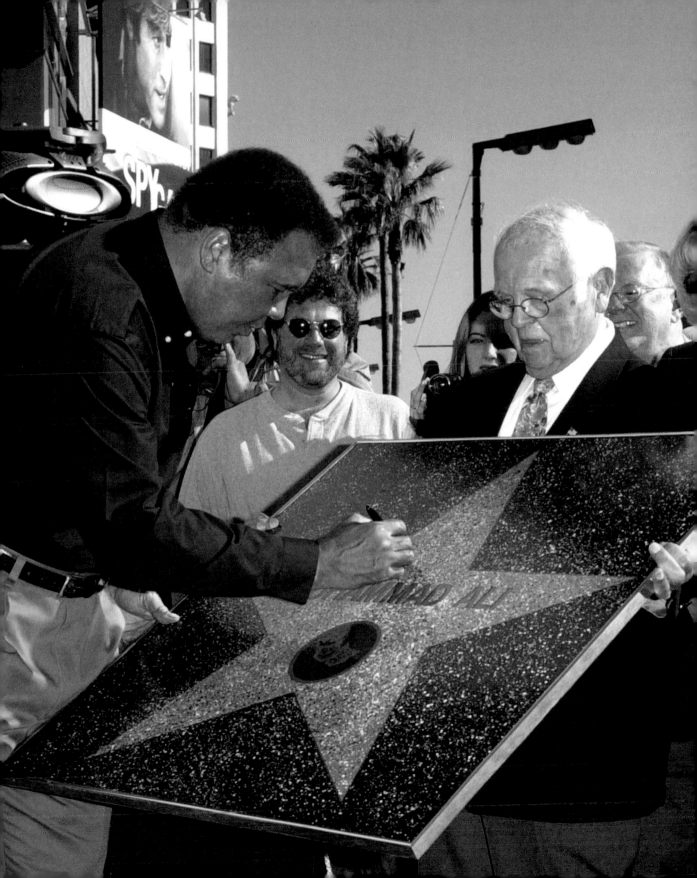

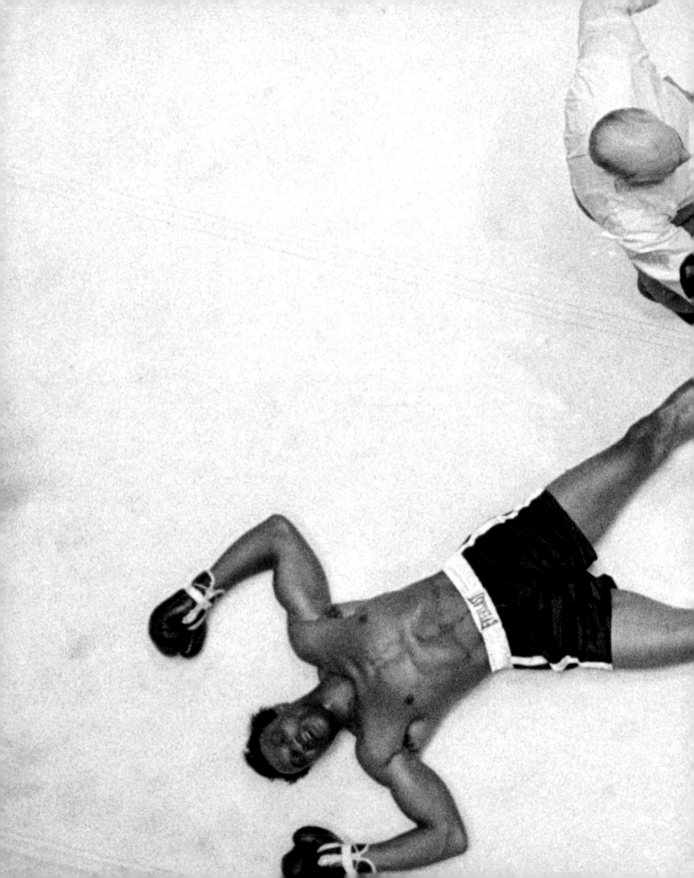

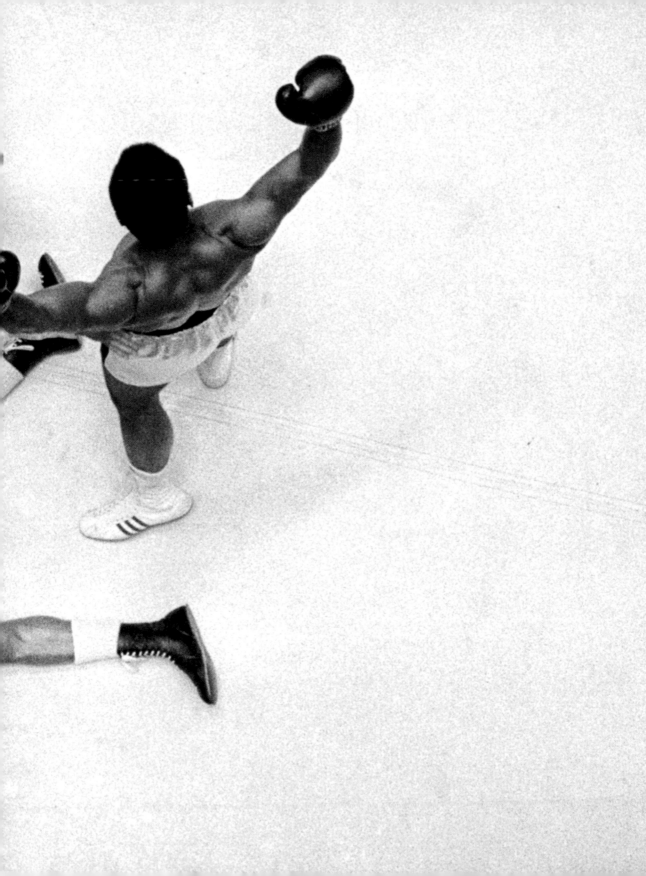

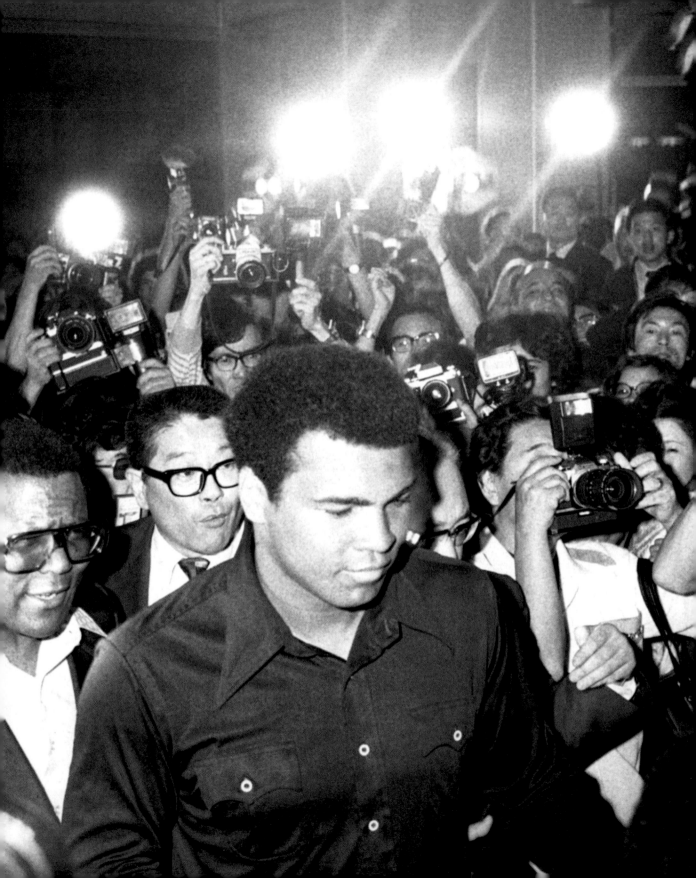

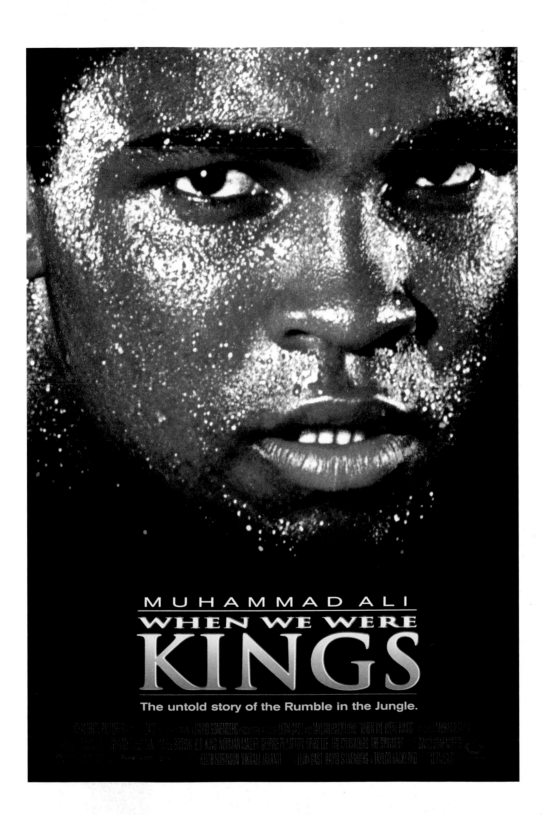

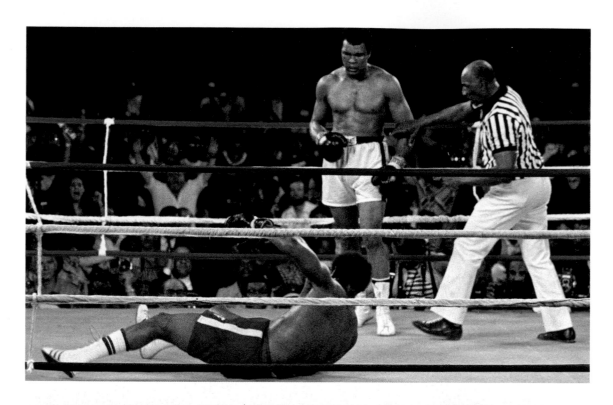

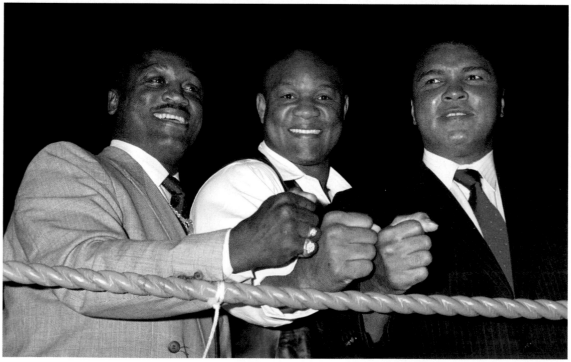

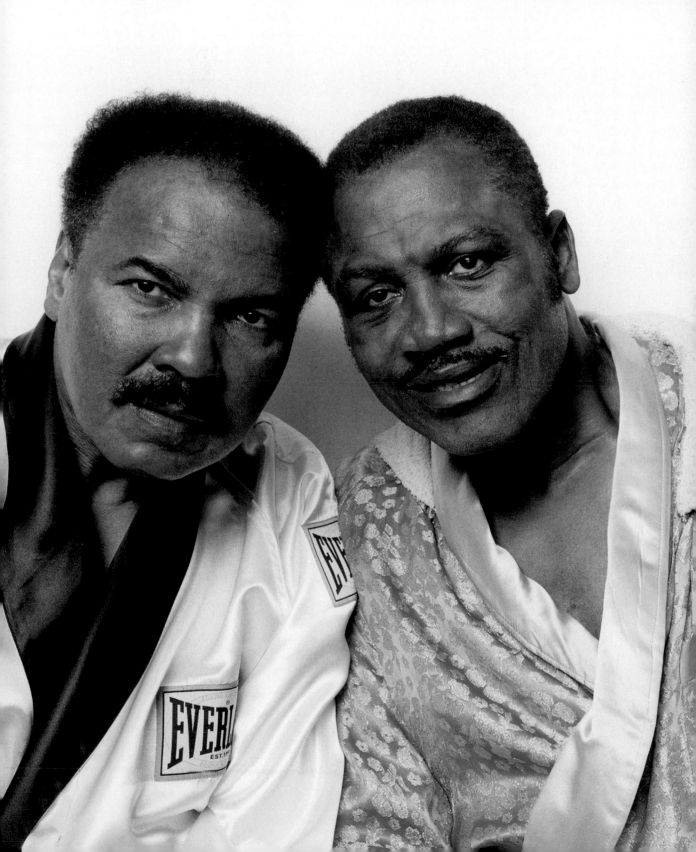

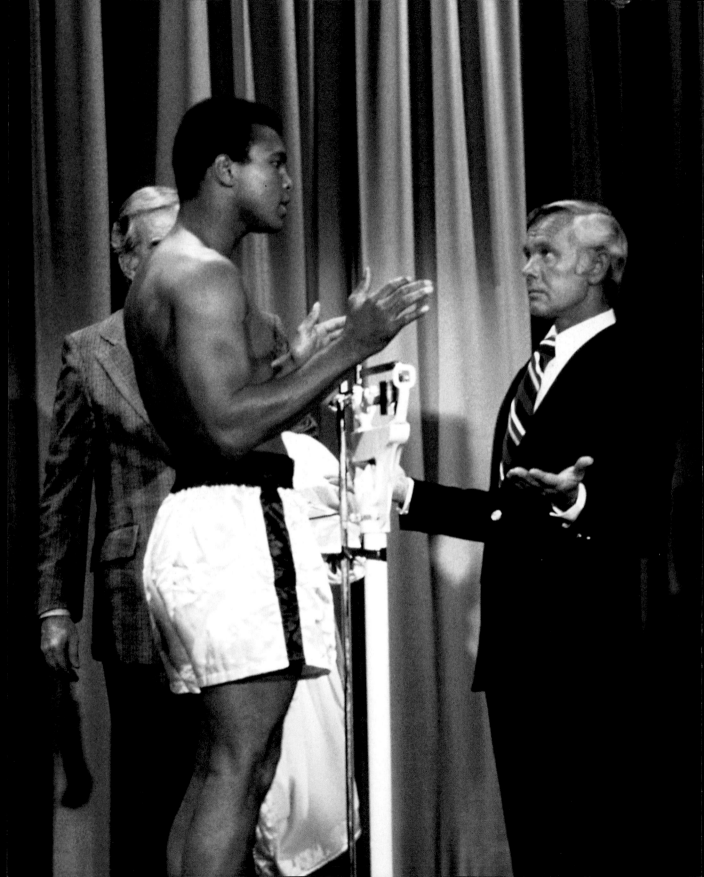

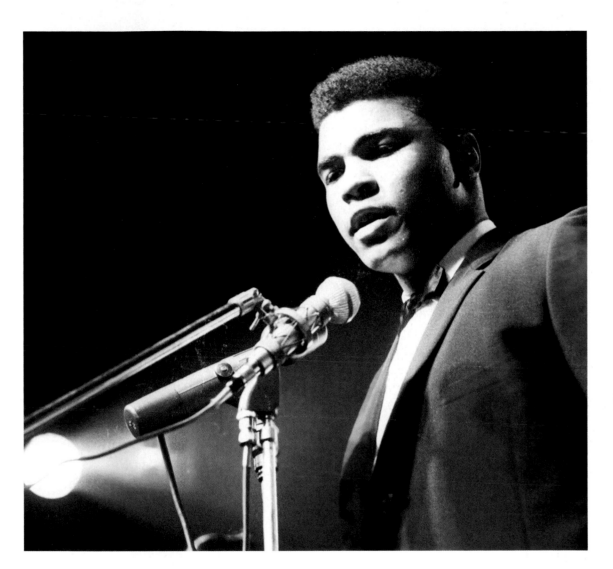

"He became arguably the most famous person on the
planet, known as a supreme athlete, an uncanny blend
of power, improvisation, and velocity; a master of rhyming
prediction and derision; an exemplar and symbol of racial
pride; a fighter, a draft resister, an acolyte, a preacher,
a separatist, an integrationist, a comedian, an actor,
a dancer, a butterfly, a bee, a figure of immense courage."
— *David Remnick*

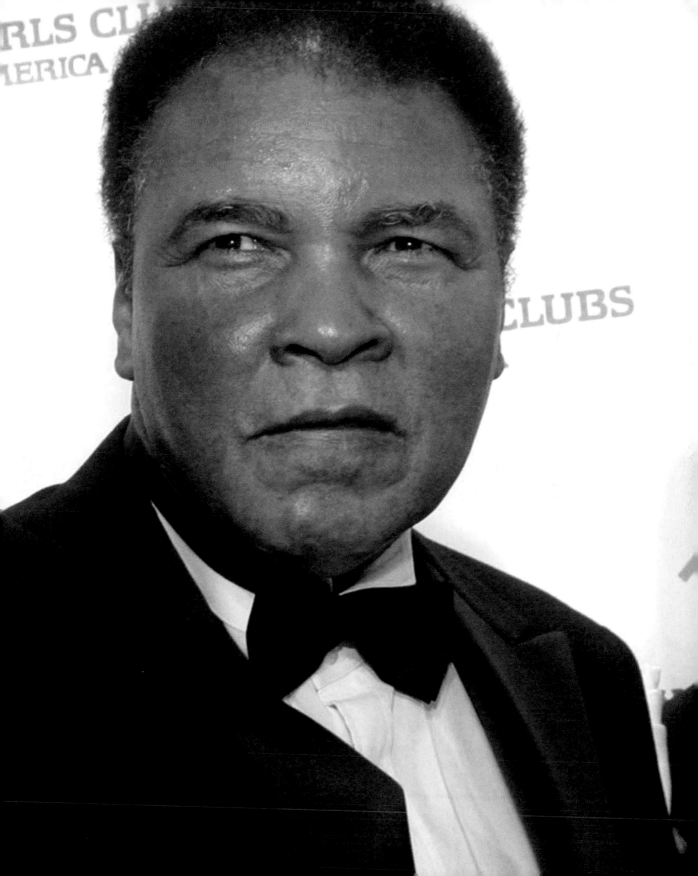

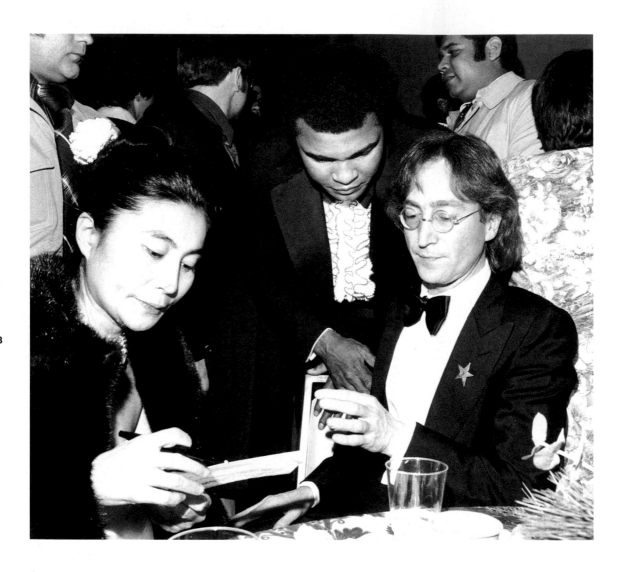

"It would be a personal joy to see them together again,"
Ali said. "The man who helps unite the Beatles makes
a better contribution to human happiness than an
astronomer who discovers a new star."

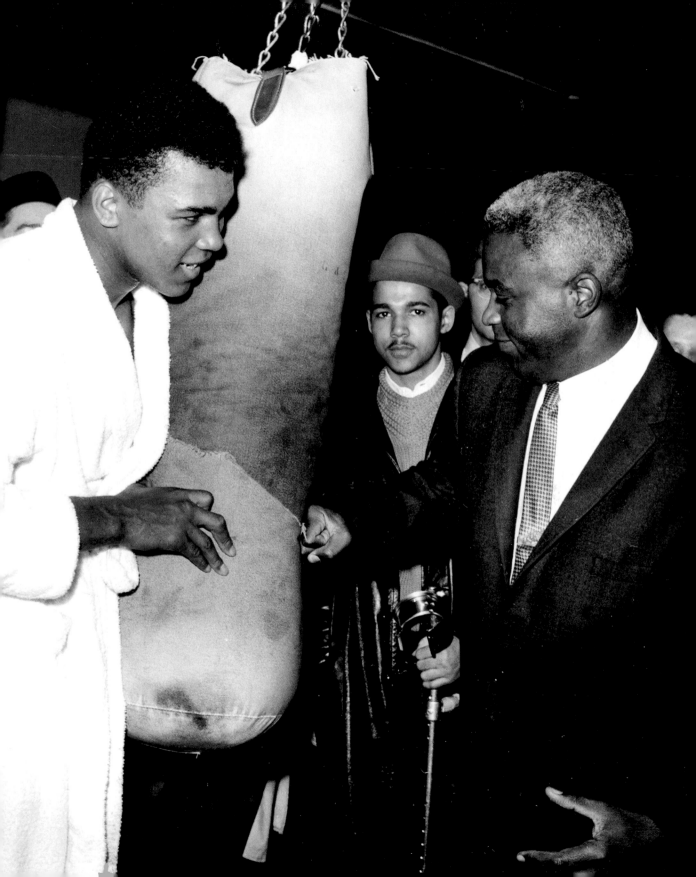

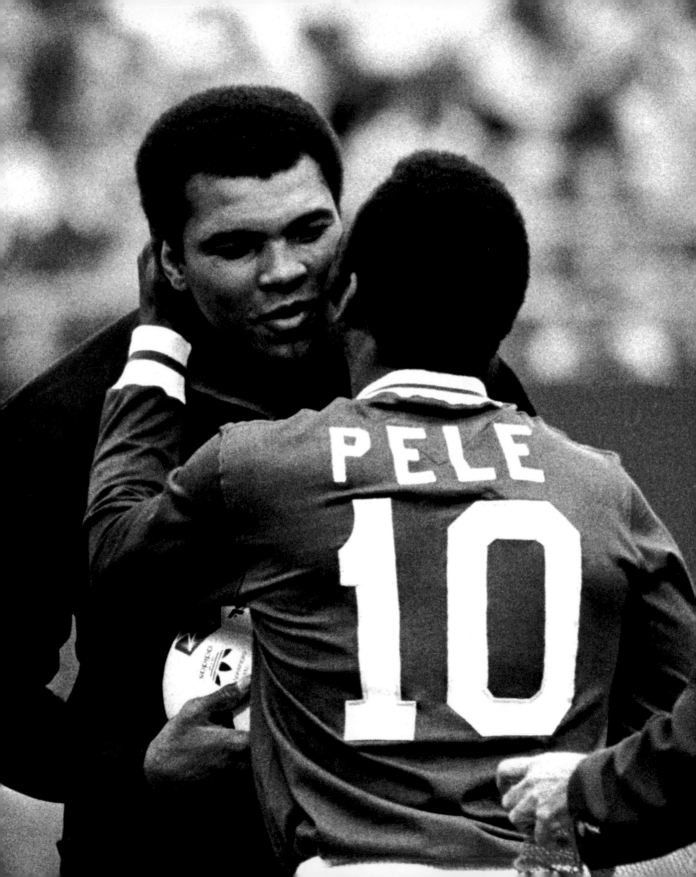

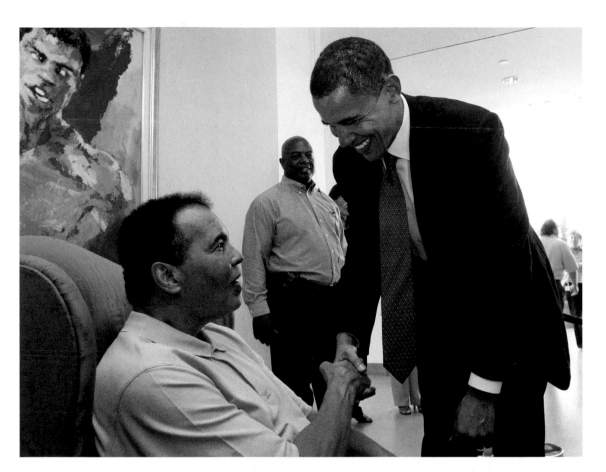

"Muhammad Ali was The Greatest. Period. If you just asked him, he'd tell you . . . he was a fighter in the ring, but a man who fought for what was right. A man who fought for us. He stood with King and Mandela; stood up when it was hard; spoke out when others wouldn't. His fight outside the ring would cost him his title and his public standing. It would earn him enemies on the left and the right, make him reviled, and nearly send him to jail. But Ali stood his ground. And his victory helped us get used to the America we recognize today.

Muhammad Ali shook up the world. And the world is better for it. We are all better for it."

— *Barack Obama*

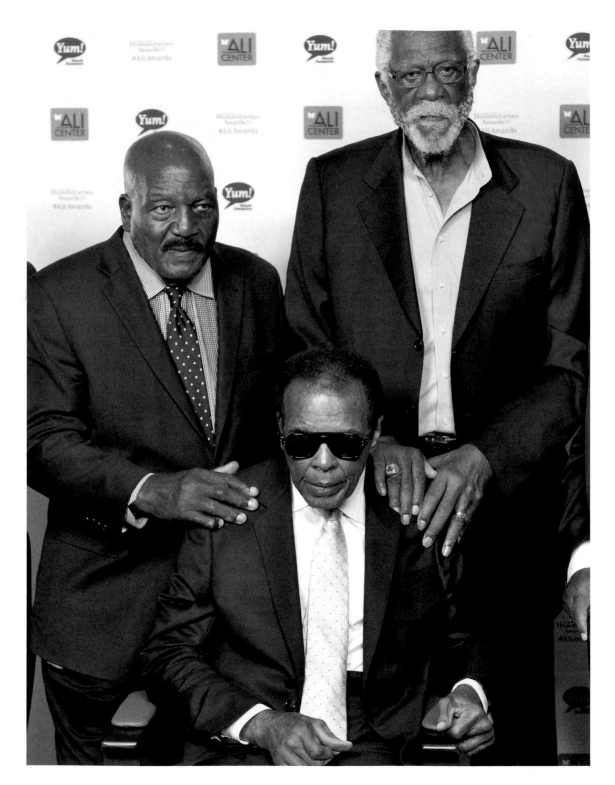

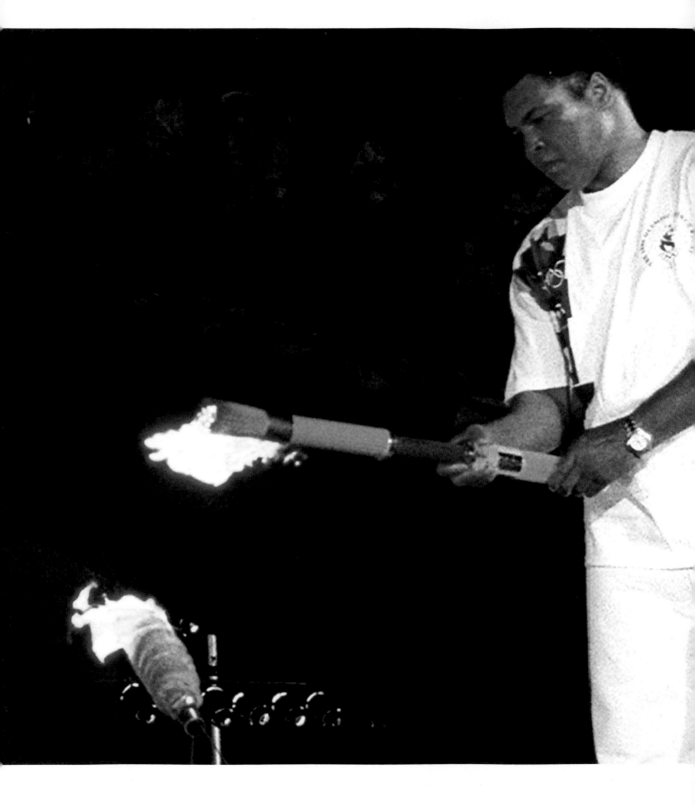

"
I WISH PEOPLE
WOULD LOVE
EVERYBODY
ELSE THE WAY
THEY LOVE ME.
IT WOULD BE A
BETTER WORLD.
"

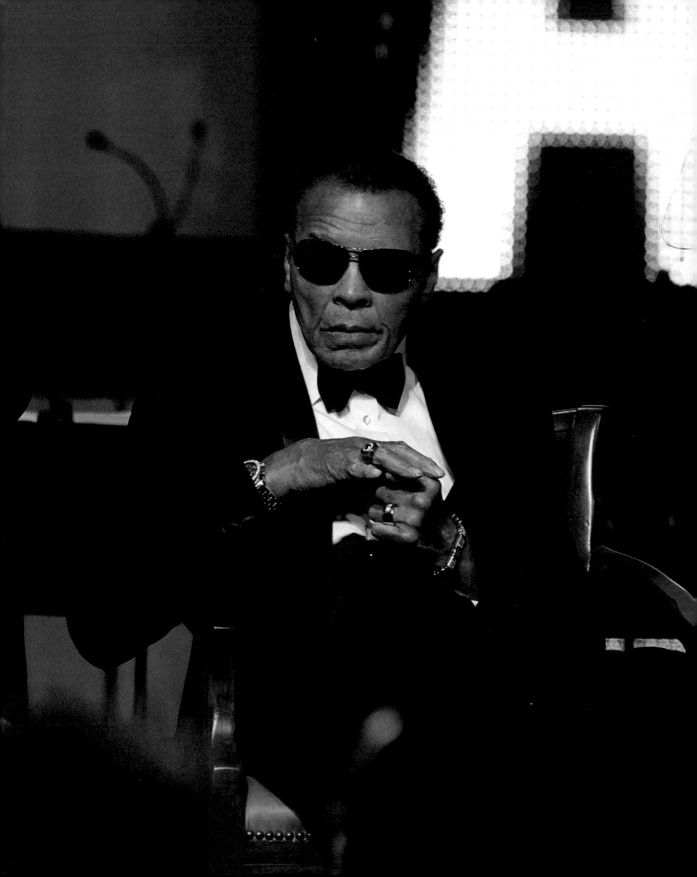

"He belonged to everyone. That means his impact recognizes no continent, no language, no color, no ocean. It belongs to us all, just as Muhammad Ali belongs to us all."
— *Maya Angelou*

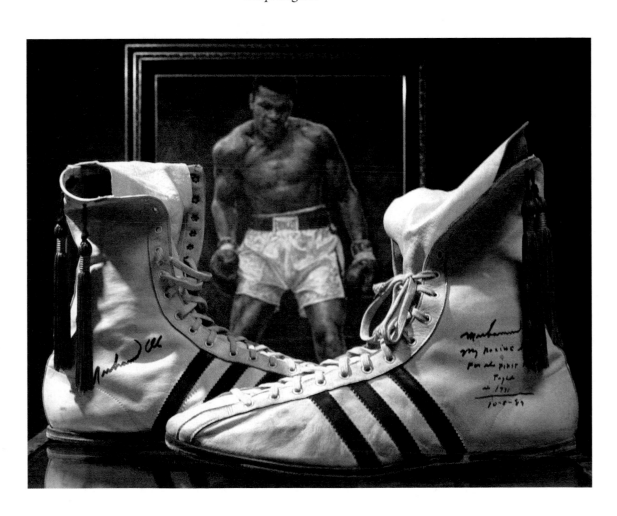

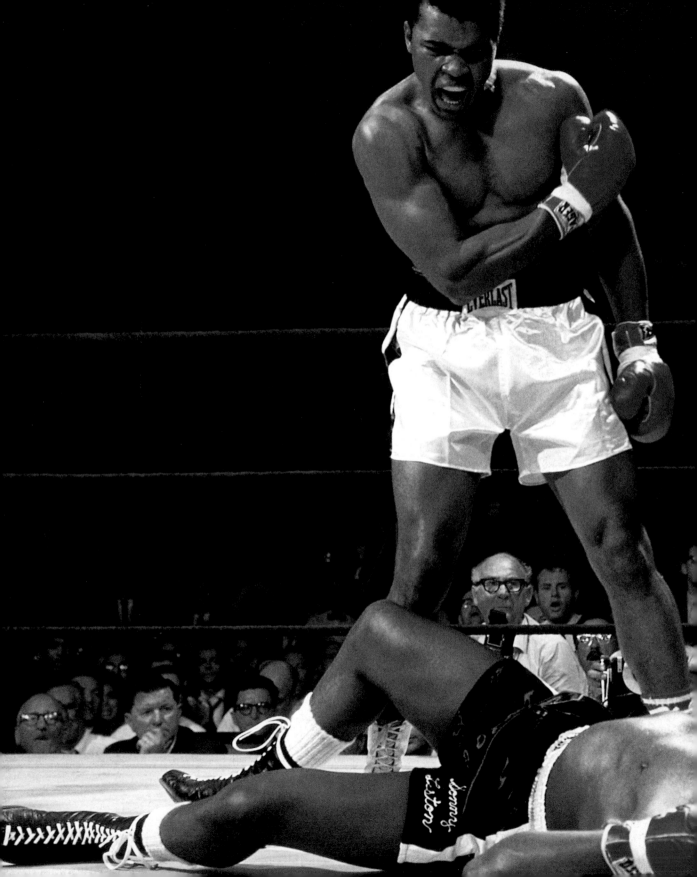

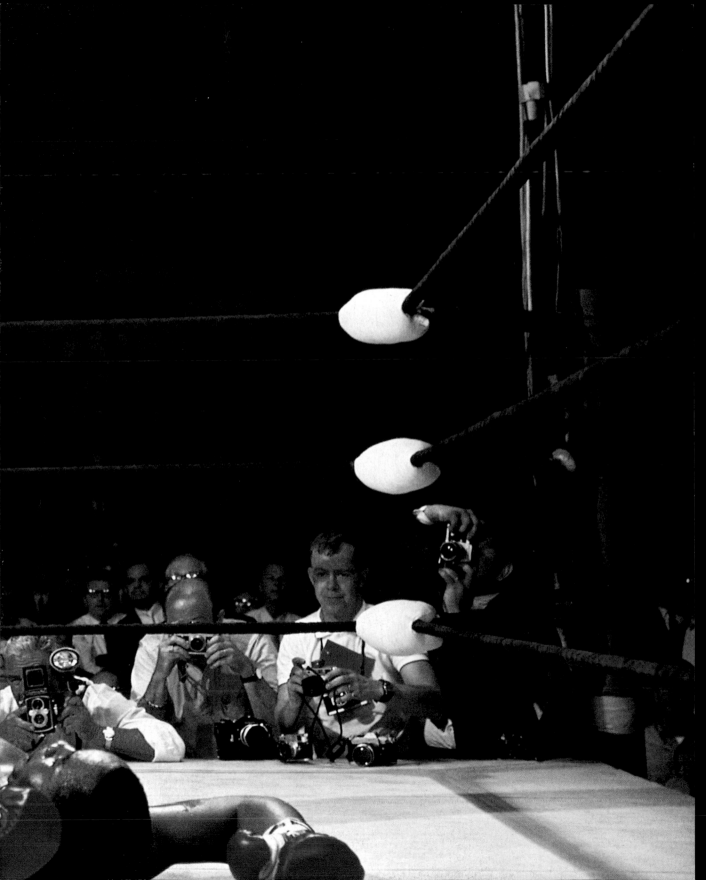

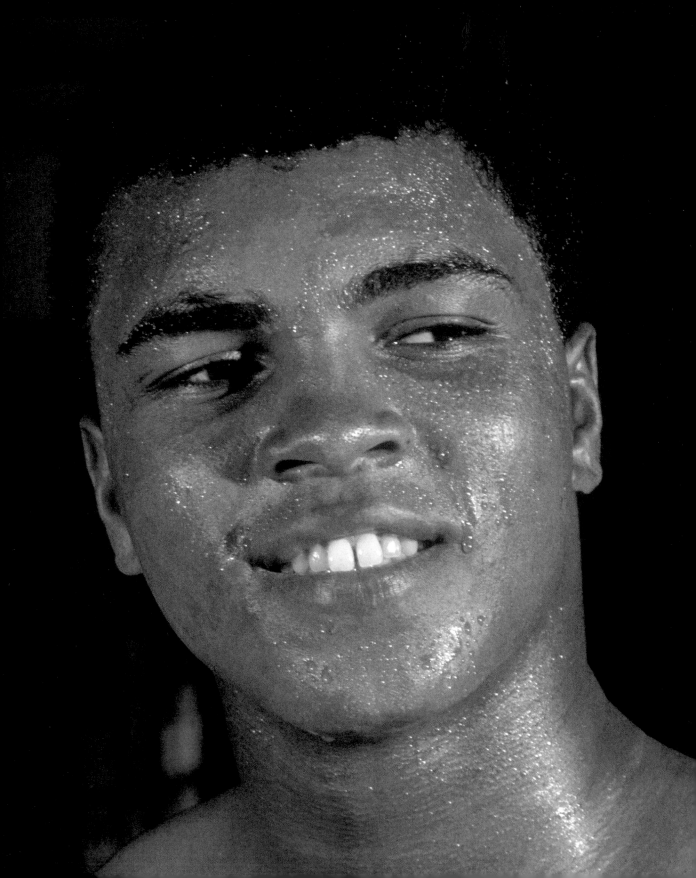

GETTING READY TO MEET GOD

BY MUHAMMAD ALI

I want to say something right here that you all might—this might make you all think.

Life is not really long.

Let's say the average person is thirty years old. If you're thirty years old, you're not but about seven years old. How can I prove it?

Add up all the seven, eight, nine hours you slept for thirty years. Out of thirty years, add up all the nights.

Last night, when you went to bed, and woke up this morning, you don't remember a thing.

You've been unconscious for about eight years, if you're thirty years old. You've slept for about eight years.

How much traveling have you done in thirty years? From the television station to home, to another country, to another city, to school, to church, you've probably traveled two years—just getting back and forth to where you're going.

So there's eight years of sleeping, two years of traveling. That's ten years out of your life before you accomplish anything.

How long do you sit in school? In America, we stay in school from the first grade to twelfth grade. Six hours a day for twelve years.

Break it down: You sit in a classroom for three years. Without leaving.

OK. That's two years of traveling. Eight years of sleeping. Three years of school.

How many movies have you went to, how many wrestling matches, how much entertainment, how many movie theaters, live plays, baseball games? That's probably two years of entertainment.

So by the time a man—and you older people know!—by the time you've made a way for your children, by the time you paid for your home, you're pushing sixty years old!

So, life is really short.

You add up all your traveling, add up all your sleeping, add up all your school, add up all your entertainment, and you've probably been, for half your life, doing nothing.

I'm thirty-five years old.

In thirty more years, I'll be sixty-five. We don't have no more influence. We can't do nothing at sixty-five. Your wife will tell you that!

What I'm saying is: When you're sixty-five, there ain't too much more to do, so . . .

Did you know I'll be sixty-five in thirty more years?

In those thirty years, I have to sleep nine years. (I don't have thirty years of daylight!) About nine years of sleeping.

All my traveling—that's probably four years of traveling in the next thirty years.

Television, movies, entertainment—about three years of entertainment. Out of thirty years, I might have about sixteen years to be productive.

So this is how we can all break individual lives down.

What am I gonna do in the next sixteen years? What's the best thing I can do?

Get ready to meet God.

Going into real estate, going into business, teaching boxing—that won't get me to heaven.

How many people here believe there's a supreme being? Believe there's a God? How many people believe there's some power that made the sun, the moon, the stars? How many believe that stuff didn't just come out of air, somebody wiser than us made it?

How many believe there's a God?

How many believe there's not a God?

[Ali holds up a glass.]

If I told you, you who don't believe in God, if I told you that this glass sprung into existence, this glass made itself, no man made this glass, would you believe it? Would you believe if I just told you this thing made itself?

When I tell you, you wouldn't believe it, right?

I'm just saying: You wouldn't believe it. If I turn to this television station, and it just popped into existence—no man made it.

You're saying, "Muhammad Ali's crazy." All right.

Well, if this glass can't make itself, if I told you those clothes you have on wove themselves and nobody created them, those clothes made themselves, you wouldn't believe it.

But if your clothes didn't make themselves, if that glass couldn't make itself, if this building didn't make itself—how did the moon get out there? How did the

stars? And Jupiter, Neptune, and Mars and the Sun? How did Nature? How did all this come here? Didn't no wise something plan to make it?

What I'm saying is: I believe we're all going to be judged.

Should a man like Hitler kill all the Jews and get away with it? Somebody should punish him. Maybe he won't get it now, he'll get it when he dies, in hell for eternity.

What I'm going to do, when I get out of boxing, is to get myself ready to meet God. Because my plane may blow up. Don't planes blow up sometimes and crash?

Don't people die everyday?

It's a scary thing to think I'm going to hell. To burn eternally forever. So, what am I going to do?

I'm explaining what you asked. When you ask me questions, I can't just answer, like . . .

When I get out of boxing, when I'm through, I'm going to do all I can to help people. That's why I'm here with Johnny Walker. Here's a poor man who came all the way to America because a bunch of boys needed some money. Somebody is calling me to help them. God is watching me.

God don't praise me because I beat Joe Frazier. God don't care nothing about Joe Frazier. God don't care nothing about England or America.

As far as we're all concerned, it's all his.

He wants to know: How do we treat each other? How do we help each other?

So I'm going to dedicate my life to using my name and popularity to help charities, helping people, uniting people. People are bombing each other because of religious beliefs. We need somebody to help us, to make peace.

When I die, if there's a heaven, I want to see it.

Because we live how long? Eighty years? The odds are everybody in this room, some of you are going to be dead twenty years from now. Some of you are going to be dead fifty years from now. Some of you are going to be dead sixty, seventy years from now.

We are all going to die soon.

And if you live to be, say, a hundred and twenty-five years old—which we don't do, right? Or let's say we live to be two hundred and fifty years old. You're still going to go to him after that. So we don't have but about eighty years on earth. This is a test to see where we will spend our life, in heaven or in hell.

This is not the life now. Your real self is inside you. Your body gets old. Some of you go to look at yourself, and you don't have teeth, your hair is leaving you, your body is getting tired. But your soul and your spirit never die. That's going to live forever. Your body is just housing your soul and spirit. So God is testing us on how we live, how we treat each other, to see whether our real home is in heaven.

This fizzle of stuff won't last for so long.

This building is going to be here when the man who built it is dead. There have been many queens and kings of England. They're all dead. After this one is gone, another one will come.

So we don't stay here. We're just trustees. We don't own nothing. Even your children are not yours.

Do you think I'm lying?

Your wife is not yours. You die and come back a year later and go slip in your bedroom and see if your wife is by herself. Because you don't own your wife.

I divorced my wife. You may have read about it, and my four children—they call another man Daddy now. They don't see me no more. You don't own your children. You don't own your family.

So what am I saying?

The most important thing about life is what's going to happen when you die. Are you going to go to heaven or hell? And that's eternity. And when you die and go to hell and you're burning forever and ever and ever, with no end, how long is that?

How long is eternity? Let's imagine.

Take the Sahara desert. There's a lot of sand on the Sahara desert, right? Imagine I tell you to wait a thousand years—and every thousand years, I want you to pick up one grain of sand. Okay, wait another thousand years, pick up a fresh grain. Wait another thousand years before you get the next grain. Keep that up until there's no more sand in the desert. Do that until the desert is empty.

Whew!

You know how long that just took? I mean, America's not but two hundred years old. We've got eight hundred more years to go before we reach one thousand.

It scares me to think that I might die one day and go to hell. I'm on an airplane that might blow up, and I might go to hell and God is going to judge my soul. I might kill people. I might rob people. The authorities might not catch me. The police, the FBI, Scotland Yard, they all might not catch me. But when I die, somebody's watching me and keeping count, and I can't get away and I'm going to burn forever and ever and ever. I'll go to hell.

So what am I going to do when I'm through fighting, when I only have sixteen years to be productive?

Getting myself ready to meet God. And go to the best place.

Don't that make sense?

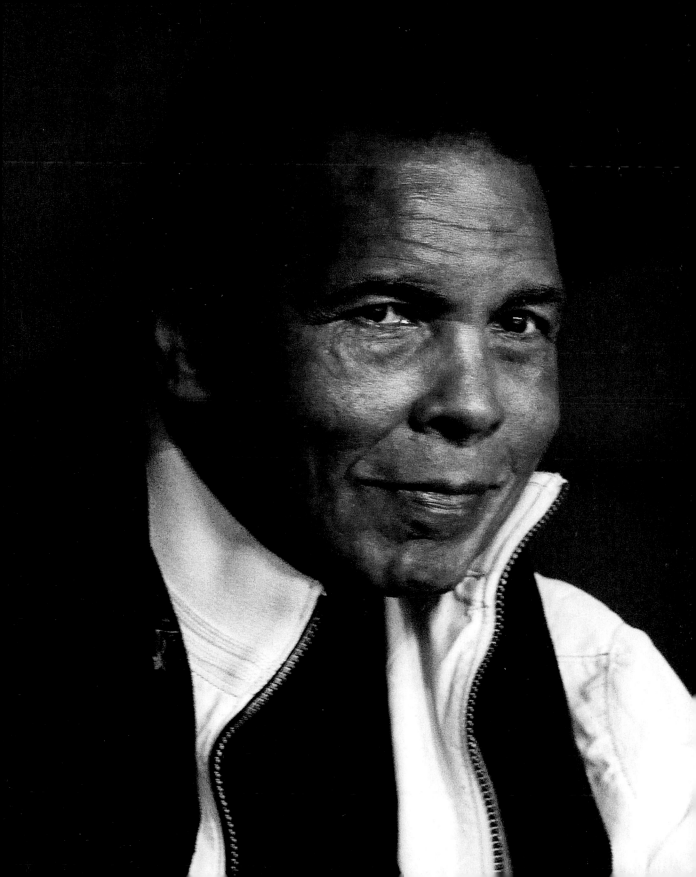

ACKNOWLEDGMENTS

Special thanks to: Jamie Salter, Nick Woodhouse, Pamela Bebry, Simon Chin, Matt Van Ekeren, Bridgette Fitzpatrick, Katie Jones, Steve King, Brian Lee, Jennifer Mbagwu, Marc Rosen, Corey Salter, and Matt Salter.

A note from Lonnie Ali: I would like to acknowledge the hundreds of photographers who chronicled Muhammad so prolifically throughout his career and life. They have provided a treasure trove of memories that will continue to give me, our family, and Muhammad's fans endless moments of happiness, laughter, and tears, as well as a renewed appreciation of the incredible life Muhammad lived.

PHOTOGRAPHY CREDITS

MUHAMMAD ALI ENTERPRISES LLC.:
Ken Regan, Pgs. 4-5, 6-7, 16-17, 24, 40-41 (3), 44-45, 46-47, 52-53, 54, 57, 60-61, 76, 80, 83, 200, 214, 222, 223, 235

GLOBE PHOTOS:
Pgs. 30, 32, 33 (2), 36, 37, 62-63, 66 (2), 67, 68, 69, 70-71, 72-73, 78-79, 166-167, 168, 169, 170 (2), 171

SHAW FAMILY ARCHIVES:
Larry Shaw, Pgs.142, 144, 145 (top)

USA TODAY SPORTS:
Keith Williams/The Courier-Journal, Pgs. 2-3, 164; **H. Darr Beiser,** Pg. 18; **Mark Zerof,** Pg. 23; **Warren Klosterman/The Courier-Journal,** Pgs. 28-29; **Al Blunk/The Courier-Journal,** Pg. 31; **The Courier-Journal,** Pgs. 84, 98-99, 101, 150-151, 165, 190; **Thomas Hardin/The Courier-Journal,** Pg. 102; **Al Hixenbaugm/The Courier-Journal,** Pg. 103; **Jean A. Baron/The Courier-Journal,** Pg. 145 (btm); **Larry Spitzer/The Courier-Journal,** Pgs. 146, 192-193; **Charles Fentress Jr./The Courier-Journal,** Pg. 147; **Bud Kamenish/The Courier-Journal,** Pg. 148; **Jay Thomas/The Courier-Journal,** Pg. 149; **Jebb Harris/The Courier-Journal,** Pg. 191; **Bill Luster/The Courier-Journal,** Pgs. 208-209; **Sam Upshaw Jr./The Courier-Journal,** Pg. 241; **Brian Spurlock/The Courier-Journal,** Pg. 243

ASSOCIATED PRESS:
G. Marshall Wilson/Ebony Collection, Pg. 8; **Doug Mills,** Pgs. 14-15; **Press Association,** Pg. 26; **Associated Press.** Pgs. 27, 38, 39, 51, 75, 107, 110, 117, 130, 131 (2), 140-141, 172-173, 174, 175, 184-185, 202, 211, 215, 220, 223, 228-229, 230, 232, 238, 239, 240; **Ed Kolenovsky,** Pgs. 81, 112; **Paul Cannon,** Pg. 90; **Kishore,** Pg. 96; **GS,** Pg. 106; **Horst Faas,** Pg. 111; **Dieter Endlicher,** Pg. 112; **Richard Drew,** Pgs. 113, 160; **Olivier Douliery/Sipa USA,** Pg. 120; **Ron Frehm,** Pgs. 129, 205; **Harry Harris,** Pgs. 132-133; **Wally Fung,** Pg. 134; **Dave Pickoff,** Pg. 135; **Lois Raimondo,** Pgs. 136-137; **Greg Baker,** Pgs. 138-139; **Star Shooter/MediaPunchinc/IPX,** Pg. 153; **Express Newspapers,** Pgs. 155, 232; **Frederick Watkins, Jr./Ebony Collection,** Pg. 176; **Isaac Sutton/Ebony Collection,** Pg. 186; **Walter Zeboski,** Pg. 199; **Picture-Alliance/dpa,** Pg. 203; **Joe Migon,** Pg. 206; **Jim Palmer,** Pg. 207; **Ron Sachs/CNP/Picture-Alliance/dpa,** Pg. 216; **Lennox McLendon,** Pg. 217; **Tina Fineberg,** Pgs. 236-237; **Timothy D. Easley,** Pg. 242; **Michael Probst,** Pgs. 244-245; **Frank Micelotta/Invsion,** Pg. 246; **Michael Caulfield,** Pg. 247; **David Drapkin,** Pg. 255

GETTY IMAGES:
Columbia Pictures, Pgs. 12-13; **Neil Leifer/Sports Illustrated,** Pgs. 42-43, 65, 92, 94-95, 177, 179, 234, 248-249; **Hy Peskin/Sports Illustrated,** Pg. 48; **Tony Triolo/Sports Illustrated,** Pg. 49; **Marvin Lichtner/Pix Inc./The LIFE Images Collection,** Pg. 50; **Fred Morgan/NY Daily News Archive,** Pg. 55; **Walter Iooss Jr./Sports Illustrated,** Pgs. 56, 233; **Stanley Weston,** Pg. 57; **Jerry Cooke/Sports Illustrated,** Pg. 64; **John Shearer/The LIFE Picture Collection,** Pg. 77; **Chris Smith/Popperfoto,** Pg. 82; **Bob Gomel/The LIFE Picture Collection,** Pgs. 86, 88, 89, 250; **Daily Express/Archive Photos,** Pg. 87; **Robert Abbott Sengstacke,** Pgs. 91, 221; **Bob Thomas,** Pg. 97; **Franco Origlia,** Pg. 100; **Scott Olson,** Pgs. 114-115; **Mario Tama,** Pg. 116; **Abdelhak Senna/AFP,** Pg. 121; **Paula Bronstein/UNICEF,** Pg. 122; **Ezra Shaw,** Pg. 122; **Ray McManus/Sportsfile,** Pg. 123; **Bernard Gotfryd,** Pgs. 124-125; **Ken Regan/Camera 5 via Contour by Getty Images,** Pg. 128; **Mitchell Layton,** Pg. 152; **James Drake/The LIFE Images Collection,** Pg. 154; **Steve Schapiro/Corbis,** Pgs. 156, 182; **EyeOn/UIG,** Pg. 157; **Len Trievnor/Express,** Pgs. 158-159; **Terry Fincher/Hulton Archive,** Pg. 161; **Frank Tewkesbury/Evening Standard,** Pg. 178; **Jeff Kravitz/FilmMagic, Inc.,** Pg. 179; **Central Press,** Pg. 183; **Paul Slade/Paris Match,** Pg. 187; **Paul Harris/Online USA, Inc.,** Pgs. 188, 189; **Stephen Lovekin/MJF/WireImage,** Pgs. 194-195; **Mirror Syndication Intl./The LIFE Images Collection,** Pg. 196; **Michael Ochs Archives,** Pg. 197; **Lynn Pelham/Sports Illustrated,** Pg. 198; **Keystone,** Pg. 204; **Jack Smith/NY Daily News Archive,** Pg. 205; **Popperfoto,** Pg. 210; **Time Life Pictures/DMI/The LIFE Picture Collection,** Pgs. 212-213; **Getty Images,** Pgs. 224-225; **Paul Bereswill,** Pg. 226; **J.P. Aussenard/WireImage,** Pg. 227; **John D. Kisch/Separate Cinema Archive,** Pg. 231; **John Moore,** Pg. 243; **Bettmann Collection,** Pgs. 52-53, 74, 93 (2), 108-109; 126-127